P9-CAW-532

The complete paintings of

Picasso

Blue and Rose Periods

Introduction by **Denys Sutton**

Notes and catalogue by **Paolo Lecaldano**

Harry N. Abrams, Inc. *Publishers* New York

Classics of the World's Great Art

Editor
Paolo Lecaldano

International Advisory Board
Gian Alberto dell'Acqua
André Chastel
Douglas Cooper
Lorenz Eitner
Enrique Lafuente Ferrari
Bruno Molajoli
Carlo L. Ragghianti
Xavier de Salas
David Talbot Rice
Jacques Thuillier
Rudolf Wittkower

This series of books is
published in Italy by Rizzoli
Editore, in France by
Flammarion, in the United
Kingdom by Weidenfeld and
Nicolson, in the United States
by Harry N. Abrams, Inc.,
in Spain by Editorial
Noguer and in Switzerland by
Kunstkreis

Standard Book Number 8109-5514-8
Library of Congress Catalogue
Card Number 70-92261
© Copyright in Italy by
Rizzoli Editore, 1968
Printed and bound in Italy

Table of contents

Photographic sources

Colour plates: Baltimore Museum of Art, Baltimore (Md.);
Blauel, Munich; Brenwasser, New York; Conzett &
Huber, Zürich; Göteborgs Museum, Göteborg; Goetz,
Los Angeles (Cal.); Held, Ecublens; Hinz, Basle; Ides et
Calendes, Neuchâtel; Mas, Barcelona; Mellon,
Washington, DC; Merkel, Saõ Paulo; Metropolitan
Museum of Art, New York; National Gallery of Art,
Washington, DC; Nimatallah, Milan; Scott, Edinburgh;
Service T.I.P., Liège; Solomon R. Guggenheim Museum,
New York; Staatsgalerie, Stuttgart; Toledo Museum of
Art, Toledo (Ohio); Virginia Museum of Fine Arts,
Richmond (Va.); Warburg, New York; Whitney, New
York. Black and white illustrations: most of these were
supplied by the respective galleries or collections, or
were already in the Rizzoli archives. Photographs nos.
49, 93 B, 149, 176, 177, 181, 238, 245 C, 246, 258 A,
275 A, 289 B, 298, were reproduced by kind permission
of the authors and publishers, from *Picasso 1900–1906*,
by Pierre Daix and Georges Boudaille, Neuchâtel 1966,
Editions Ides et Calendes.

Introduction

If Pablo Picasso had died in 1906 he would have been only twenty-five but he would have left behind him a formidable body of work – the many paintings, water-colours, drawings and etchings from the Blue and Rose Periods which have rightly won him so many admirers. They are among the most enchanting pictures pro-duced in the early years of this century and their vivacity and freshness have not diminished with the years.

One of Picasso's achievements at this time was to have taken the more or less conventional subject-matter of the *fin de siècle* and given it his own personal twist, elegant in style and often elegiac in mood. Yet his art, while reflecting the temper of the day, suc-ceeded in being more than modish. He was already a master of paradox for, although often considered an extreme radical, he has invariably been a lover of earlier art and his connoisseur's eye has permitted him to look in many different directions, adapting to his own ends anything that has captured his fancy.

His intellectual and artistic appetite is displayed to the full in his salad days, when he was in touch with the intelligentsia and the artistic world of Barcelona, Madrid and Paris. He was one of the circle that gathered in the famous "Els 4 Gats", where he made spirited drawings of his companions, and in Madrid in 1901 he edited the avant-garde review *Arte Joven*. He numbered among his Spanish friends the painter Nonell, who was his senior and exerted a decided influence on him, Junyer, Manolo the sculptor, Ricardo Canals and the writer Utrillo. In Paris, which he visited for the first time in 1900 and where he settled in 1904, he formed valuable contacts with a lively circle which included Guillaume Apollinaire, Max Jacob and André Salmon and he owed much to his relationship with Fernande Olivier. It was thanks to these connexions, as well as to his own love of novelty, that he kept abreast of modern trends in literature, ideas and art.

Picasso grew up at the tail-end of historicism so it is small wonder that, during his artistic and intellectual *wanderjähre* (1900–6), he tapped so many different sources – Toulouse-Lautrec, Steinlen, Beardsley, Rosetti, El Greco and Iberian sculpture. He was an exponent of the theory of the "museum without walls" before it had been coined by André Malraux. The range of his borrowings has been examined in detail by Sir Anthony Blunt and Dr Phoebe Pool. Although some of their theories have been challenged by MM. Daix and Boudaille, the authors of the standard work on the early work of Picasso who reject the debt to Edvard Munch, their chief conclusions are valid.

So much emphasis is now placed on the merit of an artist who immediately casts off an inheritance, that it is sometimes overlooked that many painters in earlier times found nothing wrong in leaning on either their forbears or their contemporaries when formulating their own style. Such debts were not felt to hamper their own originality and there is no reason why they should do so. Rubens looked at Elsheimer, Correggio, Titian and Tintoretto, not to speak of the Antique, without in any way impairing the robustness of his own work. Another artist fond of "quoting" from the Old Masters was Sir Joshua Reynolds. Picasso therefore may be placed in a noble tradition; he is an aesthete who has got the best out of a period of aestheticism.

The old view that Spain in the 1890s and 1900s was an artistic backwater is now seen to be misleading. In fact, this period witnessed a considerable resurgence of intellectual life in Spain, and besides Picasso himself, reference may be made to Gaudí, Unamuno and Ortega y Gasset. The Catalan Renaissance, for instance, afforded a specific contribution to European culture which was international in character. Its exponents looked at the Spanish tradition obviously, but, also, at the achievements of France and, no less significantly, of the North. Wagner, Schopenhauer and Nietzsche were names to conjure with in Barcelona

and Picasso is even said to have read in his teens most of the writings of the last-mentioned German philosopher. Picasso is well-read so that a literary flavour was only to be expected in his painting at this stage. He is one of the many artists and men of letters who succumbed to the then fashionable pessimism and who were fascinated by the problem of giving artistic expression to physical and psychological illness.

On arriving in Paris in 1900, Picasso adopted the traditional path of the tourist and was intrigued, understandably so, by the night life of the city; by places such as the Moulin de la Galette and the garishly dressed prostitutes with their feather boas. His approach resembles that of other masters of *la belle Époque*; however, his early pictures of such subjects were endowed with a sense of psychological insight which was not to be found in those of many of his contemporaries. His themes and the mood of his pictures were then derived from the tradition of the French poets of urban life – Baudelaire, Verlaine and Laforgue and express nostalgia, a sense of pathos and melancholy. Yet Picasso was opposed to Naturalism and, unlike painters such as de Nittis or Raffaëlli, he did not paint mean streets in an anecdotal manner. The first Paris pictures reflect a youthful zest for strong colours and for black outlines that anticipate the procedures of Fauvism by some years.

Inevitably this impressionable painter responded to the willowy lines and decorative appeal of Art Nouveau, then such a dominant European style. The subject-matter he chose to paint – the nature of relations between the sexes as in *Life* (no. 89) – was also akin to the iconography of this movement. His closeness to Symbolism is no less evident. Cirici Pellicer, in his valuable account of the early Picasso, has drawn attention to the parallels existing between Picasso's painting and that of Maurice Denis; the differences between them are telling, however, for Denis aimed at rendering the bliss of domestic life and the consolations of religion, while Picasso produced works in which faith is conspicuously absent. As an heir to the Decadent tradition, he sought an artistic equivalent for nihilism and pessimism.

The sort of ideas that Picasso expressed in his early painting can be found in Unamuno's books, above all in *Del sentimiento trágico de la vida*, 1912, in which this influential thinker emphasised that man's life was a tragedy from birth to death. It is no less relevant that Ortega y Gasset's contact with German philosophy heightened the pessimism ventilated in *España invertebrada* (1921) and *La rebelión de las masas* (1930). It is significant that certain of Picasso's representa-

tions of women and children reveal affinities with those of Carrière. The connexion is based on their mutual love of pathos and their sympathy for the poor – evident in Picasso's pictures of beggars and Carrière's espousal of Socialism. However, their technique and concept of colour were different; Carrière restricted his palette practically to monochrome. Picasso clothed his works in blue. His almost exclusive use of this colour in 1902–3, as Sir Anthony Blunt and Dr Pool point out, "has never been satisfactorily explained". It has been attributed to the fact that he was too poor to buy other colours and that he worked by lamplight. However, a convincing explanation is that blue is the colour that was so much admired by Romantics and the Decadents. It is certainly one that well accorded with his themes and heightened their pervasive sense of mystery.

Picasso, who has never denied his debt to other artists, acknowledges the influence on him of Van Gogh which can be most effectively seen in the *Self-Portrait* (no. 21). His appreciation of El Greco is particularly interesting for this artist had only begun to be admired again in the 1890s – Sargent for one championed his work. There is no doubt that the manneristic twist, the elongations and the spiritual mood of the great Spanish painter were congenial to him. Picasso's unusual picture, *Burial of Casagemas* – a poet who had committed suicide in Paris – was indebted to El Greco's *Dream of Philip II* or *Burial of Count Orgaz*. There is a fascinating echo from Odilon Redon in Picasso's picture also; for the plunging horse must surely derive from one of this artist's illustrations to Flaubert's *Tentation de Saint-Antoine*. Picasso's interest in Spanish painting may also be observed in his pictures of bull-fights with their inevitable relationships with Goya and Lucas.

The stage has played a considerable role in Picasso's art but only since the publication of Douglas Cooper's important book on this topic has the importance of his contribution to the Russian ballet of Diaghilev been fully realised. This theatrical streak is evident in Picasso's early pictures, not only in their subject matter – harlequins and circus people (he loved the Cirque Médrano) – but in the disposition of space which often suggests that the protagonists in a picture are on the stage. Yet there is nothing at all naturalistic about his conception. The figures in *The Acrobats* (no. 192) seem to have strayed on to a stage from some dream world and it is easy to understand the deep appeal of this picture to Rilke; it inspired the celebrated opening of the fifth of his Duino elegies: "But tell me, who are they, these acrobats, even a little more fleeting than we ourselves – so urgently, ever since

childhood wrung by an (oh for the sake of whom?) never-contented will?" Picasso's paintings of the circus and harlequins, as well as the Salome series, stress the exquisite side of his art: this dandy of art possesses a true Parisian chic. Another sign of his cult of elegance is his rose tones in many pictures of 1905.

Picasso was in touch with several of the men of letters, headed by Moréas, who in 1905–6 supported a return to the Antique world. Yet in turning in this direction, Picasso did no more than adhere to the tradition of idealistic painting associated with Puvis de Chavannes, Hans von Marées and (mixed with Celtic mystery) Augustus John. Picasso, in fact, is one of the last of the great nineteenth-century classicists – a breed which produced Rodin, Richard Strauss and Hugo von Hofmannsthal. Picasso appreciated the elegant linearism of Greek vase painting and the perfect pose of Archaic sculpture.

By 1905 significant changes may be detected in Picasso's art. The intricacies of his style at the period and the confused chronology of his evolution have been well analysed by MM. Daix and Boudaille. Picasso paid visits to Holland and to Gósol in Catalonia, where he spent the summer of 1906. Even if he did not see Iberian sculpture at Gósol (none in fact exists there), his painting was now moving in a different direction. The famous portrait of Gertrude Stein, for instance, shows a stronger, more brutal and more monumental treatment of form. It may well be that his concern with primitivism was a sign of a reaction against aestheticism.

How may the works of the Blue and Rose Periods be compared with those of the Cubist Period or with Picasso's later development? Do they seem to be old-fashioned and dated or is it that his expression of a vision, in which man's alienation from an increasingly mechanistic and impersonal world is conveyed with a melancholy and sweetness, has more to offer us than is often believed, more even than his Cubist and later pictures?

DENYS SUTTON

An outline of the artist's critical history

. . . Picasso's art is extremely young. Gifted with an observing eye that does not forgive people's weaknesses, he manages to plumb beauty even in the horrible, which he then puts down with the sobriety of a man who paints because he sees and not because he knows how to achieve this or that effect. . . .

In Paris they have given him a nickname: his appearance, his wide-brimmed hat which has endured the inclemencies of Montparnasse, his eyes – the bright eyes of a southerner who is also master of himself, his neck enveloped in fantastic, ultra-impressionistic scarves, have all inspired his French friends to call him "Little Goya".

We believe that he will not be false to his name physically: his intensity tells us that we are right. MIGUEL UTRILLO ("PINCELL"), review of the exhibition in the Sala Parés, in *Pèl i Ploma*, Barcelona, June 1901

. . . The recent Spanish flowering, which is wholly pictorial this time, is imbued above all with harsh, dark, corrosive imagery which can also be magnificent at times, but with a deliberately gloomy, violently autochthonous magnificence.

All these artists are, indeed, related by a marked family likeness: underneath their apparent influences one detects their great predecessors, and especially Goya, that sad, powerful genius: as, for example, in Picasso, the latest striking arrival on the scene.

Picasso is absolutely, decisively a painter, as his feeling for material is sufficient to show: like all true painters, he loves colour for itself, and every material has its own colour.

So that every subject arouses him, therefore, everything may become a subject for him. The dazzling explosion of flowers over the rim of a vase, towards light and the luminous atmosphere that enfolds them: the multicoloured surge of the crowd, the green of a race track, the dry sand of a bull-ring; the exposure of female bodies, of every kind of female body, or the concealment of them and the way they are defined, revealed as solid behind the soft layers of mothy stuffs . . . And the unexpected: the light green of one of the three dancing girls contrasting with the white of their petticoats, or the very stiff, masculine whiteness of the starched underclothes of the little girls; the white and yellow of a woman's hat: and so on.

Just as every part of a subject is a subject for him, so everything assists him to render it: slang, dialect, even his neighbour's vocabulary. And it is not difficult to discover the many probable influences on him. Delacroix, Manet (the most legitimate since he, too, derives something from the Spanish school), Monet, Van Gogh, Pissarro, Toulouse-Lautrec, Degas, Forain, maybe even Rops . . . But all of them in passing, dissipated almost before they are apprehended.

His impetuosity has clearly prevented him as yet from developing a style of his own: his personality is expressed precisely in this effusion, this youthfully furious spontaneity. (He is said to be not yet twenty years old, yet to complete three canvasses a day.) Herein, however, lies danger, in this very impetus which could direct him to facile virtuosity and even more facile success. "Prolific" and "fertile" are adjectives, just like "energetic" and "violent". It would be a shame, when he shows such exuberant virility. FÉLICIEN FAGUS, "L'Invasion espagnole: Picasso", in *La Revue Blanche*, Paris, 15 July 1901

. . . As for M. Picasso, who they tell me, is still very young, he marks his début with such élan that I am afraid for his future. One could make a list of the origins of all his paintings: their variety is too astonishing. This is not to deny his gift: but I should advise him, for his own good, not to paint more than one canvas a day. FRANÇOIS CHARLES, review of the exhibition at the Galerie Vollard, in *L'Ermitage*, Paris, September 1901

. . . Earlier a blazing riot of colour, Picasso is now concentrating his powers on the line of energy.

The absorbed, almost benumbed little girl with the stubborn, thin, serious brow and sick, mistrustful, pitiless eyes, painted entirely in light shades of blue, is poised like a character from history. The young girl who is standing upright in the tub to sponge herself, with slender legs and lean torso, has a rounded shoulder whence branches the arm that carries the sponge: she emerges as a fragile figurine, self-contained, extraordinarily peaceful. The courtesan whose outline is stamped on the thick azure background is unaware of her dignity. The feline twist of her shoulders and hands, and the fixity of her expression under the statuesque headgear of her wide hat with its nodding plume together make something hieratic of her, which is fully expressed in the golden-haired virgin (herself, or her sister?): she is just a young girl stretching down, her head erect and an absent-minded expression on her face; her short, feline nose is slightly wrinkled, between sniffing and breathing – a wonderful creature, almost a goddess, a sphinx. The whole is contained within an opacity which flashes with light and with open areas imprisoned inside perfectly conceived and considered perimeters, painted with great emphasis and command: a simplification which solidly confirms the impression aroused by these canvasses of stained glass. . . .

All these Spanish artists . . . have temperament, breeding and personality. Each one is an absolute master in his own field, exclusively his own, yet very closely related to his neighbour's. As yet, however, there is no great man among them; no one who dominates them, absorbing and recreating everything, whom

they all depend upon and who is great enough to build a world of his own without any limits.

We may mention the names of Goya, Zurbarán, Herrera, who fight on the same side as our own Impressionists, Manet, Monet, Degas and Carrière. Which of them – and the time is ripe – will become their El Greco? FÉLICIEN FAGUS, "Peintres espagnols", in *La Revue Blanche*, Paris, September 1902

One of the extraordinary elements is the empty sadness whose weight is felt through the entire, already vast output of this young man. Picasso, who began to paint even before he learned to read, seems to have been commissioned to record the whole of our existence with his brush: he could be called a young god, come to build the world anew. But a dark god. The hundreds of faces he has painted are all sombre, not a smile amongst them and the world is no more habitable than are its leprosy-infected factories. His painting itself is diseased.

Incurably so? I do not know. We certainly stand here before a man of power, vocation, and real talent. Some of the drawings give the impression – like a simple crouching nude – of an already mature prodigy. Some compositions – such as the two spectators in a box, a man and woman, who look away from the stage where, in the distance, a ballerina is performing pirouettes – draw us and disturb us like some poem from the *Fleurs du Mal*. These are almost sexless beings, the demons of everyday, with desolate eyes, lolling heads and brows shadowed by despairing or criminal thoughts....

Should we even wish that such painting should be cured? Or should this disconcertingly precocious young man be destined to consecrate with the title of masterpiece the negative feeling in life, whose suffering he, like all of us, shares? CHARLES MORICE, "Exposition", in *Mercure de France,* Paris, December 1902

... Picasso, too, can draw good likenesses: he is, one might say, a good enamellist. Some of his pastels are in metallic, acidulous shades, like chemicals, which he pursues obstinately; the lines are refined, enclosing pools of rose but especially blue, which are themselves flowers, wallpapers, or vests and shawls of anxious, pensive women. There is one painting of a woman dressed in pastel yellow, an angular music-hall *diseuse*, who is consumed by her own consumption. Herein we discern a painter watchful of the effect which the poverty of present times makes in the suburbs of Paris – members of secret sects, thieving couples, agitators, women, all on hard times, rejected, on strike, forgotten, going to pieces, eaten up, tossed about by life like flotsam and jetsam. MAURICE LE SIEUTRE, introduction to the catalogue of the exhibition at the Galerie Berthe Weill, Paris, 24 October– 20 November 1904

... Blessed are the uneasy since solely for them is eternal peace reserved: Mir, Nonell, Xiró and Ruiz Picasso, who is now turning his attention to works that will surprise and even terrify us. EUGENIO D'ORS in *El poble català*, Barcelona, 10 December 1904

... He was not yet twenty years old, yet already possessed an astonishing sureness in his handling of colour relations, and of composition, such as artists of much longer experience are still striving to attain. CHARLES MORICE, preface to the catalogue of the exhibition at the Galerie Serrurier, Paris, 25 February– 6 March 1905

... I have already had several reasons to speak of Picasso, to remark upon the outstanding gifts of this very young artist, at the same time deploring the negative approach of his concentration on empty misery and on his exacerbated vision of men and things.

But the new works he is showing indicate a fundamental change in his attitude. Not that no element of his turbid early portrayal remains: Picasso is Andalusian; his predilection for the images and accents of anguish are an indelible sign of his race to Spaniards. Nonetheless, his attitudes are lightening now; the elements are less wretchedly disposed; the canvasses are brightening. No longer is there a delight, for its own sake, in all that is sad and ugly. His premature twilight of hypochondria, which ought, logically, to have led to the black night of despair and death, has given way, by some happy illogicality, to a beam of light: the dawn of compassion, of salvation is born.

What we most disliked in Picasso's early works – which were, all the same, well differentiated by the sharp imprint of a powerful personality – was that not only did he not seem to feel compassion for poverty, he seemed to love it. But his sensibilities have now deepened, just as his technique has strengthened and become more refined. His structures are now more solid. CHARLES MORICE, review of the exhibition at the Galerie Serrurier, in *Mercure de France*, Paris, March 1905

It has been said that Picasso's works reveal his early disillusionment with life. I think the opposite.

He is, in fact, delighted with everything. The incontestable talent he has has been put, as it seems to me, to serve an imagination that mixes in just the right amounts the magnificent and the horrible, the crude and the refined. The scrupulous exactitude of his naturalism borders on that mysticism that is tucked away somewhere in the depths of all Spanish minds, even those least religious. Castelar, as we know, carried a rosary in his pocket: and if Picasso is not exactly religious, as to credo, I will wager that he nurses a stealthy respect for St Theresa or St Isidore.

During carnival in Rome, there are masques (with Harlequin, Columbine, the French cook . . .) in which, after an orgy that frequently ends in murder, everyone goes off in the morning to kiss St Peter's worn big toe. These people would certainly fascinate him greatly.

Beneath the gaudy tinsel of the dancers he paints we see, undoubtedly, the young; cunning, malicious, crafty, poor and liars. The mothers he depicts clench slender hands just like those that the young mothers of working people have. The pubic hair that classical painters disdain to show, and which is the touchstone of western shame, his women, however, reveal. GUILLAUME APOLLINAIRE, "Picasso, peintre et dessinateur", in *La Revue Immoraliste*, Paris, April 1905

If we possessed wisdom, all the Gods would wake up and get moving. Born out of the deep awareness that humanity looks after itself, the pantheisms that it worships and which are in its likeness have fallen asleep. But despite their eternal sleep, there are eyes in which are reflected whole humanities amounting to divine, joyous visions. Eyes, wide-awake, like flowers continually turned towards the sun. What joyous richness for those born to see with eyes like this.

Picasso has looked at the human images that vacillate in the blue haze of memory and that generate metaphysics, through

their unity with the divine: pious heavens disturbed by scenes of rape: dim pervasive lights like those in caverns.

Wandering youths, without beliefs, halt while the rain evaporates: "Look: there are people who live outside this man-made world, people who wear tattered clothes." Young men who have never known an embrace, yet understand everything – oh mother, love me! – They can cut capers, and their cartwheels are like the whirling of minds.

There are women no longer loved, who remember. Too long have they contemplated their frail ideas; devoted to their memories, they do not pray: they crouch down in their twilight as if in some ancient church. Women who have given up weaving crowns of straw, whose fingers would fumble to do so now. Women who fall mute as dawn breaks, washed over by silence. Women who have opened countless doors. Mothers protect their babies from misfortune and see, when they lean over them, that the smile of their little ones tells them they are good. Women accustomed to giving thanks, whose forearms tremble like children.

Enveloped in icy mists, old men wait without thinking at all, since only the young think. . . . There are other beggars, whom life has worn out: feeble, stupid, the lees of life, they are stunned to have reached an end which is still blue, yet no longer the horizon. As they have grown old, a folly has seized them like that which overtakes kings who own too many heads of elephants and rule tiny states. Some are travellers who have confused the flowers and the stars.

Aged as oxen who have endured for twenty-five years, the young men lead girls who will be mothers under the moon.

In the purity of daylight, the women keep silent, their bodies like angels and their glances fluttering: deep inside they are smiling at danger; they await fear to confess their harmless sins.

For a whole year Picasso has lived this dewy life, blue like the damp bottom of the abyss, compassionate, with a compassion that has made him harsher.

The squares display hanged corpses stiff against the houses and leaning over the passers-by in expectation of some redeemer, on strings that hang miraculously straight under roofs ablaze with brilliant flowers. Enclosed in their rooms, impoverished artists draw velvet nudes by the light of a lamp: the abandoned shoes by the bed are a mark of tender attention.

After the frenzy, calm.

Under their rags, harlequins come to life, when the painter summons his colours together, and makes them burgeon or fade to show the strength and duration of passions, when the lines describing vests curve, break and rush together.

Paternity transfigures the harlequin framed in his room, while his wife washes herself in freezing water and is happy with herself, as slim and lithe as her husband is puppet-like, and a flicker of fire warms his caravan: sons are heard from far off, and soldiers pass by, cursing the day. Love is fine, once you get past it and the habit of living at home intensifies the fatherly feeling: children bring the father and mother, whom Picasso renders as glorious and immaculate, together again.

The mothers, bearing a child for the first time, were not expecting to do so: because of a chattering old crow, perhaps, or an unfavourable omen. Christmas! And so, they will give birth to future acrobats, a cross between tame monkeys and bear-like dogs.

Adolescent sisters, balancing immense balloons, imprint on the spheres the moving rays of the worlds: innocent adolescent sisters, in the anxiety of innocence, to whom animals reveal the religious mystery. And harlequins exalt the glory of their women, whom they also look like: neither male nor female.

Colours with the opacity of frescoes, decisive lines: but relegated to the fringes of life, the animals look like humans and their sexes become indistinct.

Hybrid hearts with the wisdom of Egyptian demi-gods: taciturn harlequins whose cheeks and foreheads are worn through morbid sensibility: it is not possible to accept these acrobats, used to the devout attention of those who watch their silent rites performed with rough agility, as mere players.

In this, this artist shows himself different from the Greek vases, of which his style is sometimes reminiscent. On painted earthenware, the bearded voluble priests sacrifice animals which are resigned and have no destiny. In Picasso, virility is beardless, but is revealed in the tendons of thin arms and the planes of faces, while the animals assume an air of mystery.

Picasso's predilection for the fugitive and transient penetrates to the core of things and changes them, producing utterly unique originals in flowing chalcographic lines, in which the general appearance of the world is not one whit altered by the light, which moulds the form as its colour changes.

More than all the poets, sculptors and other artists, this Spaniard leaves us breathless, as after a sudden ice-cold shower: his meditations reveal themselves in silence: and he comes from far off, from the harsh annals of the compositions and decorations of seventeenth-century Spain.

Anyone who has known him will remember his sudden truculences, which went beyond experience. His obstinate pursuit of beauty has guided his steps and made him Latin in morality, but an Arab in rhythm.

GUILLAUME APOLLINAIRE, "Les jeunes: Picasso peintre", in *La Plume*, Paris, 15 May 1905

Sandricourt pointed his finger at a considerable painting full of flat, almost faded, colours [on the walls of the "Lapin Agile": see no. 197 of the *Catalogue*] and remarked:

"This Harlequin and Columbine are hungry. Look at their eyes . . . yet they haven't a penny, so they may not eat. That's why they drink. They aren't even looking at each other, yet we know they are in love. The dauber who splashed them on canvas in a couple of hours will become a genius, if Paris does not murder him first."

He must have been protesting because he had at once recognised the hand which had painted the yellowy-red and green lozenges of the vests of those wasted bodies.

"Dear Sir, the painter of this Harlequin is already well-known and soon . . . To remember him in some way, you may call him the Callot of acrobats. But you had much better learn his name. It is Picasso."

EUGÈNE MARSAN, *Sandricourt au pays des firmans. Histoire d'un Gouvernement*, Paris 1906

[1901–2]

. . . In Barcelona, and subsequently in Paris, Picasso created emotive pictures, invocations to sensibility, pursuing to the extreme every refinement of feeling. The world's images produced

in him states of mind of which the figures manifested by his brush are, in a way, visual representations, an essential reclothing by which everyone may relive them. It is by instinct, not on purpose, that he draws beings weighed down by precarious mental and physical health. That is why he is able to dwell on their complicated reactions so efficaciously. In his depiction of the unhappy and the disinherited, the artist gives an attention which is entirely sympathetic, which is thus responsible for the verity of those figures, not to mention the particular quality of those pictures to stimulate an attraction not aroused elsewhere. The singular charm bewitches the beholder and constantly turns him back into his memory.

It is the so-called "Blue Period". . . . Girls, cripples, couples either famished or clutching the glass of absinthe, blind men, sorrowing mothers, angular youths, lean faces, and deformed bodies are all witnesses to a humanity which knows no joy. Sometimes a face appears, reflecting subtle meditation, but generally the figures are ambiguous, marked with profound morbidity, immersed in dark deprivation.

One might have expected the intense search for expression to have led Picasso into over-emphasis. On the contrary, his works are always stylistically impeccable and dramatically intense. Anyone except him would have slithered into the pathetic and the affected. But Picasso even though so young, knew how to reinforce his skill in anecdote with purely plastic means.

The change in his conception of the external world, as the artist knew it, brings about a parallel change in his palette and manner of painting: he passes from warm colour to an almost cold range of grey-blues and this tendency towards impoverishment of colours determined in its turn, a simplification of their use. At first he adopted very fine touches, or else wide and short, or even very long ones. In some paintings the brush strokes seem very light, in others, by contrast, very heavy when the colours have not been applied with a spatula. In other words, the techniques employed in Picasso's paintings in 1900 and the first part of 1901 were various. With those of the "blue period" he achieves the height of simplicity: light and smooth touches which are not found in any earlier works.

[1903–4]
. . . During this period, Picasso is only interested in human values: apart from figures, nothing or almost nothing stimulates his brush. There is not a single still life with the exception of two views of Barcelona, landscape is only occasionally introduced into a background. When an artist is seized by an obsession about the mystery of human life, he hardly uses landscape at all unless as an essential backcloth. What is essential to Picasso is the emotion aroused by man himself: this element is one of the main characteristics of his spirit. Some time ago he had a discussion with the sculptor Laurens about the highest form an artist can aspire to, and he put landscape at the lowest level of his ambitions, with, in a rising sequence of importance, still life, man, and above him – the gods, and above all, goddesses. But, to be plain, Picasso did not mean that to achieve elevation an artist has to choose divinity as a subject. Rather that, when he has mastered the subtlest relationships between things, when he has himself risen above the attractiveness, the beauty and energy with which, at rare moments, men can clothe themselves, when he has fused intensity of passion with spiritual strength, only then can he raise

his mind to pure beauty and – if he has the technique at his command – to invisible beauty. From this Picasso derives his interest in human beings. The elevation of art implies every other elevation of the human spirit. To give expression to the gods and goddesses the artist must exert all his faculties to the utmost, an effort which necessarily demands a total impoverishment yet brings with it an immense enrichment. One can no longer tell what is material, what spiritual and a unity of contrasts is achieved which only the miracle of true art can work.

[1904–6]
. . . The "Blue Period" came to an end. Colour timidly reclaimed its rights. More varied and richer shades can be seen in "*Les noces de Pierrette*", *Contemplation* and *Woman with her Hair Up* [nos. 142, 140–1 and 131]. The figures of 1904 are drawn with greater accuracy, the treatment is both incisive and fully expressive. We should note the attention Picasso gives to the portrayal of the hand, whose fingers are disproportionately long, as in the Catalan primitives and, in fact, in Spanish art generally which loves to let hands speak, to make them express a feeling. . . .

At the same time Picasso achieves total mastery in his drawing and displays virtuosity which is both rare and dangerous. This sureness of touch is astonishing in one who is only twenty-three: there is not the slightest uncertainty in it. Anyone else but him might have made capital out of it, would have over-exercised it. But Picasso has been endowed with many other gifts beside that of drawing to perfection; he has received abilities commensurate with his ambitions and, although very young, has an exact knowledge of himself. However one looks at his work, one always finds in it a continuous movement towards inner vision, together with an awareness of never having fully expressed what he was feeling: a superhuman ambition which leaves him eternally unsatisfied and makes him turn constantly in new directions.

In 1905 he totally abandoned his earlier work, in spirit, subject and colour. And the dramas of the "Blue Period" are followed by quieter canvases in which humanity is seen less from its suffering aspect than in plastic values. Without modifying his intensity, he extends his vision of the outside world to circus people and strolling players. He paints a fantastic series of acrobats, jugglers, tightrope walkers, actors from peripheral folk-theatres and above all, those harlequins whom he has always chosen and through whom he has woven a subtle web of emotions. A parallel change can be seen in the composition of the paintings. At first Picasso only showed single figures or couples, and produced nothing comparable to the *Acrobats* [no. 192]. . . . During the "Blue Period" he put his vision directly on canvas, which explains why there are no preliminary drawings of the work that dates from that time . . . ([the few that are known] consist of different technical means of expressing exactly the same subject). . . . So the *Acrobats* is the exception to Picasso's rule to work in one stroke: moreover, the studies differ very little from the finished work. In fact, Picasso has always found it impossible – and still does – to advance a plastic resolution whose realisation demands extensive application, and long, deliberate work.

[1905–6]
. . . All Picasso's changes have resulted not from the demands of theory but rather from the strength of his need to transmit feeling. Without even enunciating precepts, by wrapping himself, on the

12

contrary, in silence, Picasso widens his vision and extends his own range. Ever since his youth he has aspired, through consecutive approaches, to the infinite. There have been unexpected links and inevitable breaks in the chain whose effects can be seen in his recent work. This should never be lost to sight if we want to explain the renewal Picasso brought about at the end of 1905. Success was already very close then, and anyone might have grabbed it with all their might. But not Picasso, who will break out on a new adventure.

Up until then he had always endowed his characters with subjective emotions, whose intensity was in perfect accord with his own temperament and strength of feeling. Now, he rejects that. He finds himself at fault, in having created a work that he considered excessively romantic. "It's mere sentiment", he said. In these last years I have sometimes heard him express sympathy for the paintings he did between the ages of twenty-two and twenty-five, and admit that their general attitude quite closely matched his own personality. But then he meant to eliminate from his own work every trace of sentimentality, in order to achieve objectivity. With time, a mistrust grew of his own innermost feelings, against which he has reacted with every ounce of energy, as the great number of still lifes painted between 1907 and the present time bear witness. But even the ruthless struggle he has undertaken since then against narrative constitutes a clear proof of Picasso's mistrust of personal feeling.

The same motive drove him, at the beginning of 1906, to give up his habit of transcribing humanity as exactly as his mastery enabled him to. And while he devotes himself to the elimination of episode and to the restraint of his own violent feeling, in order to gain power in plasticism, he tries to acquire something equivalent to nature, to assure himself some recital of life, and to affirm the essence of humanity with greater generalisation. That is why sentiment vanishes in the figures of the "Rose Period", together with the suppression of all that might insinuate itself, that might be of exclusive relevance. Picasso frees his figures from their personal histories, from the events of their daily lives, and endows them with a richer plasticity. Their surfaces are ampler, their bodily proportions are changed, we see many of them with a large head and body somehow shortened. The details become extremely simplified and often serve as architectural setting for the figure as a whole. Even colour is altered in the general move towards simplification. The characters of 1906 are bathed in light tenuous shades of rose. . . .

CHRISTIAN ZERVOS, *Pablo Picasso*, vol. I, Paris, 1932

. . . So it was that towards the end of 1901 Picasso reduced his palette to one single colour. The Blue Period began: the period of "soaked" painting, as Apollinaire put it, in which there is certainly no forced strangeness or originality, but the first stage towards cutting off short with the recent past, by starting to reject all the effects of atmosphere and light that colour can give, and, as a result, the very situation of the impressionistic subject, which is reduced to expeditious relations of mass and chiaroscuro. This kind of wounding of the self is an exact indication of the gradual atonement Picasso had to make to get back to a point which attracted him yet still remained veiled. His decision did not, in fact, derive from an abandonment to the calm fruits of formal procedure, but was a deliberate, planned act, in which the artist made a clean break and cleared the ground to see it more clearly.

He began by simplifying his technique, and through this simplified technique, the object itself. Or rather, he tried to shatter the formulation of the image on the object. This inverted process made form abstract, making it disposable, and, basically, unimportant. Hence the customary unconcern, almost kleptomaniac, in references to Degas, such as in *The Blue Room* [no. 9], to Daumier in *Two Women at a Bar* [no. 44] and to Gauguin in his *Life* [no. 89] where the nudes . . . have the nasty, slightly perspiring look of the Councils of the Levy. But it is not difficult to perceive that in these livid images Picasso was seeking not only to contrast a plastic vision with one of colour, taking ingredients wherever he could find them: not even a plastic vision might derive from a natural object which became pertinent and almost cohesive with the very blood circulation of man. And since this too had to be avoided, the conversion of chromatic to plastic became instrumental, and although circumscribed by formula, ended by losing interest in the question of form to the point of lapsing into the general style of the *Seated Woman with Arms Crossed* [no. 29] and the *Mother and Child* [no. 16], in which the chiaroscuro invests the figures in washes of a kind of thick brine.

But we can see another element in their pictorial introduction: what we might call a warning of social edification. In the impressionistic vision there was no time to feel separation from what the image represented. There was immediate participation whether it depicted ballerinas, or barmen, horse-races, cathedrals, pale in the dawn, or flaming in the sunset. To mark detachment, Picasso attempted to inject between image and consciousness the social division which the time already pointed to. By turning, however, to generalised, programmatic types, rather than the touching encounter of the individual with his own daily life, he idolised ambiguous originals of lost women, of humble street mothers, and of wasted beggars.

This was a humanity made up by the symbolist aesthetic in which profound interest in humanity and a mastering desire for form became, for so direct and aggressive a nature, gradually falsified. The initial relation with what exists, which first drove Picasso to an authorative grip on it, was then imposed with sentimental reflection, kept the image back on the fringes of actual life. Almost as though an artist's interest in humanity should express itself only in compassion for the wretchedness of man.

But it was not long before Picasso realised his own equivocation and took stock again. . . .

Thus from the transient world of vagabonds, driven by need and hunger, Picasso moved on suddenly . . . to a much less Parisian, much more gypsy world of acrobats and jugglers. And this is not only a change of subject because once the social distress was swept away, the thick azure paste became clearer and the line tightened and thickened, evoking a vague, atmospheric feeling. Whoever considers the fascinating tempera of the *Young Man in Blue* [no. 227] might well think that at this moment Picasso had recourse to Impressionism. But the other numerous paintings of this period clarify the position a good deal. In reality Picasso is recovering certain means of expression that he had earlier discarded. The blue which he had to break, not so much with colour as with the situation of the impressionistic object, became rarer and thus admitted other colours which were clear and unmixed, milky spreads of gouache separated from each other without an

infusion of air or a chink of light. These are the colours of Harlequin's patches, seen as a thing, as one object relating to another. They are still slightly extraneous to their surroundings, like the colouring of a print, delicately washed, sometimes almost too delicately, on to those contour lines full of crevices and trembling slightly under some invisible breath. As before, but now as a result of a less physical, more deliberate fusion, diverse veins flow together. Seurat, in his almost regrettable definition of forms and even in his choice of female nudes who are, without any ideal limitations, pleasant women of the day with slightly ill-formed busts and with the curve of their backs emphasised; Puvis de Chavannes, in a certain neatness of his profiles and even more in his clear and opaque colours; Degas again, but caught unexpectedly in that initial moment of compromise between an Ingres seen through the eyes of Puvis and with the sensualities of a Courbet. Finally, Cézanne, withered, but showing up wherever the contour is more vital and has more atmosphere. We see how mistrustful Picasso is of letting the object be moved by a breath of existence, almost as if by a gust of cold air coming from outside into a warm room. The same beauty of the faces, somewhat generic and statuesque, depicted with light touches, without aspiring to noble ideals is near enough to a type to negate the fresh impact of an individual: by caressing the senses he separates contact. Then the tender, visionary families of Harlequin are born, the acrobats resting in a silk vest, and youths leading horses to bathe. Here the young Spartans of Degas, dressed only in their androgynous softness, renew that inexplicable relation with horses which became a surprising element in some parts of the Panathenean games. This early glance at classical art is so discreet as almost to pass unnoticed (not, however, by Apollinaire). Yet it is to be found in the contrived unity of stress, in the difficult marriage of form with beauty. From it can arise that magnificent woman with the fan [no. 220] whose gesture is so charged with cleanness and majesty. And sometimes in certain shadows indicated by a sudden thickening, we also perceive some recall to the magnificent, spon-

taneous daubings of Corot. But yet, so much barer in its almost conventional colour: and so smooth as if by pumice stone. As we said, somewhat antique.

Now it is time he opened his eyes: an artist who is endowed with such an intuition for form, and is not apparently satisfied with it. Here is one year's work and already the so-called Rose Period shows a new variant. Yet they contain, these works, a manner and lucidity which would make sufficient foundation for an artist like Tiepolo so that he could furnish the land with similar, happy images for tens of years. . . .

By breaking with his harlequins and jugglers, Picasso was giving up his life.
CESARE BRANDI, *Carmine, o della pittura*, Florence 1947

If history were serious it would show that the Pablo Picasso of 1901–6 is always the most lively and interesting. . . .
LEONARDO BORGESE in *Corriere della sera*, Milan, 23 September 1953

The works he did between 1901 and 1906 are different according to the "Blue" or "Rose" Periods, just because the shade, more than the actual colour, drew his attention. Picasso's mind was occupied with drawing as a power of outline, a gradation of chiaroscuro and formal proportion. He painted neither landscapes nor still lifes. He was busy with the image of humanity either to characterise it with extreme realism and constant energy, or to idealise it with an obvious classical aspiration. His sympathy for poor people and their wretchedness and for circus clowns and their unhappiness was revealed with a finesse and concern which was pure tenderness. The rich fruit of those years is the regret of all those who do not like to break with tradition, and Picasso himself returns to it quite often in moments of relaxation. LIONELLO VENTURI, in the catalogue to the Picasso Exhibition, Rome, 1953

The paintings in colour

List of plates

Cover:
Detail from *The Acrobats* [no. 192]

The arabic numeral in square brackets after the title of each work refers to the numbering of the paintings adopted in the Catalogue *(pages 87–113).*

In the captions at the foot of the plates the corresponding actual size (width) of the picture, or part of the picture reproduced in them, is given in centimetres.

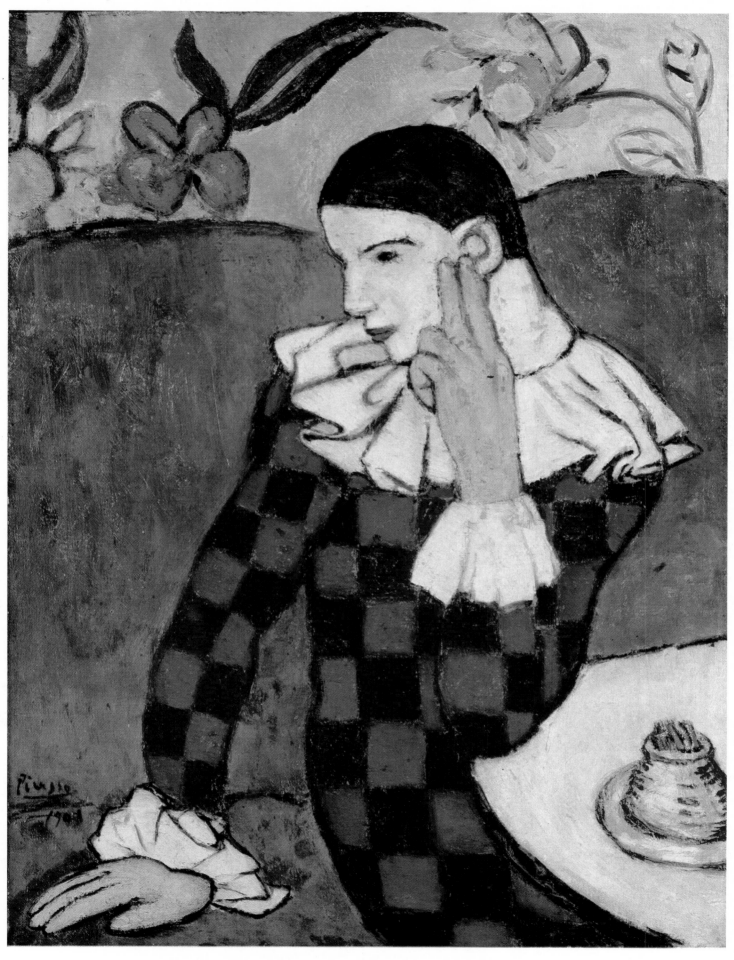

PLATE I HARLEQUIN LEANING ON HIS ELBOW New York, Metropolitan Museum of Art
Whole (60.5 cm.)

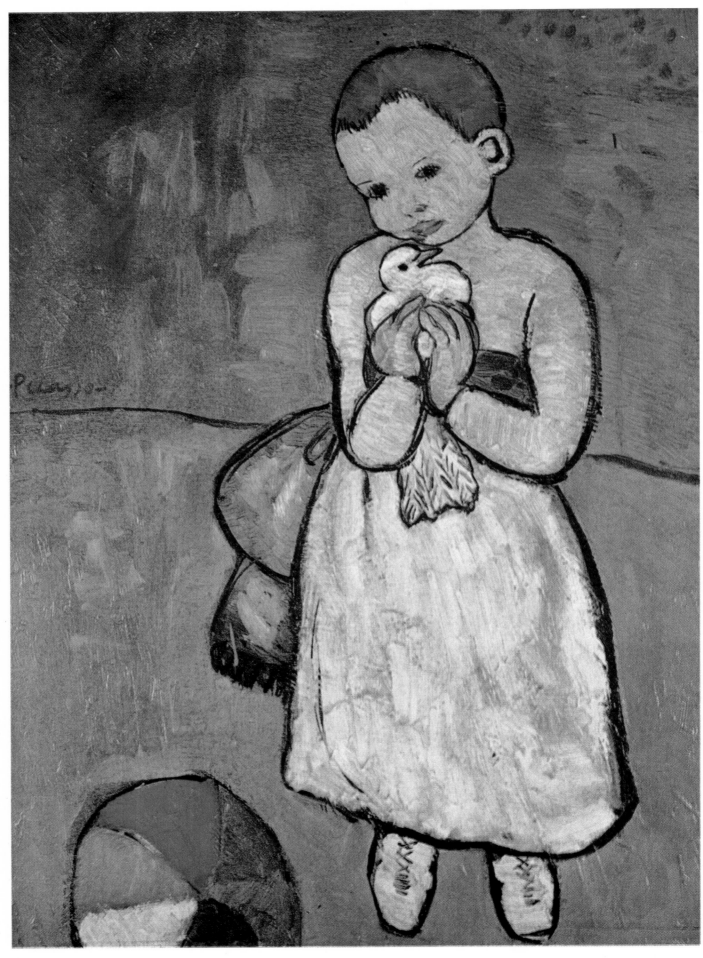

PLATE II CHILD HOLDING A DOVE London, The Dowager Lady Aberconway Collection
Whole (54 cm.)

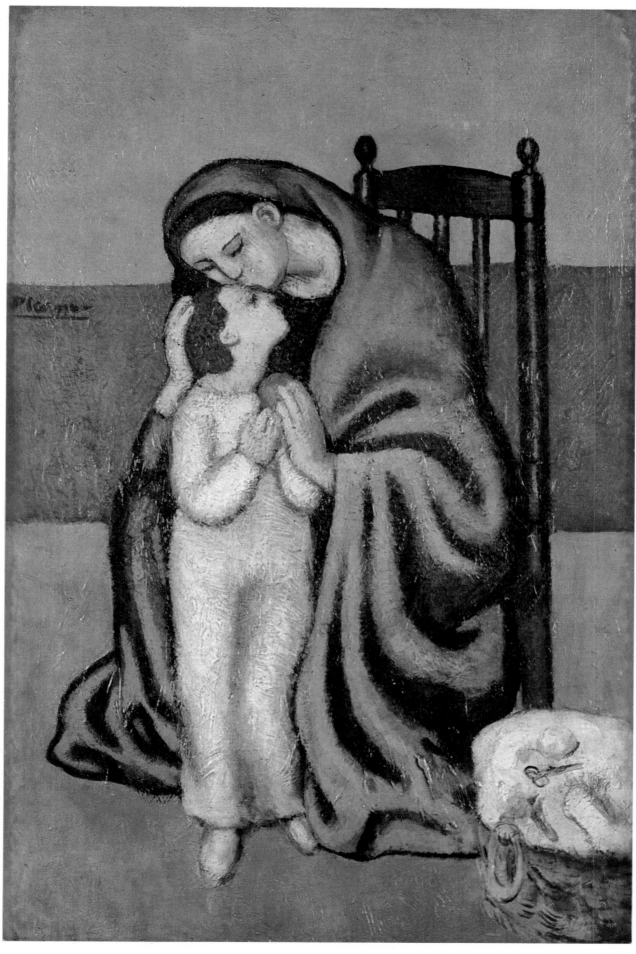

PLATE III MOTHER AND CHILD Los Angeles, Goetz Collection
Whole (60 cm.)

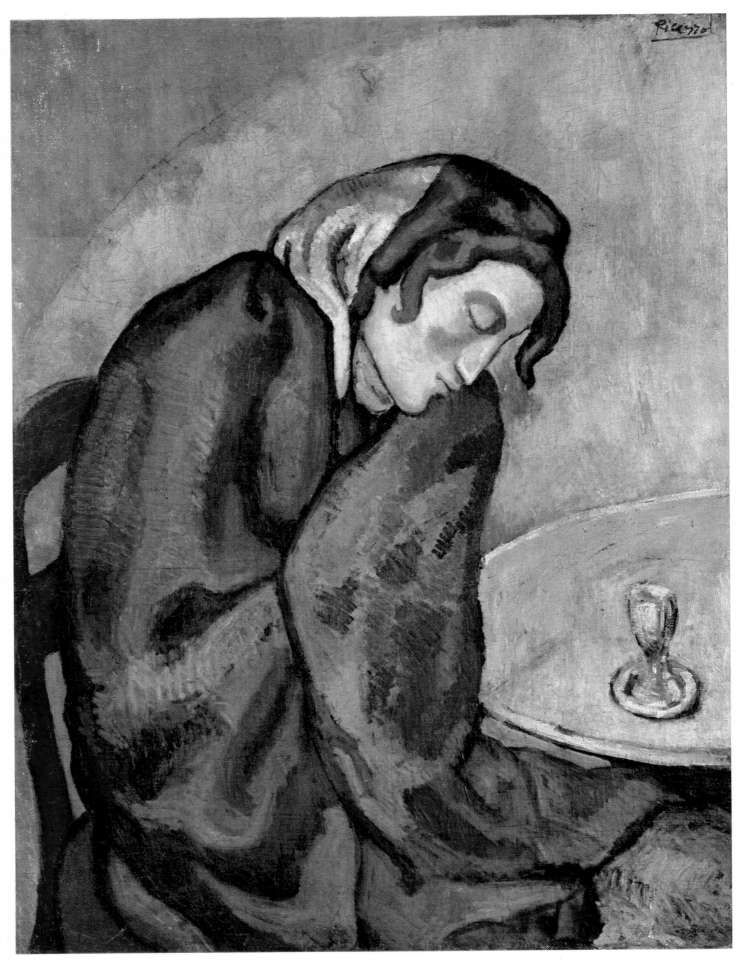

PLATE IV SLEEPING DRINKER Glarus (Switzerland), Huber Collection
Whole (62 cm.)

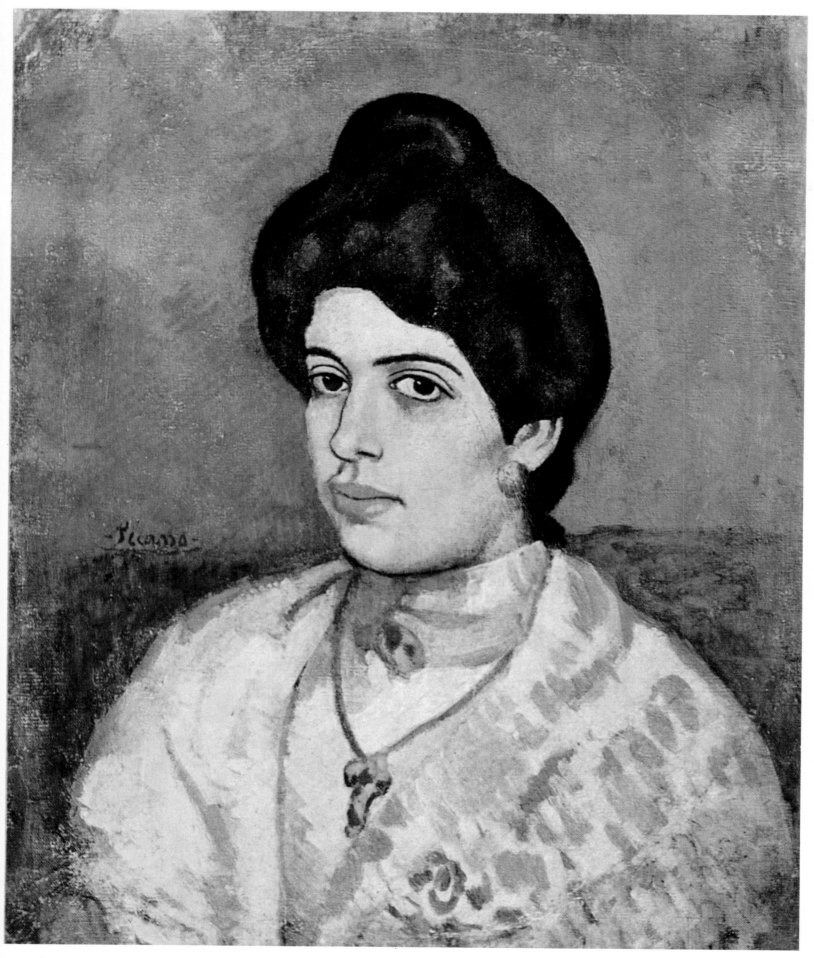

PLATE V PORTRAIT OF CORINA ROMEU Property of the Artist
Whole (49 cm.)

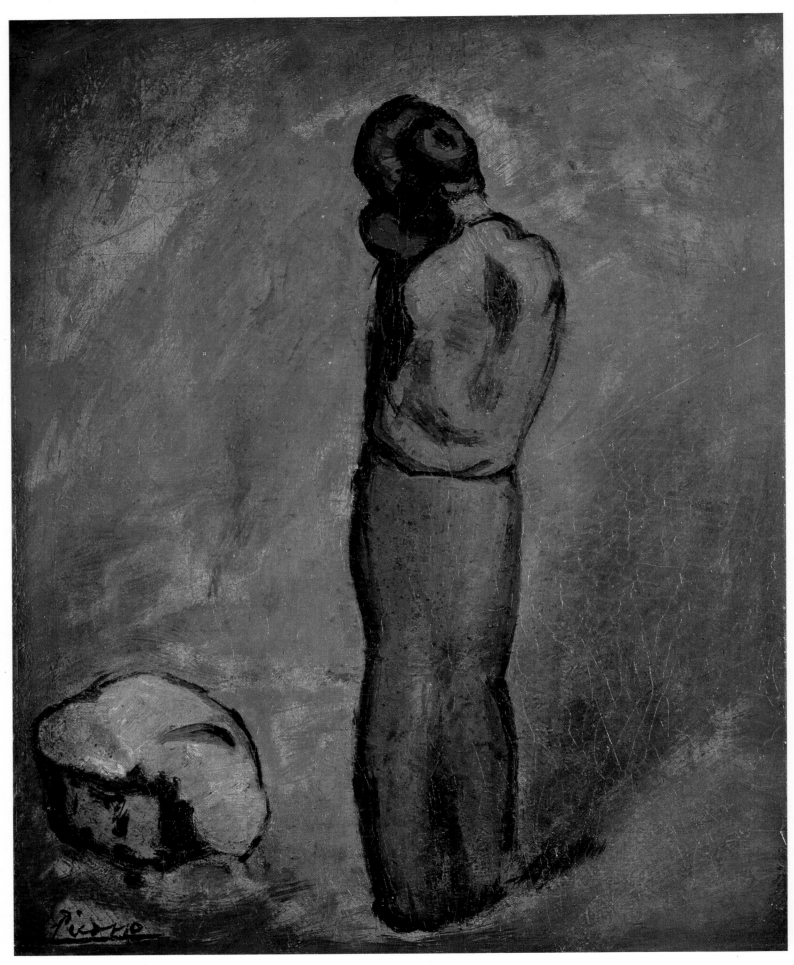

PLATE VI MOTHER AND CHILD Edinburgh, Scottish National Gallery of Modern Art
Whole (33 cm.)

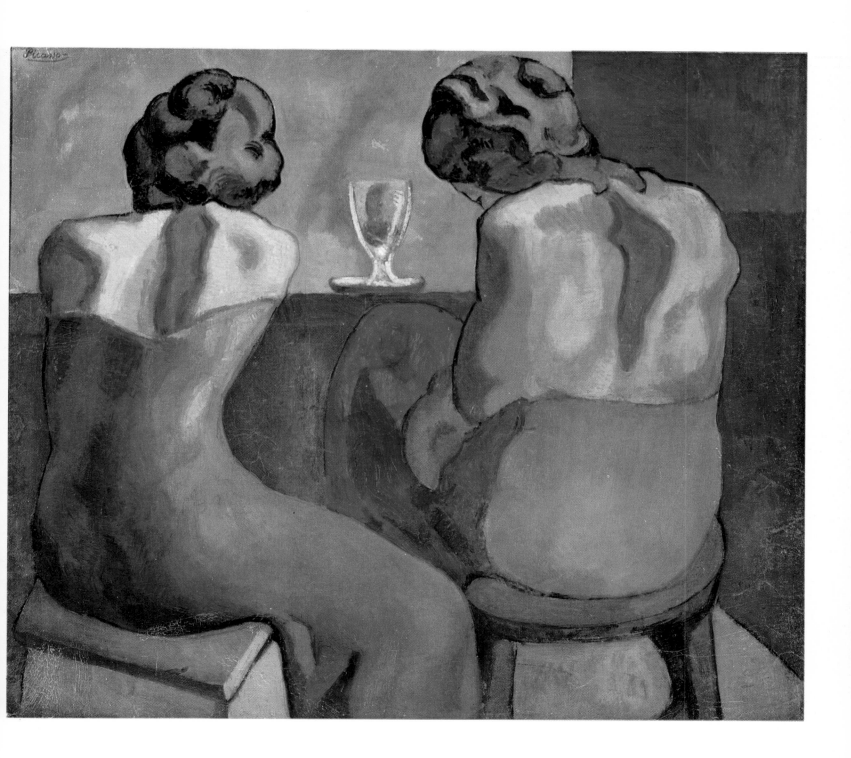

PLATE VII TWO WOMEN AT A BAR New York, Chrysler Collection
Whole (91.5 cm.)

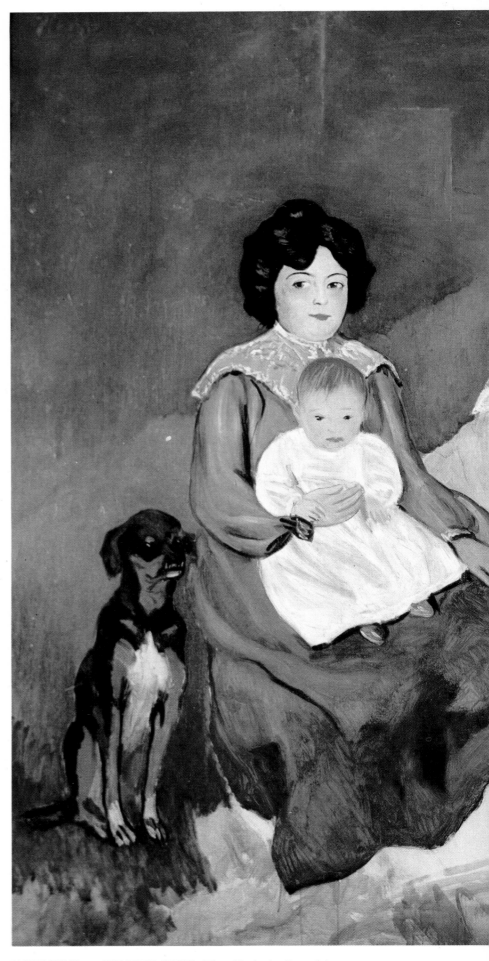

PLATES VIII-IX THE SOLER FAMILY Liège, Musée des Beaux-Arts
Whole (200 cm.)

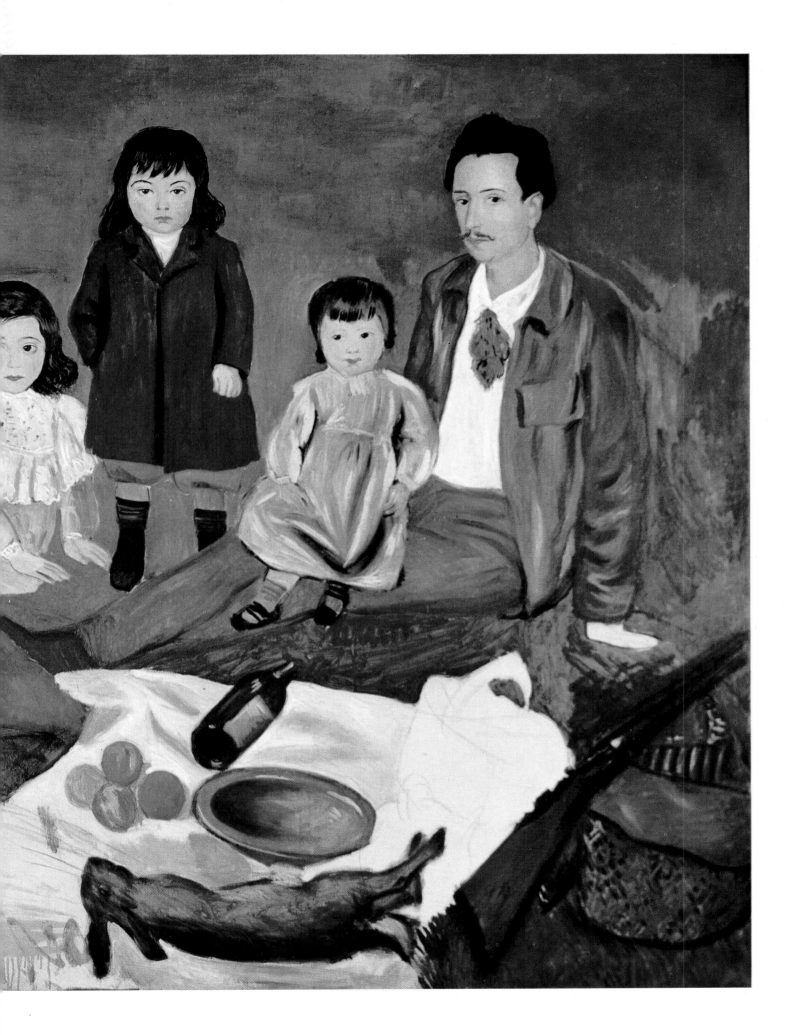

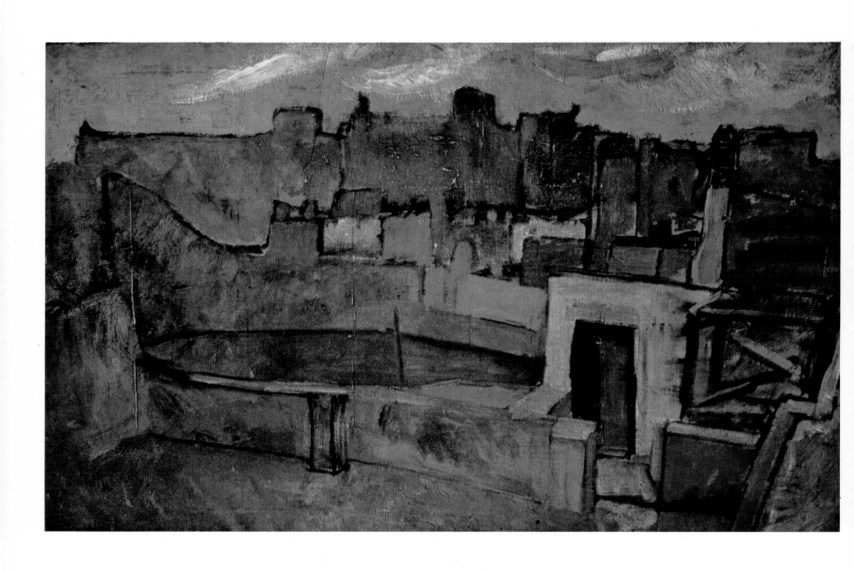

PLATE X ROOFS OF BARCELONA Property of the Artist
Whole (110 cm.)

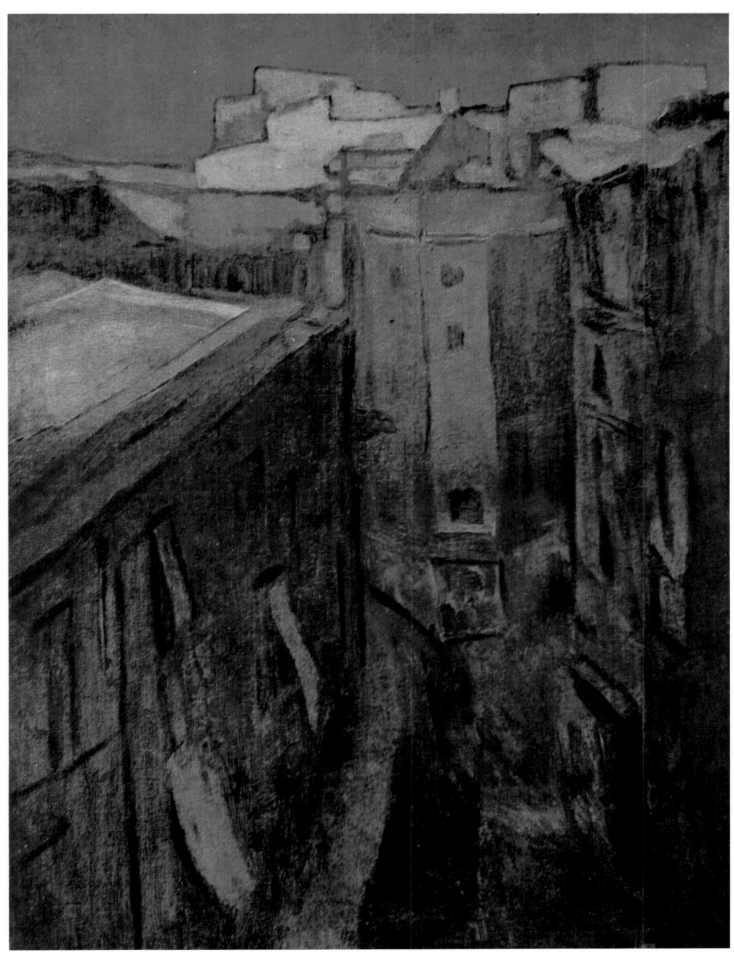

PLATE XI BARCELONA AT NIGHT Zurich, Bührle Foundation
Whole (50 cm.)

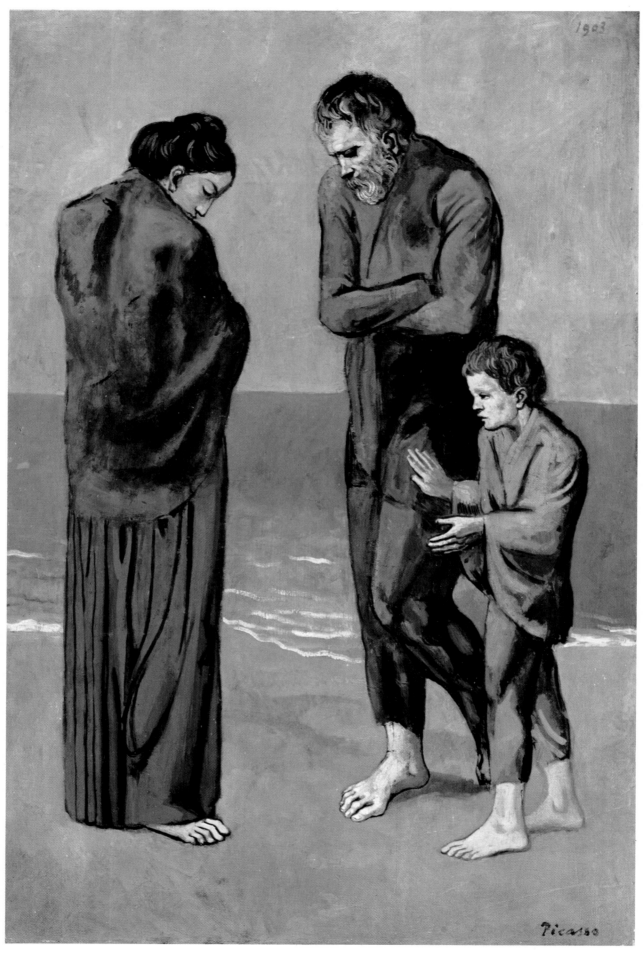

PLATE XII POOR PEOPLE ON THE SEASHORE Washington, DC, National Gallery of Art
Whole (69 cm.)

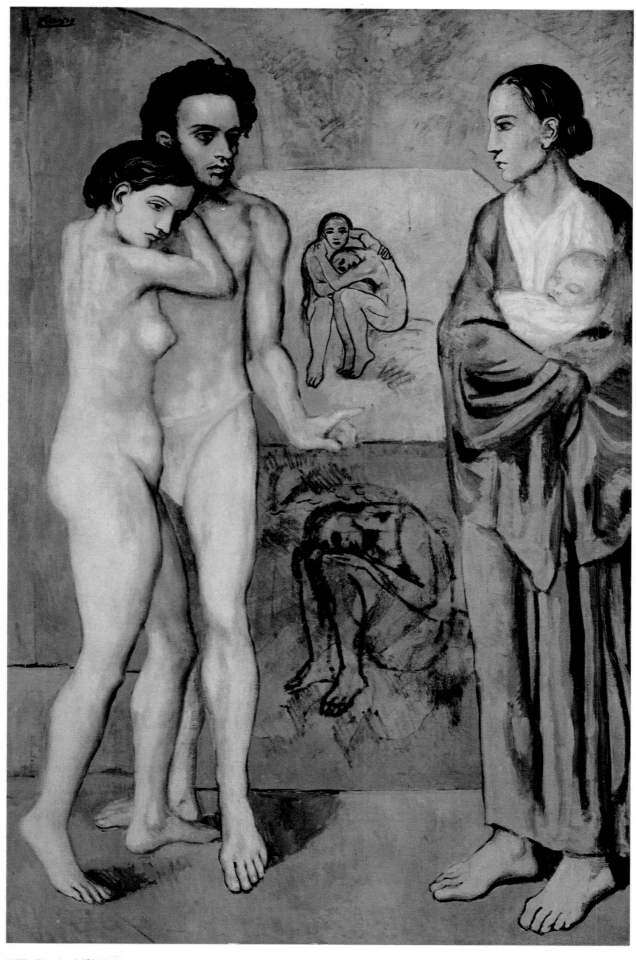

PLATE XIII LIFE Cleveland (Ohio), Museum of Art
Whole (127.5 cm.)

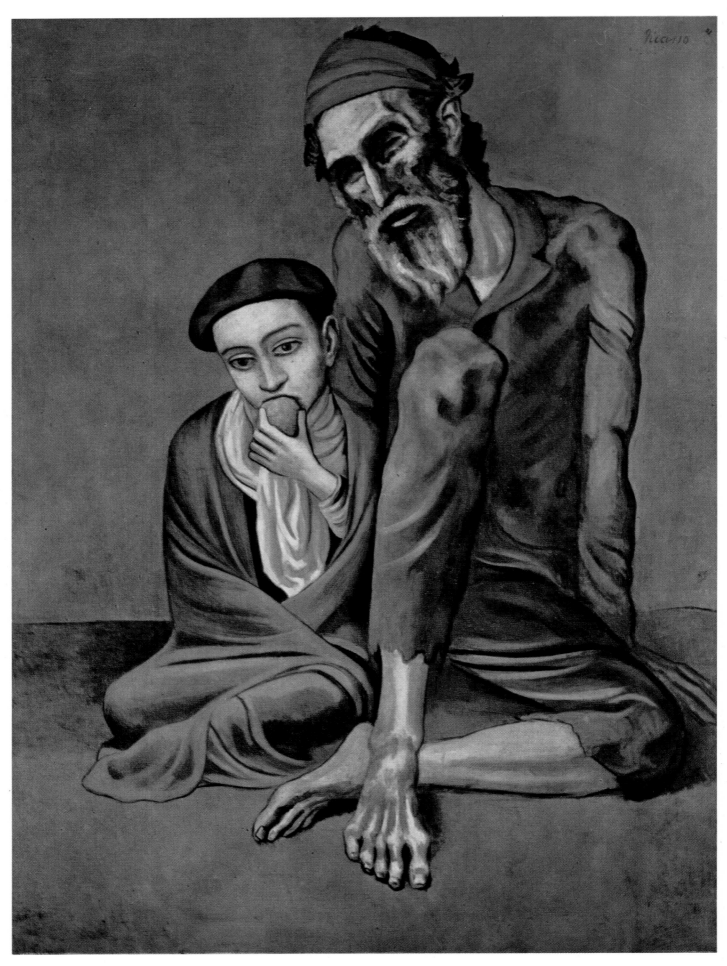

PLATE XIV BLIND OLD MAN AND BOY Moscow, Pushkin Museum
Whole (92 cm.)

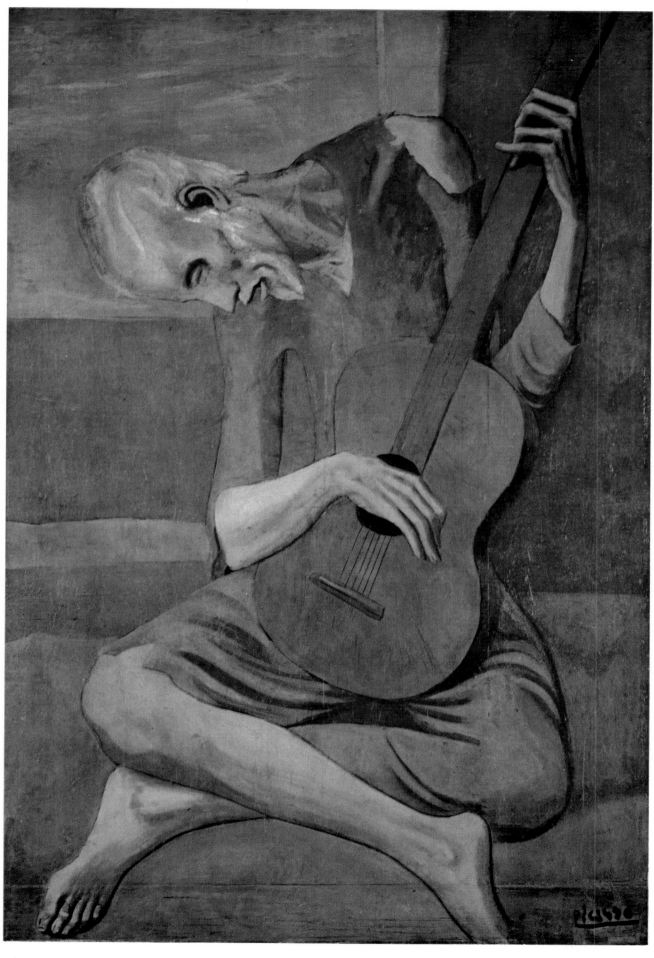

PLATE XV THE OLD BLIND GUITAR PLAYER Chicago (Ill.), Art Institute
Whole (82 cm.)

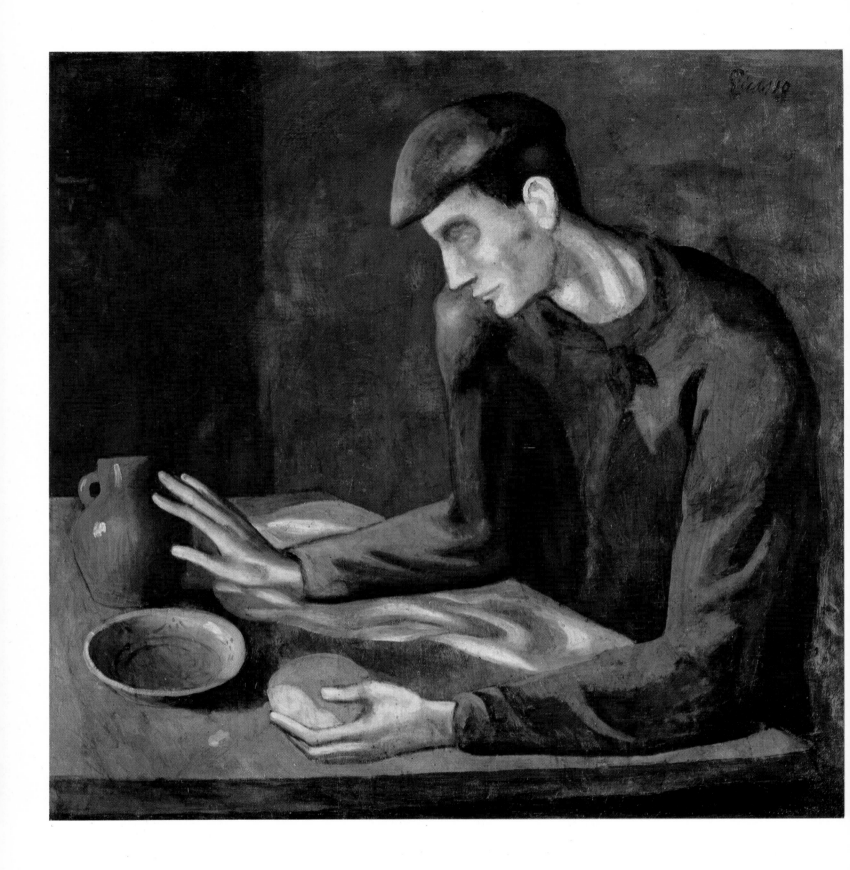

PLATE XVI THE BLIND MAN'S MEAL New York, Metropolitan Museum of Art
Whole (94.5 cm.)

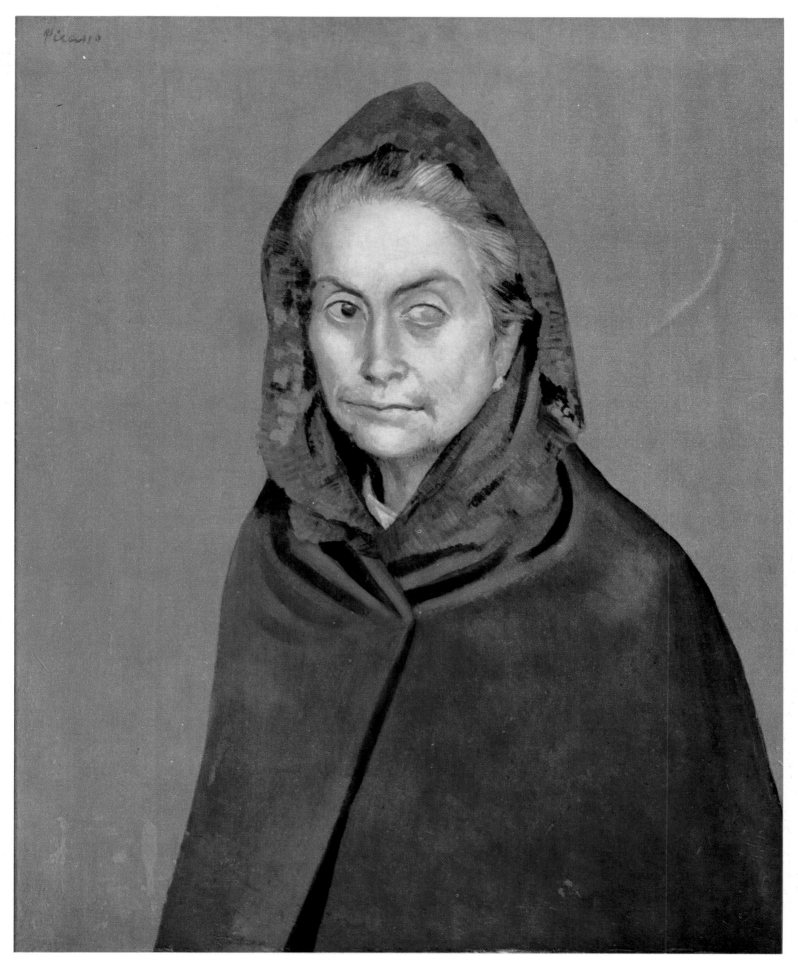

PLATE XVII CELESTINA Paris, Private collection
Whole (56 cm.)

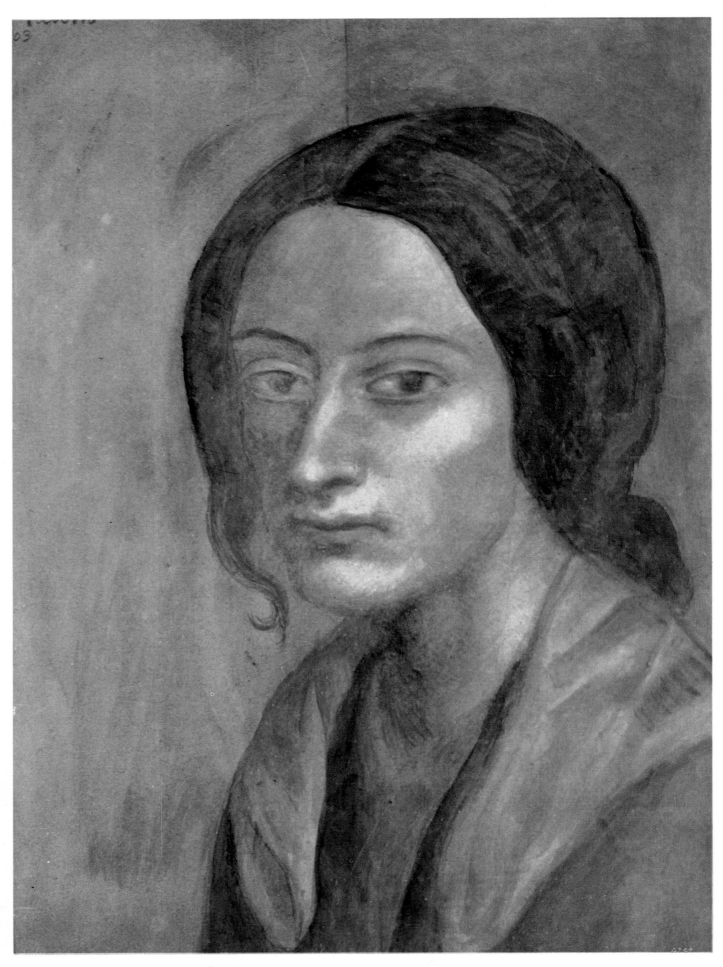

PLATE XVIII WOMAN WITH LOCK OF HAIR Barcelona, Picasso Museum
Whole (37 cm.)

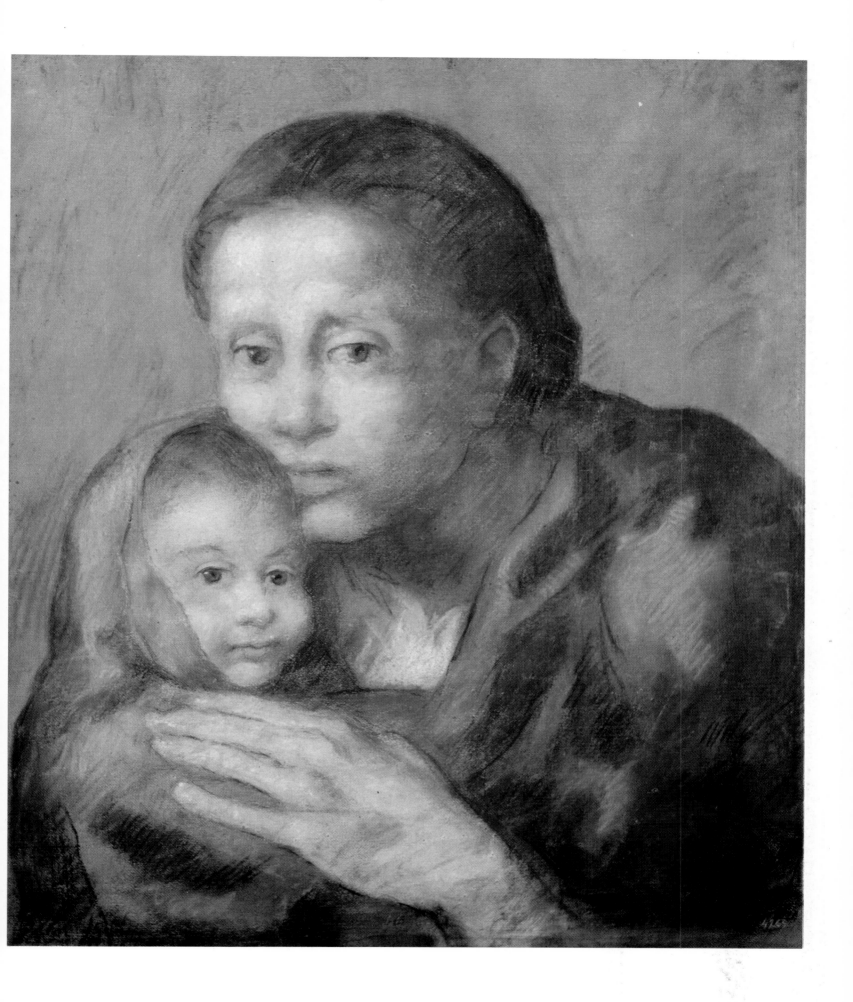

PLATE XIX MOTHER WITH SICK CHILD Barcelona, Picasso Museum
Whole (41 cm.)

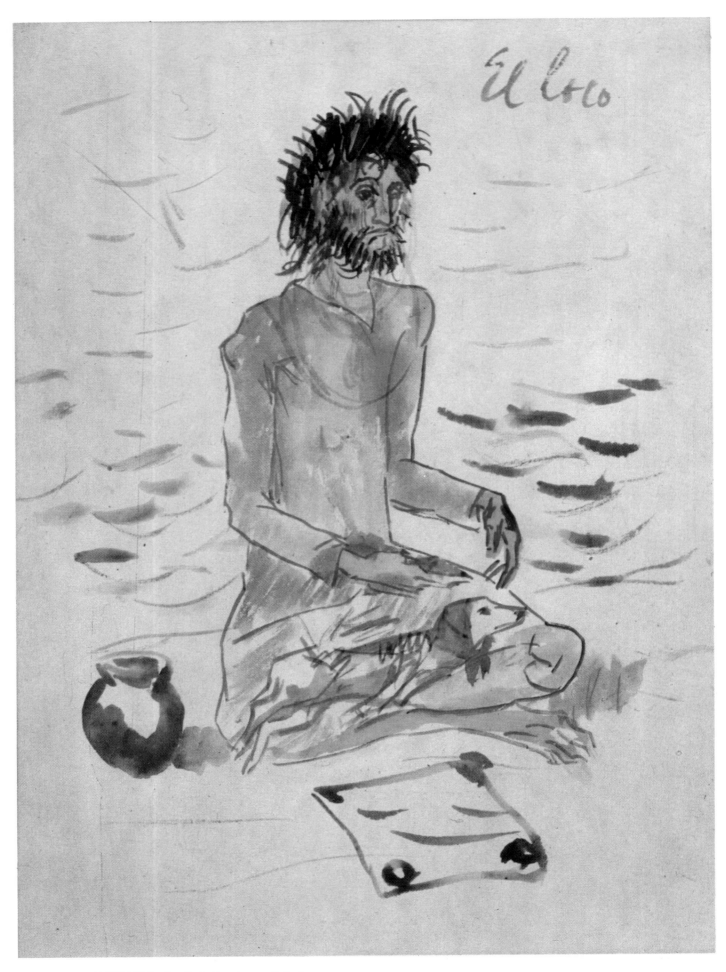

PLATE XX BEGGAR MAN WITH DOG New York, Thannhauser Collection
Whole (21 cm.)

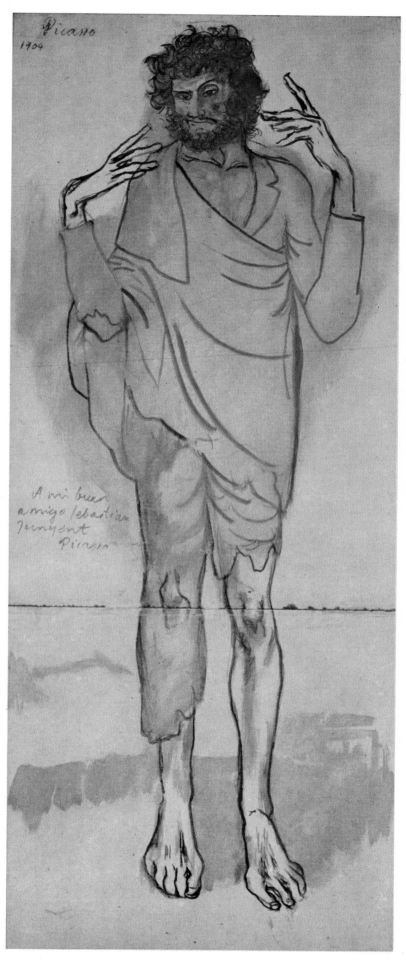

PLATE XXI

THE MADMAN Barcelona, Picasso Museum
Whole (36 cm.)

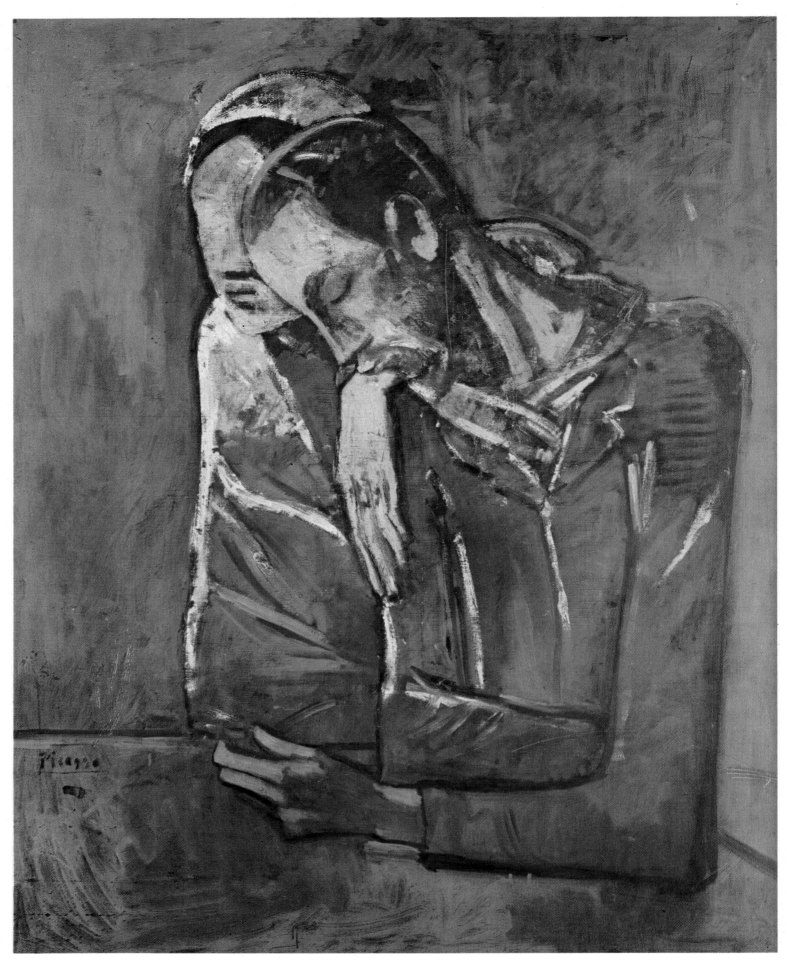

PLATE XXII THE COUPLE Ascona, Private collection
Whole (81 cm.)

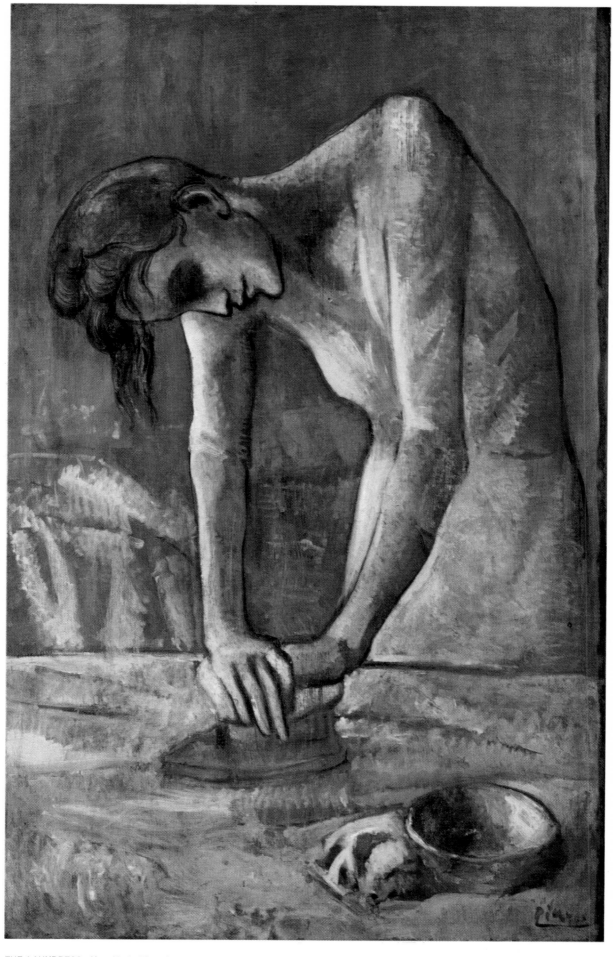

PLATE XXIII THE LAUNDRESS New York, Thannhauser Collection
Whole (72.5 cm.)

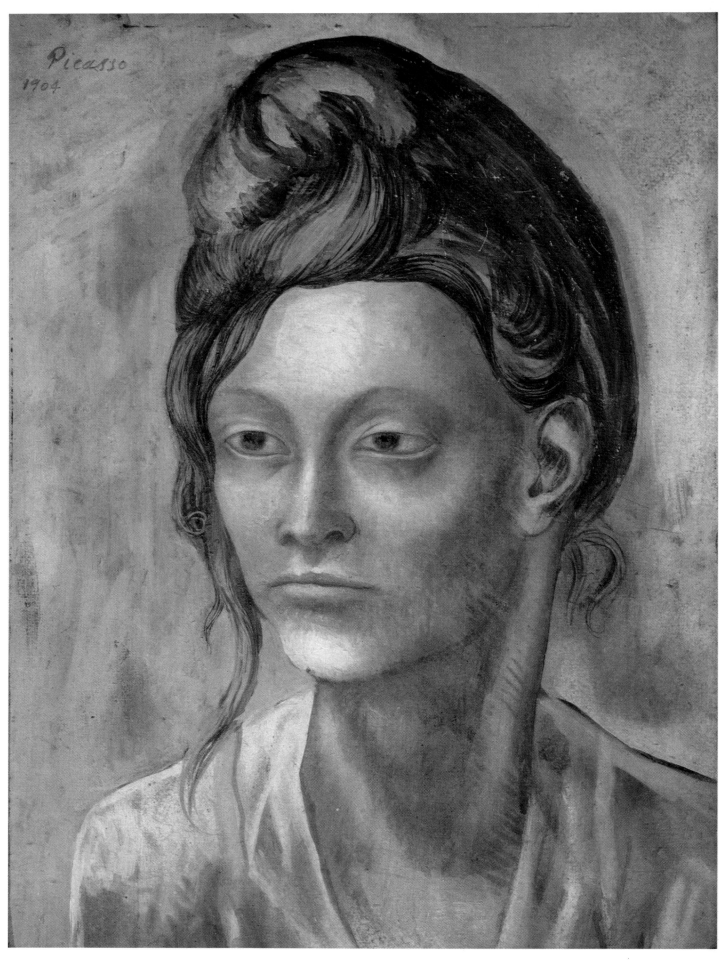

PLATE XXIV WOMAN WITH BRAIDED HAIR Chicago (Ill.), Art Institute
Whole (31 cm.)

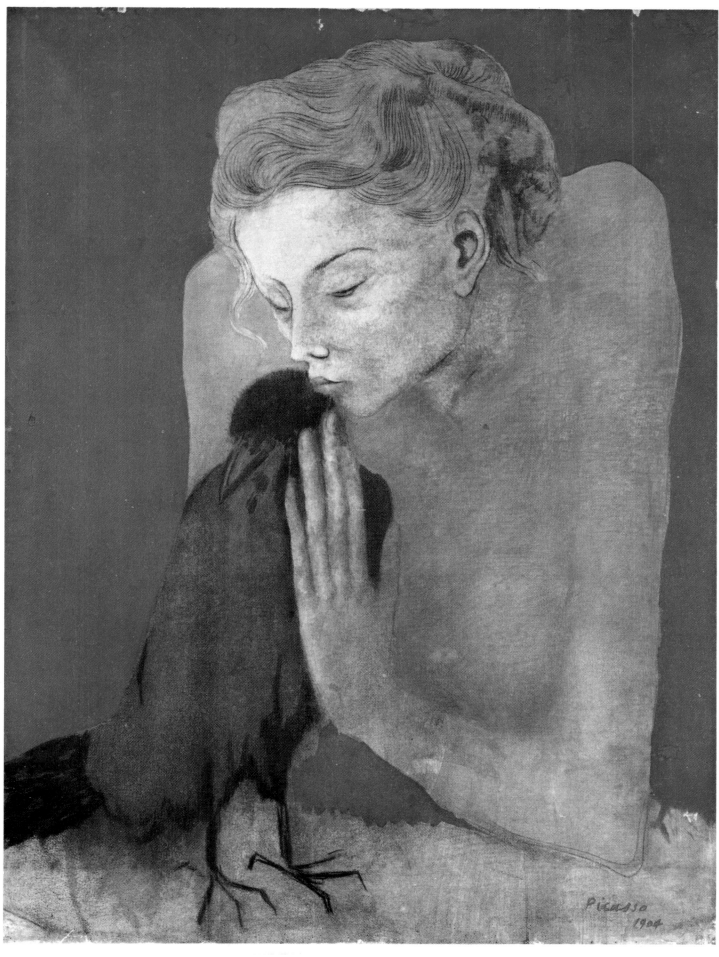

PLATE XXV GIRL CHILD WITH CROW Toledo (Ohio), Museum of Art
Whole (49.5 cm.)

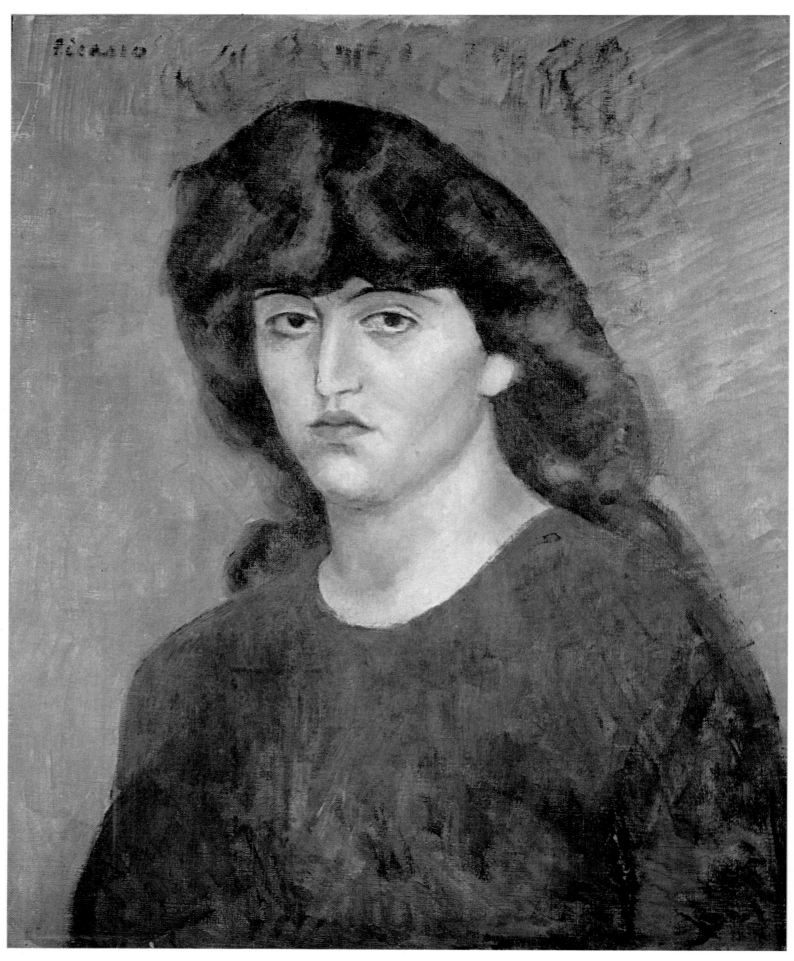

PLATE XXVI PORTRAIT OF SUZANNE BLOCH São Paulo, Museu de Arte
Whole (54 cm.)

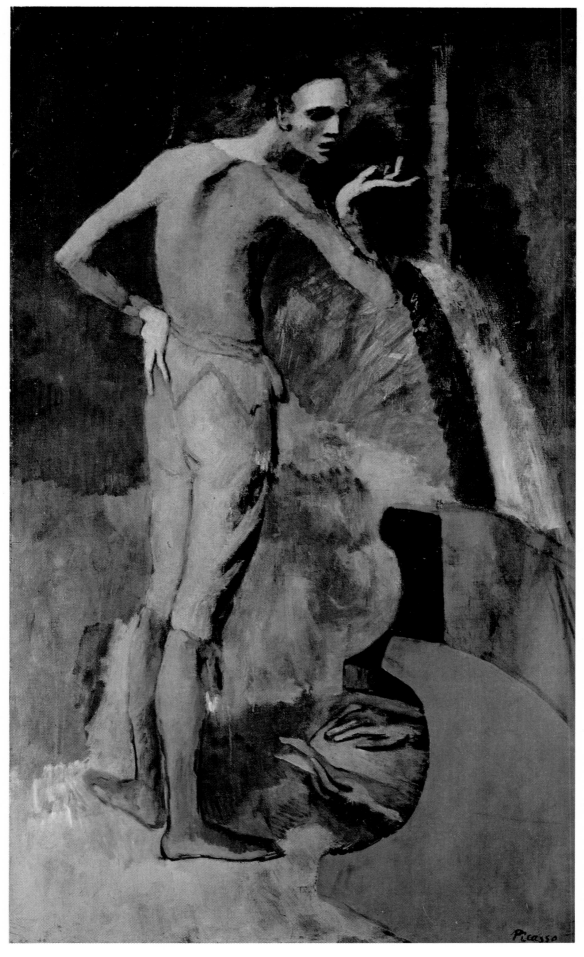

PLATE XXVII THE ACTOR New York, Metropolitan Museum of Art
Whole (112 cm.)

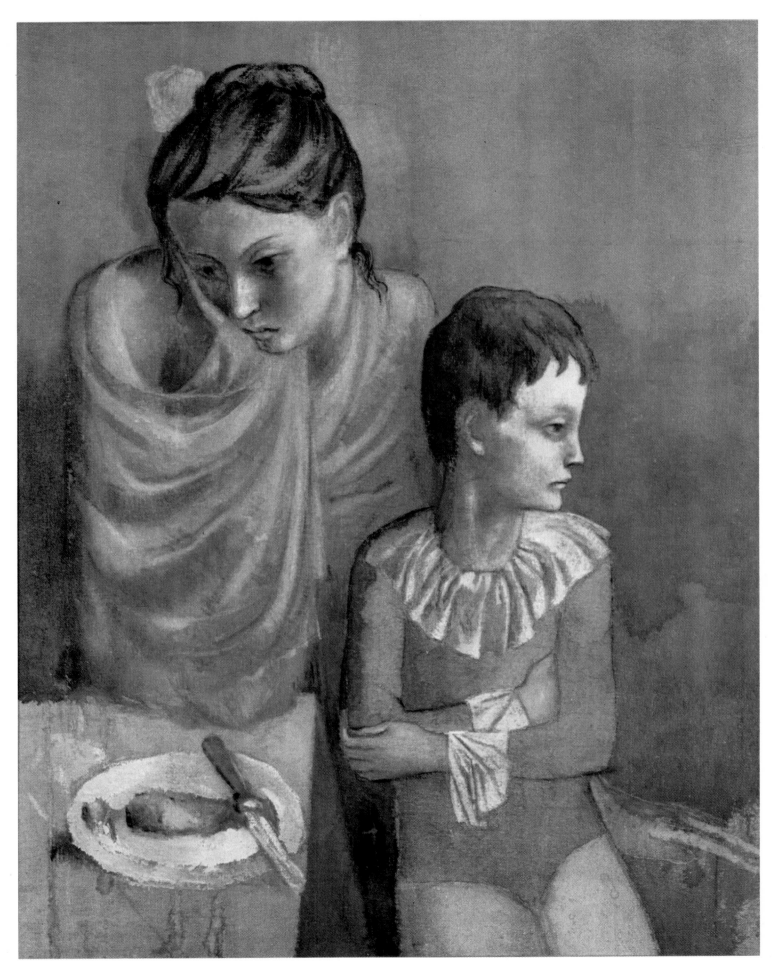

PLATE XXVIII MOTHER AND CHILD Stuttgart, Staatsgalerie
Whole (69.5 cm.)

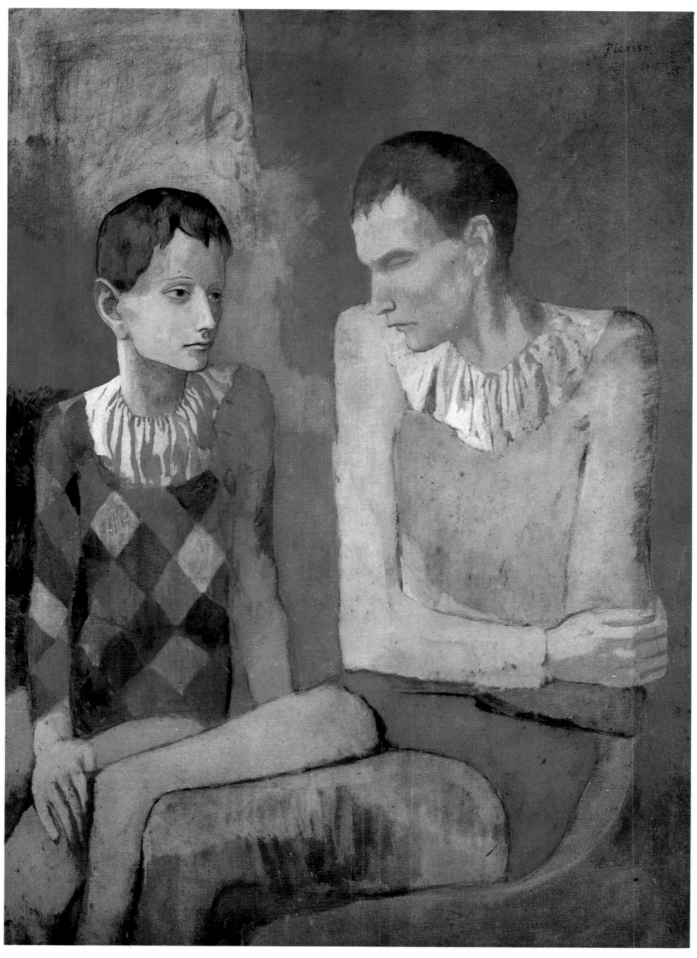

PLATE XXIX ACROBAT AND YOUNG HARLEQUIN Belgium, Private collection
Whole (76 cm.)

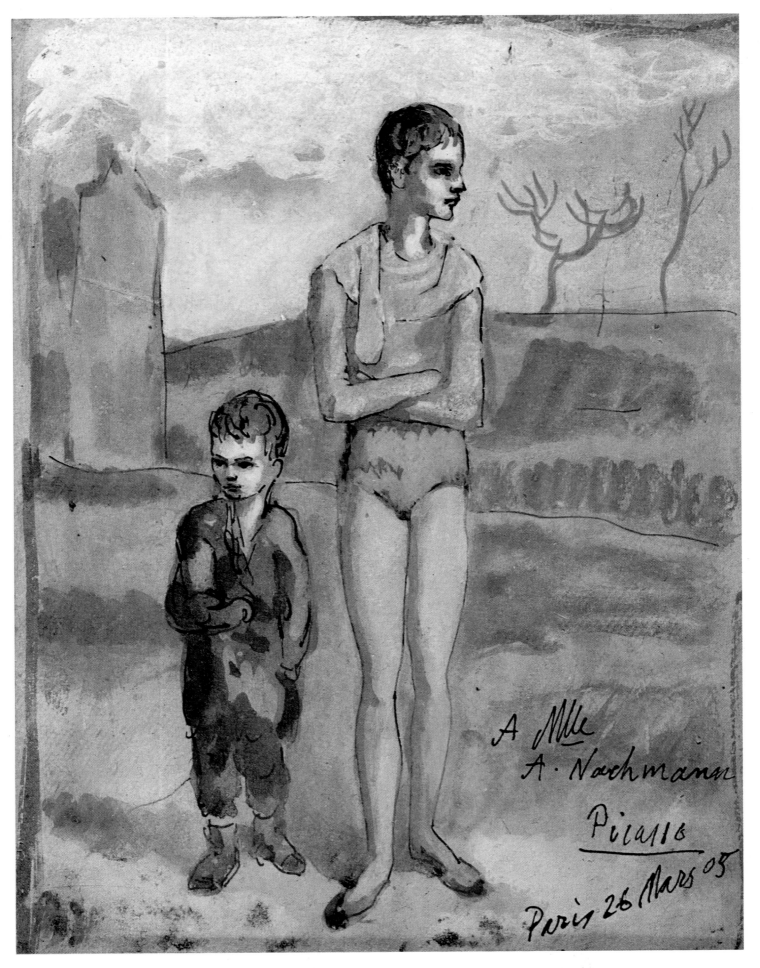

PLATE XXX YOUNG ACROBAT AND CHILD New York, Thannhauser Collection
Whole (18 cm.)

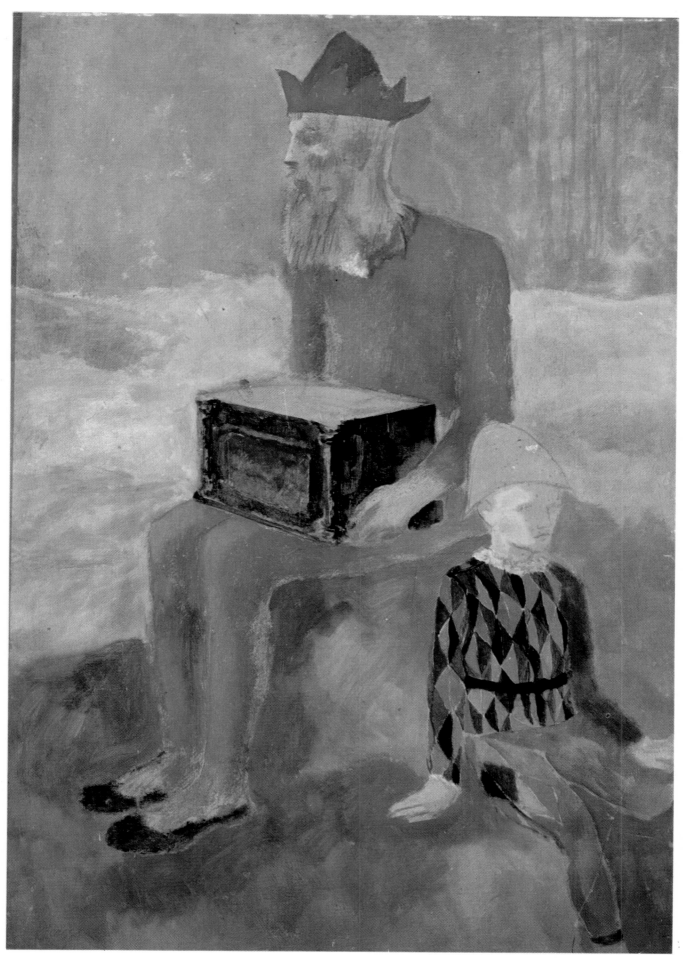

PLATE XXXI THE HURDY-GURDY PLAYER AND YOUNG HARLEQUIN Zürich, Kunsthaus
Whole (70 cm.)

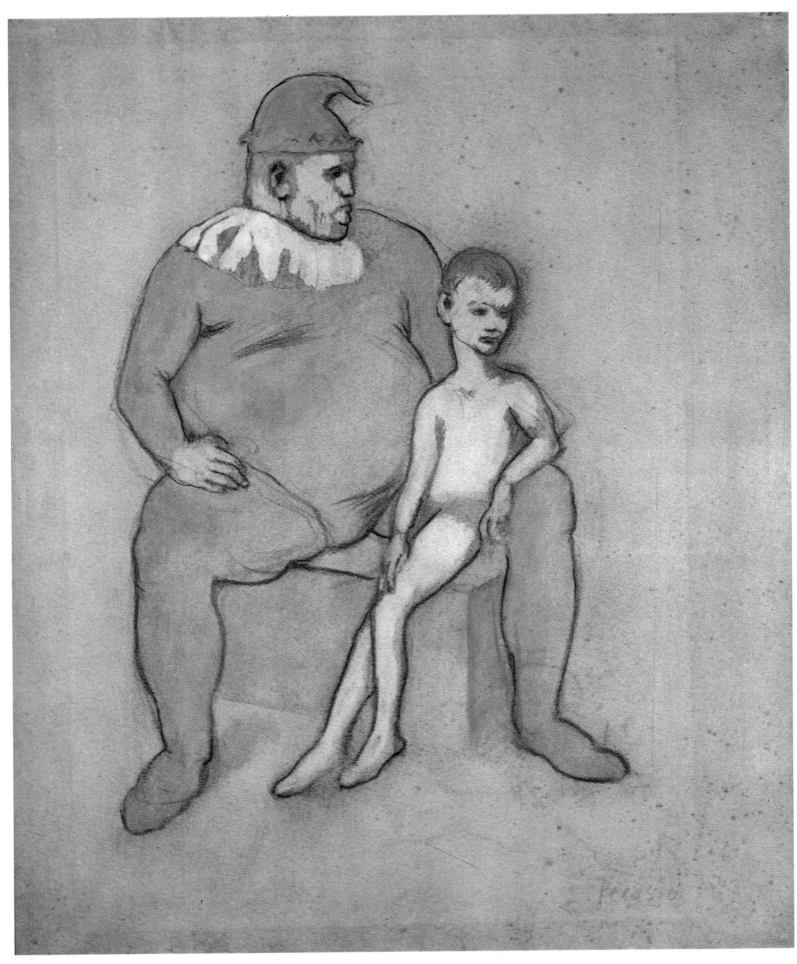

PLATE XXXII CLOWN AND YOUNG ACROBAT Baltimore (Ma.), Museum of Art
Whole (47 cm.)

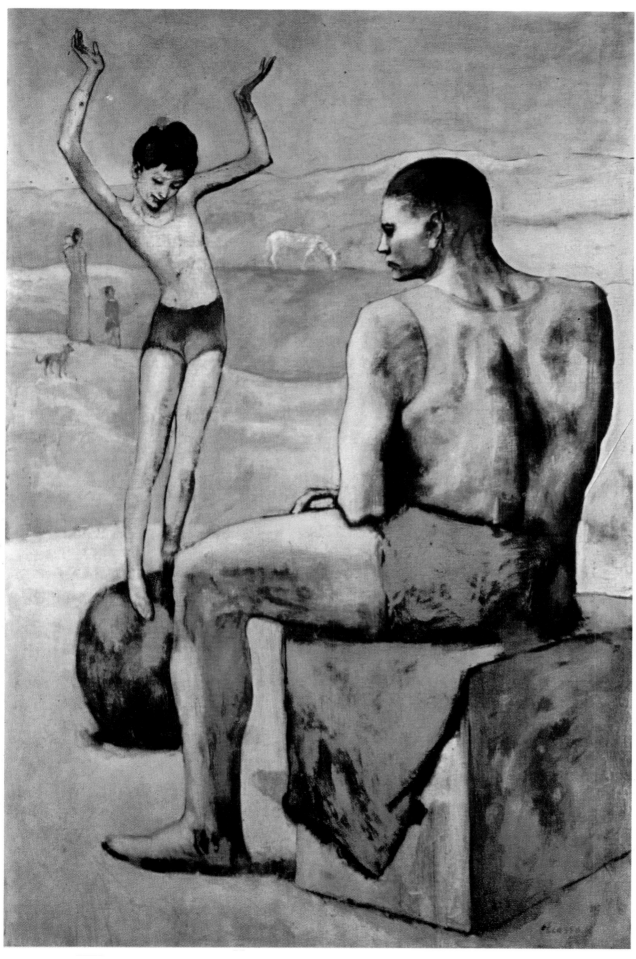

PLATE XXXIII ACROBAT AND YOUNG EQUILIBRIST Moscow, Pushkin Museum
Whole (95 cm.)

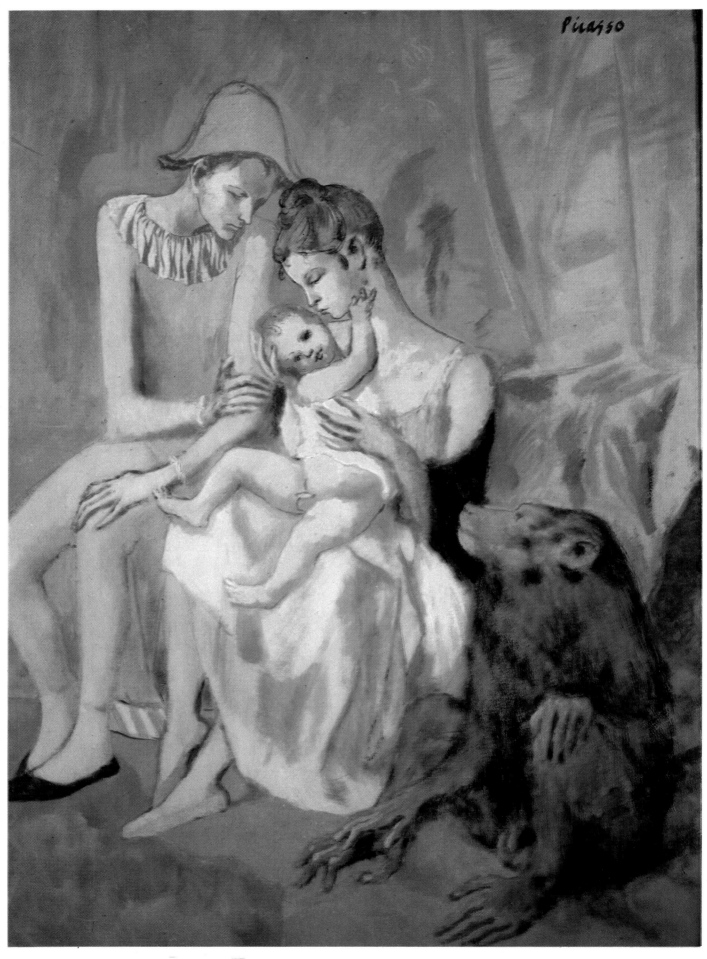

PLATE XXXIV FAMILY OF ACROBATS WITH APE Göteborg, Konstmuseum
Whole (75 cm.)

PLATE XXXV FAMILY OF ACROBATS Baltimore (Ma.), Museum of Art
Whole (30.5 cm.)

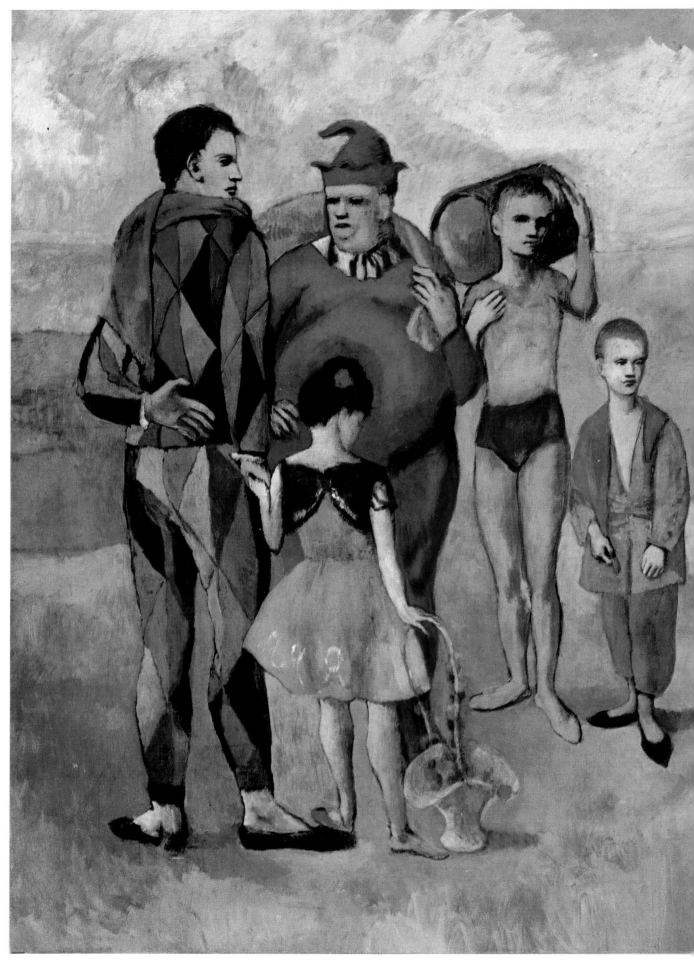

PLATES XXXVI-XXXVII THE ACROBATS Washington, DC, National Gallery of Art
Whole (229.5 cm.)

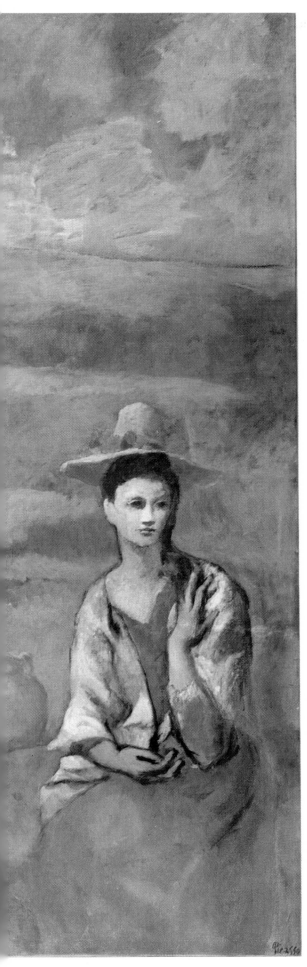

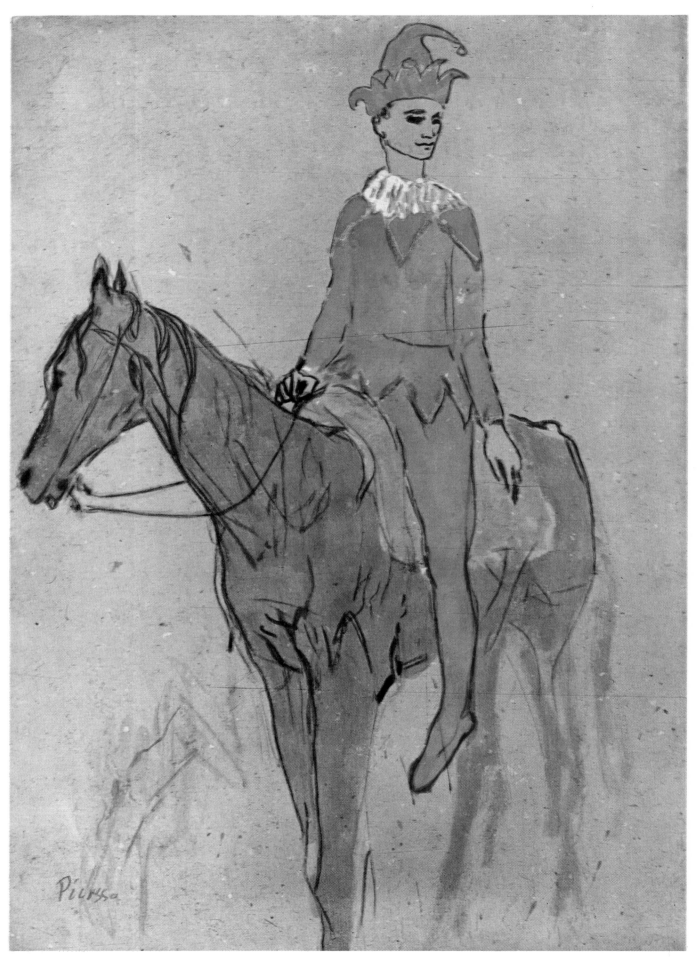

PLATE XXXVIII HARLEQUIN ON HORSEBACK Washington, DC, Mellon Collection
Whole (96 cm.)

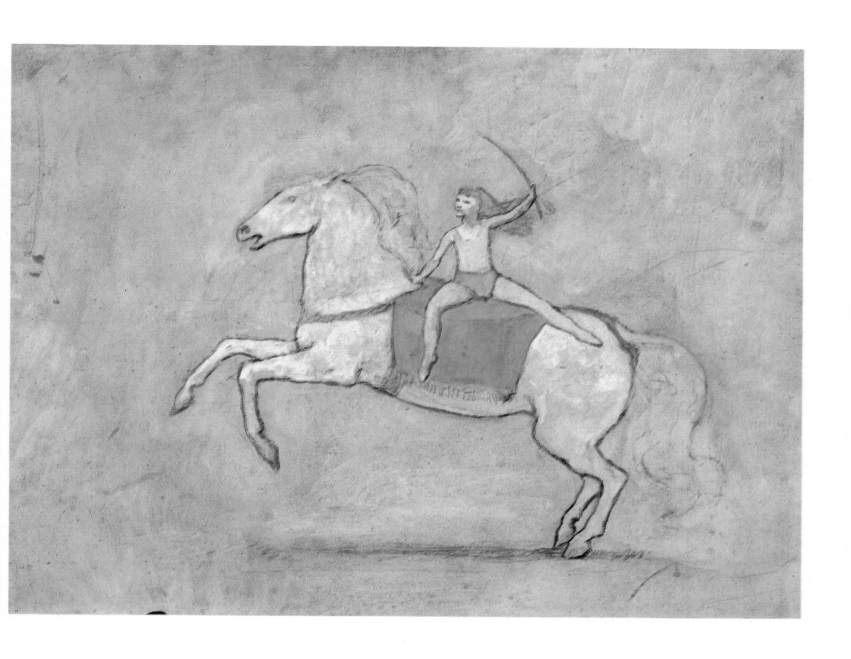

PLATE XXXIX YOUNG EQUESTRIENNE Property of the Artist
Whole (78 cm.)

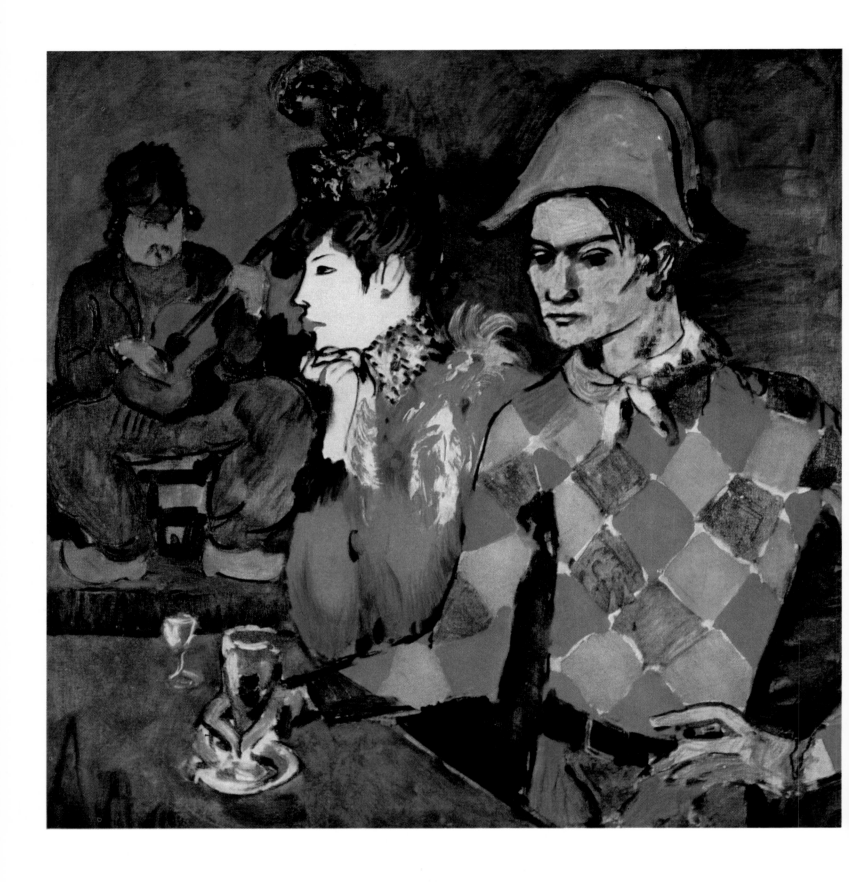

PLATE XL SELF-PORTRAIT IN THE DRESS OF A HARLEQUIN IN A CAFÉ New York, Payson Collection
Whole (100.5 cm.)

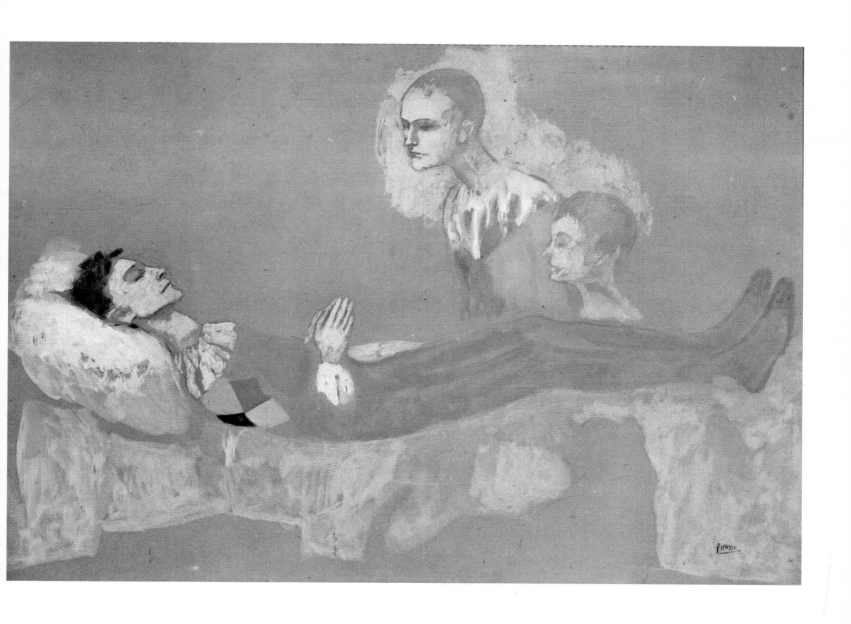

PLATE XLI THE DEATH OF HARLEQUIN Washington, DC, Mellon Collection
Whole (95 cm.)

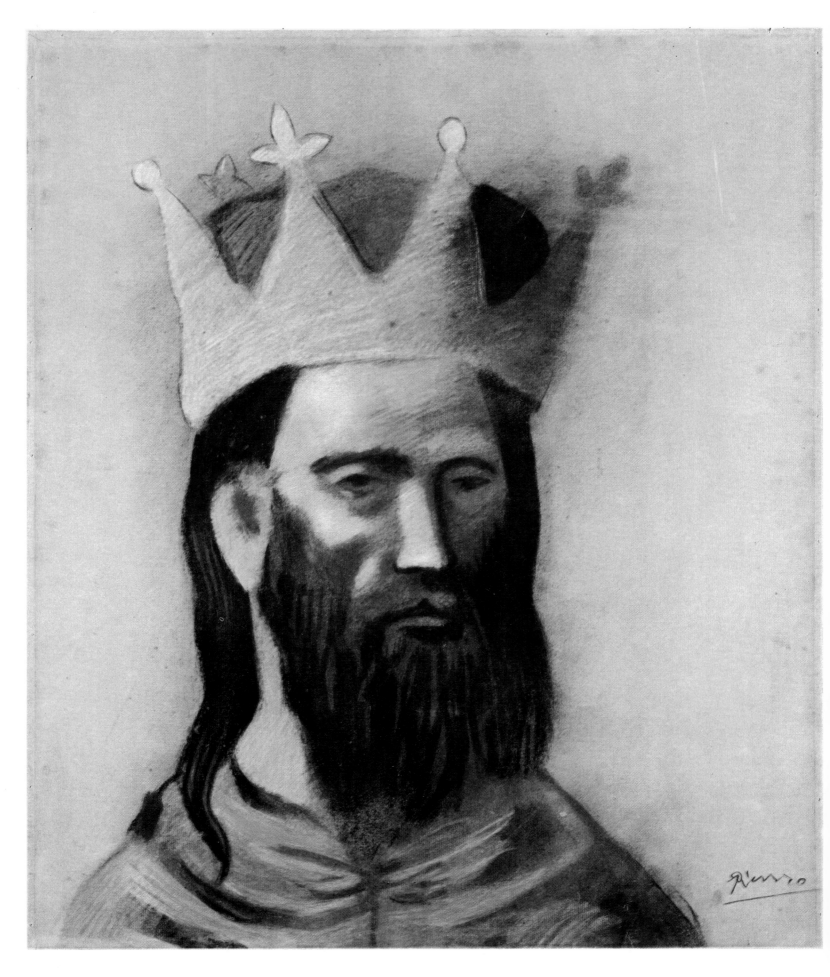

PLATE XLII THE KING Stuttgart, Staatsgalerie
Whole (45 cm.)

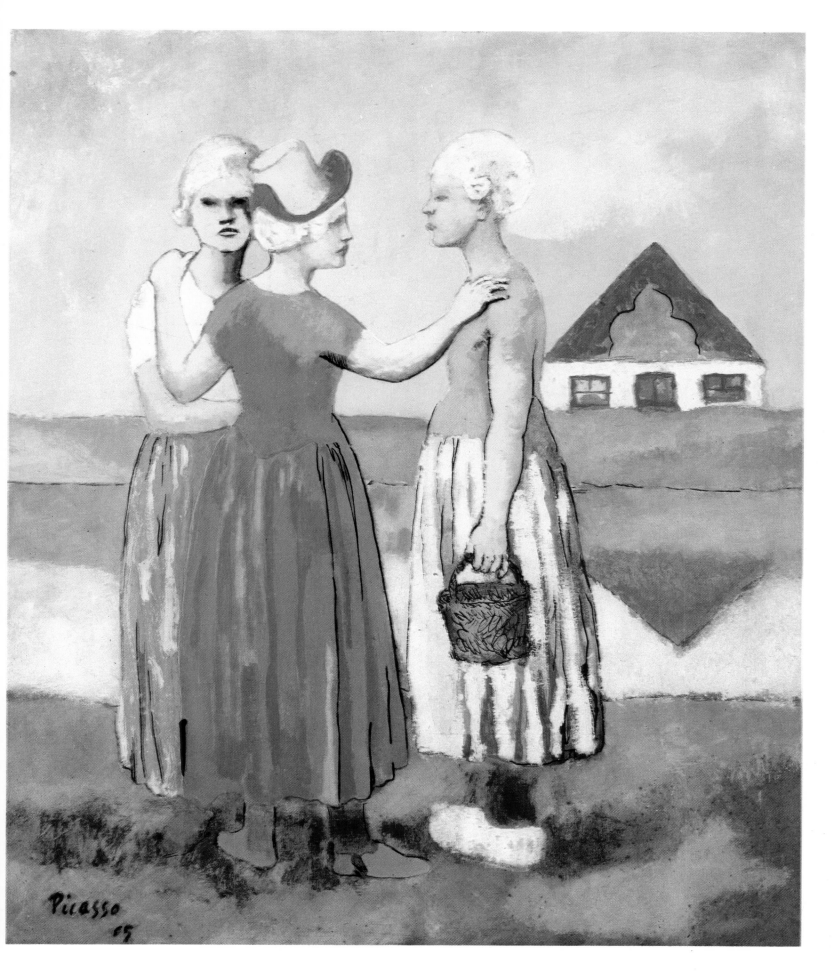

PLATE XLIII THREE DUTCH WOMEN Paris, Musée National d'Art Moderne
Whole (66 cm.)

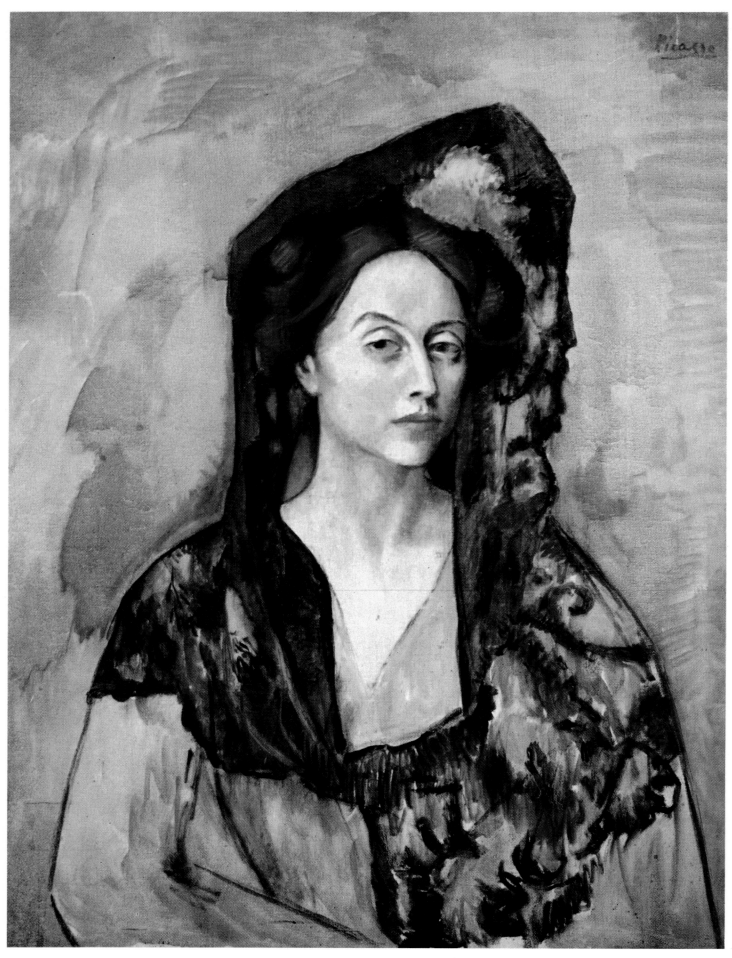

PLATE XLIV PORTRAIT OF BENEDETTA CANALS Barcelona, Picasso Museum
Whole (70.5 cm.)

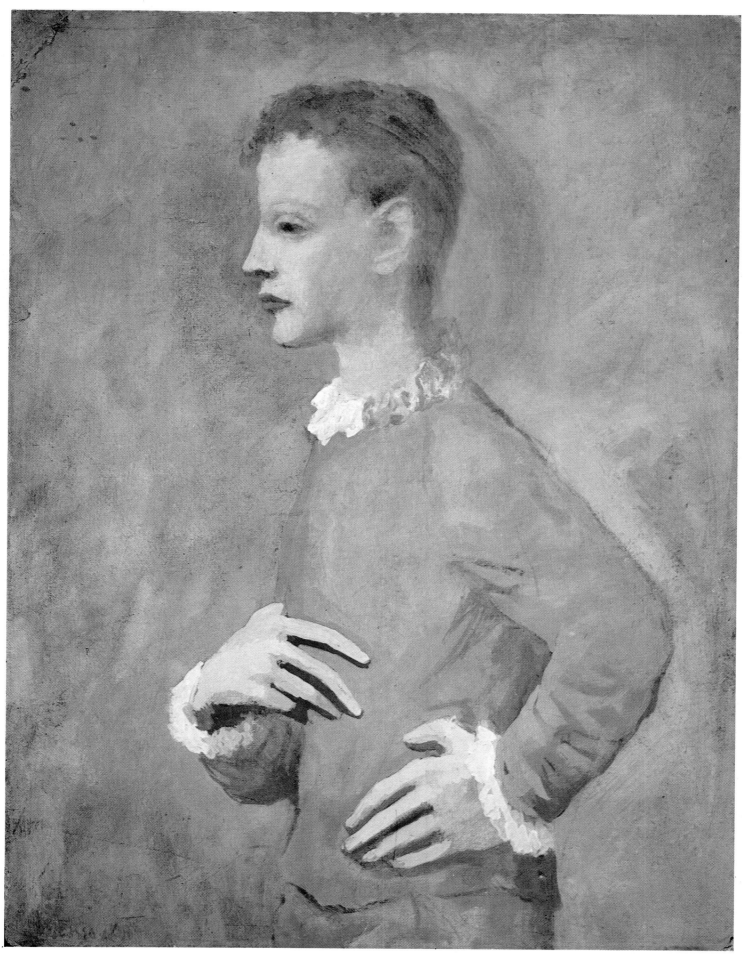

PLATE XLV PROFILE OF A YOUNG MAN WITH A LACE COLLAR Worcester (Mass.), Art Museum
Whole (59.5 cm.)

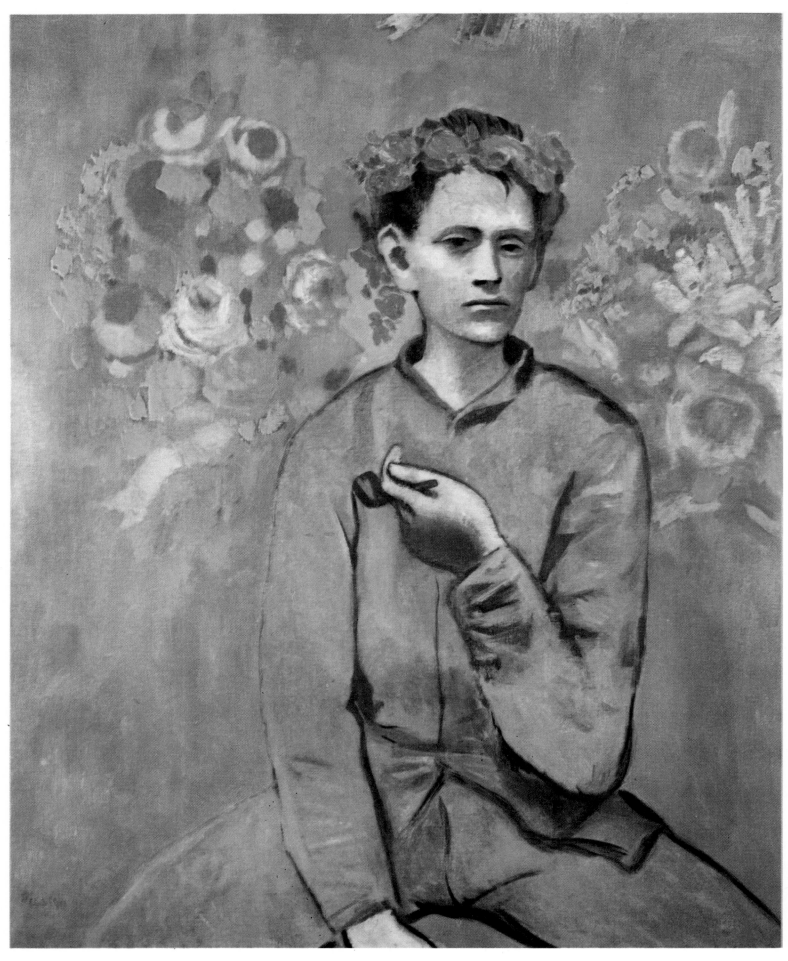

PLATE XLVI YOUNG MAN WITH GARLAND OF ROSES New York, Whitney Collection
Whole (79 cm.)

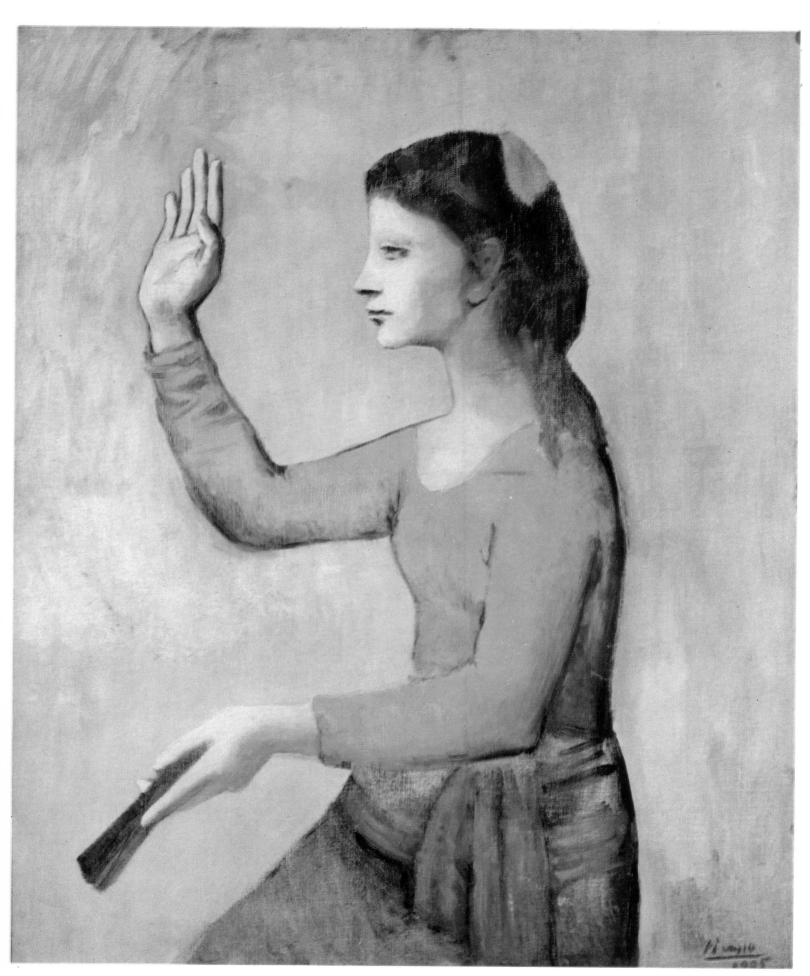

PLATE XLVII YOUNG WOMAN WITH RAISED ARM New York, Harriman Collection
Whole (81.5 cm.)

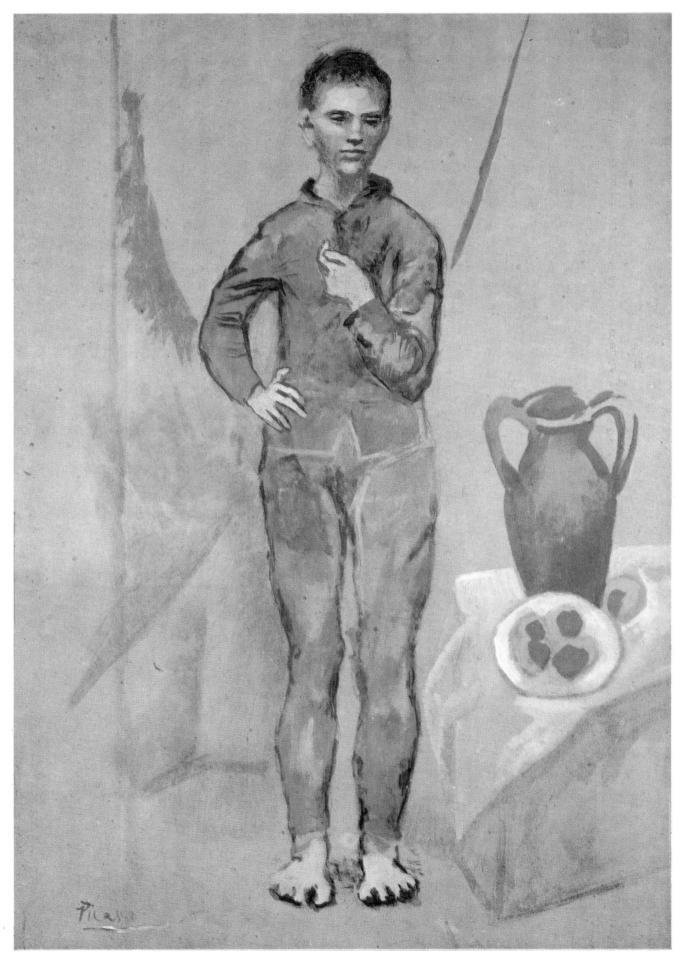

PLATE XLVIII ACROBAT AND STILL LIFE Washington, DC, National Gallery of Art
Whole (70 cm.)

PLATE XLIX YOUNG MAN IN BLUE New York, Warburg Collection
Whole (55.5 cm.)

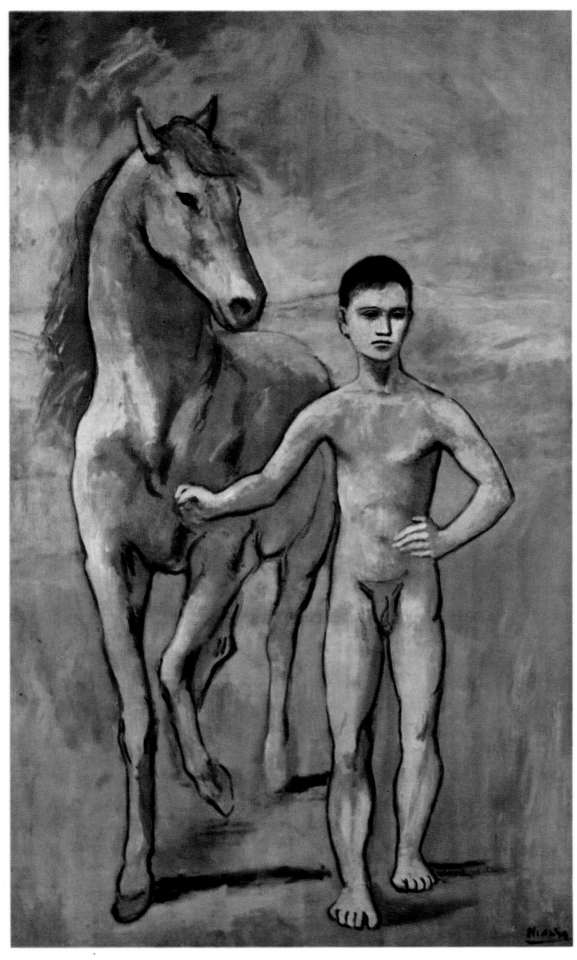

PLATE L NUDE YOUNG MAN WITH HORSE New York, Paley Collection
Whole (130 cm.)

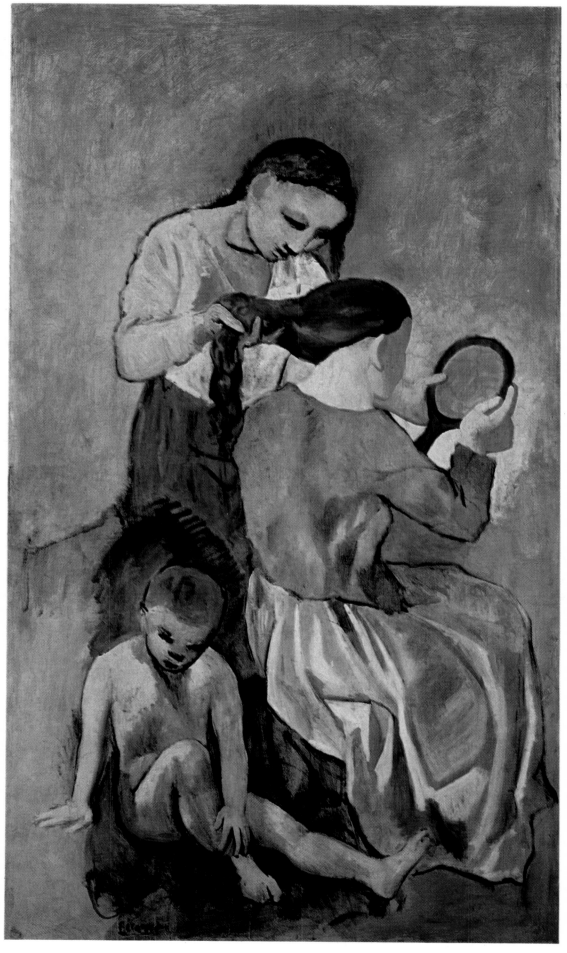

PLATE LI "LA COIFFURE" New York, Metropolitan Museum of Art
Whole (99.5 cm.)

Picasso

PLATES LII-LIII HORSES BATHING Worcester (Mass.), Art Museum
Whole (58 cm.)

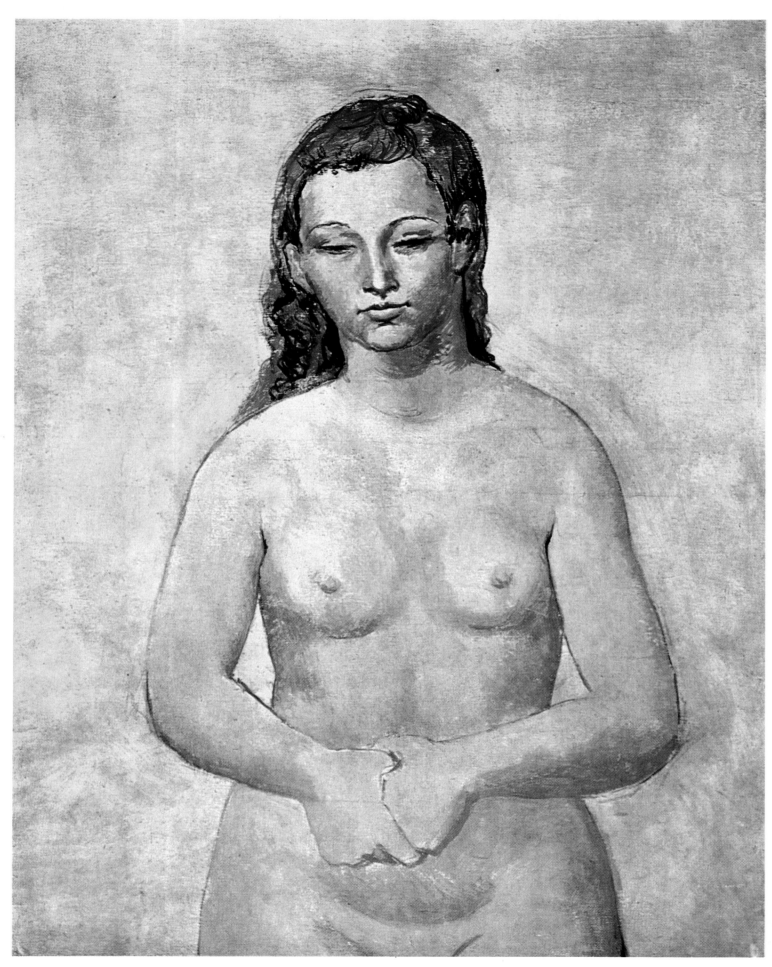

PLATE LIV NUDE OF FERNANDE OLIVIER WITH CLASPED HANDS Toronto, Zacks Collection
Whole (75.5 cm.)

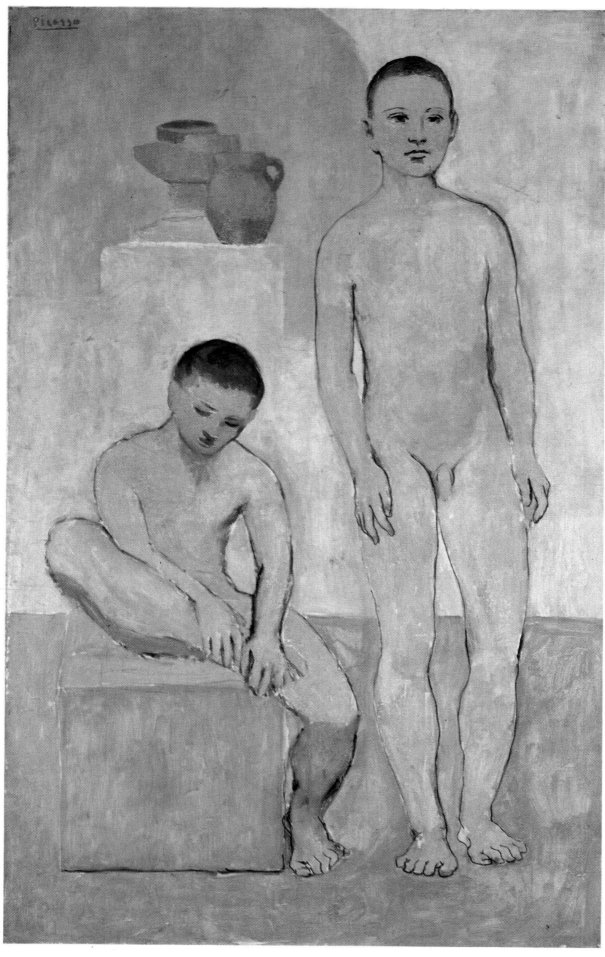

PLATE LV TWO NAKED YOUTHS Washington, DC, National Gallery of Art
Whole (93.5 cm.)

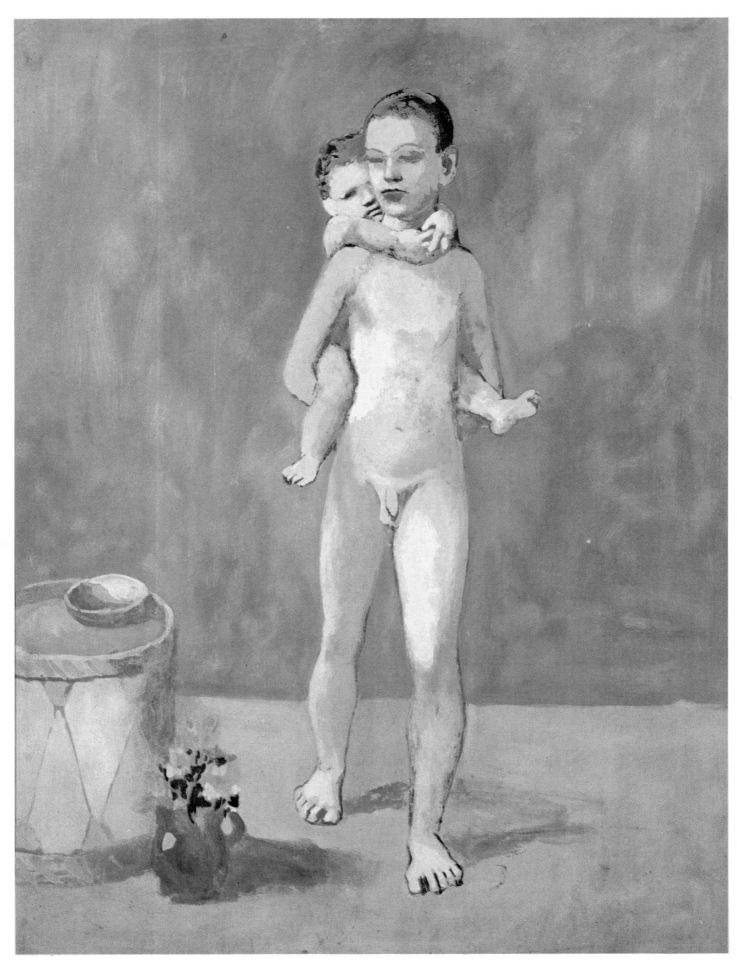

PLATE LVI THE TWO BROTHERS Property of the Artist
Whole (60 cm.)

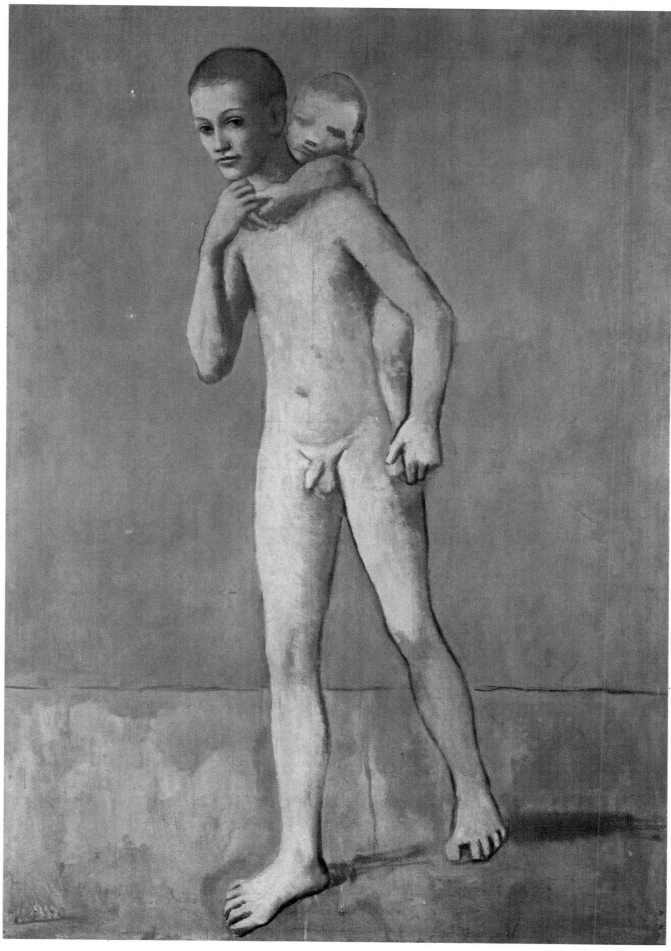

PLATE LVII THE TWO BROTHERS Basle, Kunstmuseum
Whole (97 cm.)

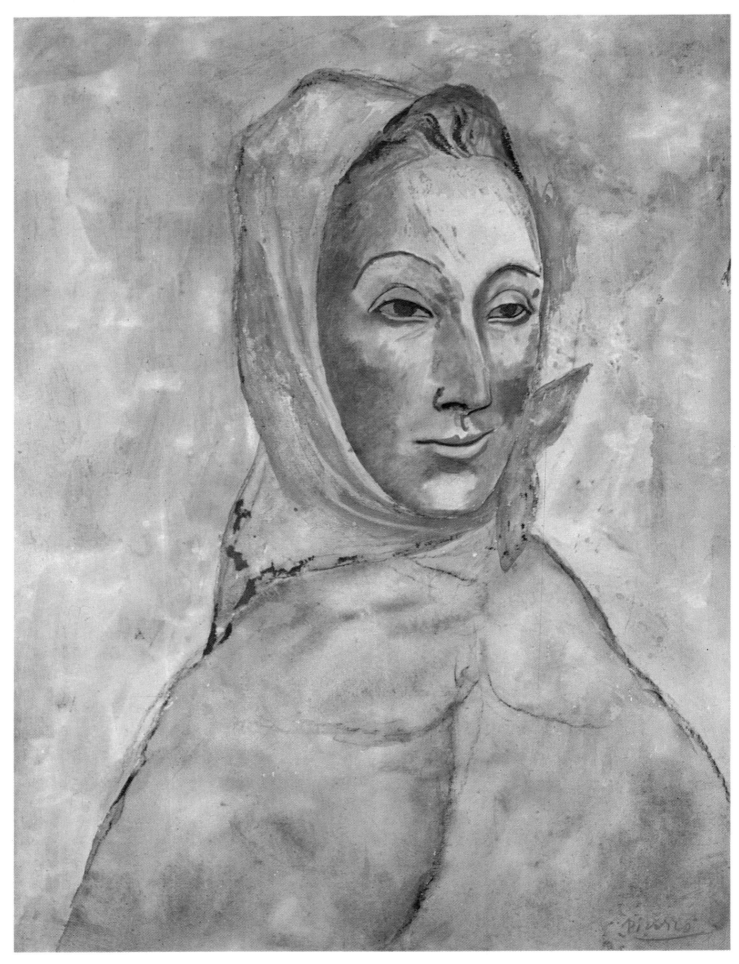

PLATE LVIII PORTRAIT OF FERNANDE OLIVIER WITH HEADSCARF Richmond (Va.), Virginia Museum of Fine Arts
Whole (49.5 cm.)

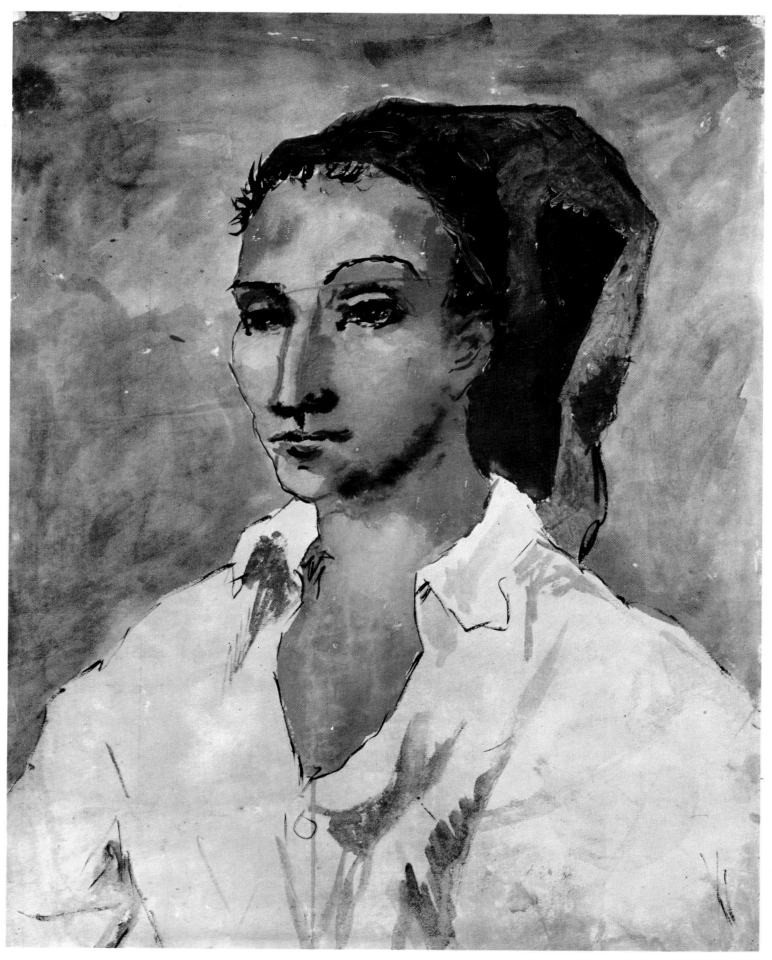

PLATE LIX HEAD AND SHOULDERS OF A YOUNG SPANIARD Göteborg, Konstmuseum
Whole (48 cm.)

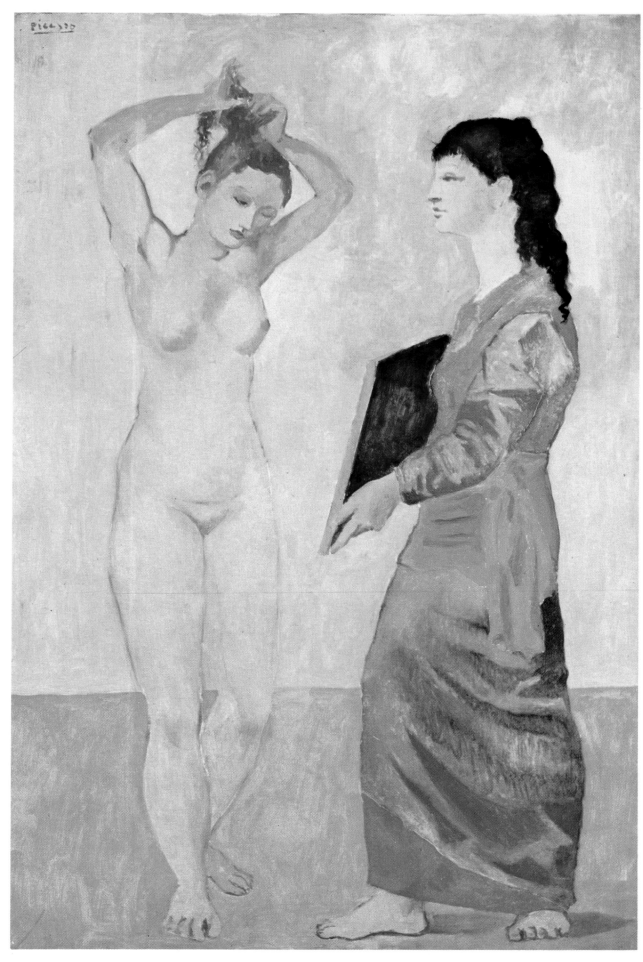

PLATE LX "LA TOILETTE" Buffalo (NY), Albright-Knox Gallery
Whole (99 cm.)

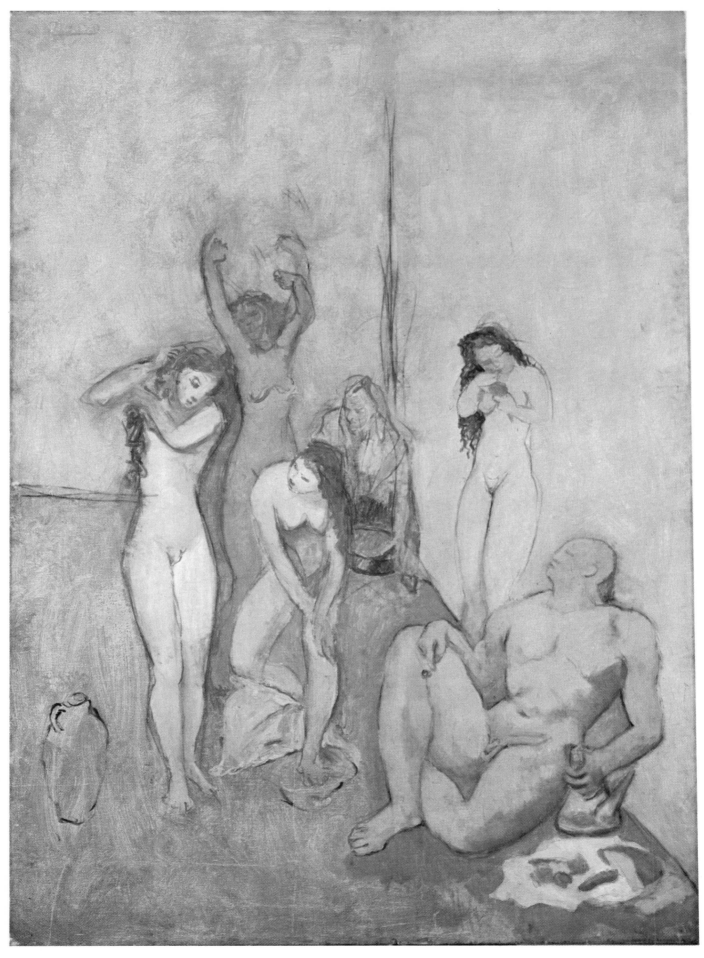

PLATE LXI THE HAREM Cleveland (Ohio), Museum of Art
Whole (109.5 cm.)

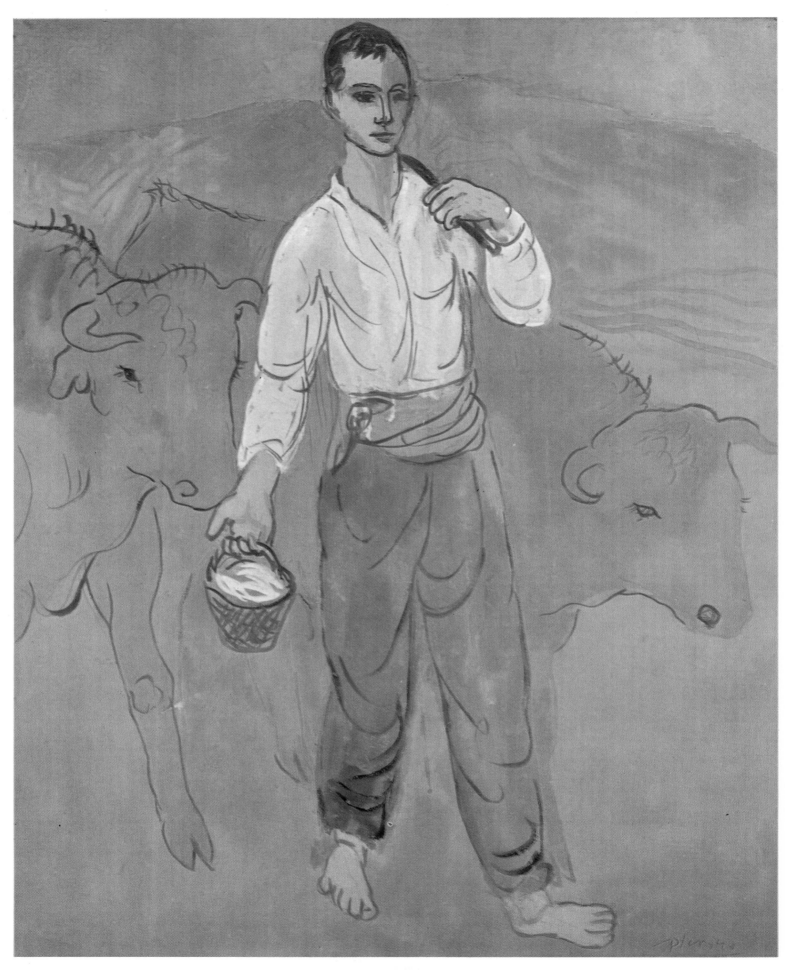

PLATE LXII CATTLE DROVER WITH SMALL BASKET Columbus (Ohio), Gallery of Fine Arts
Whole (47 cm.)

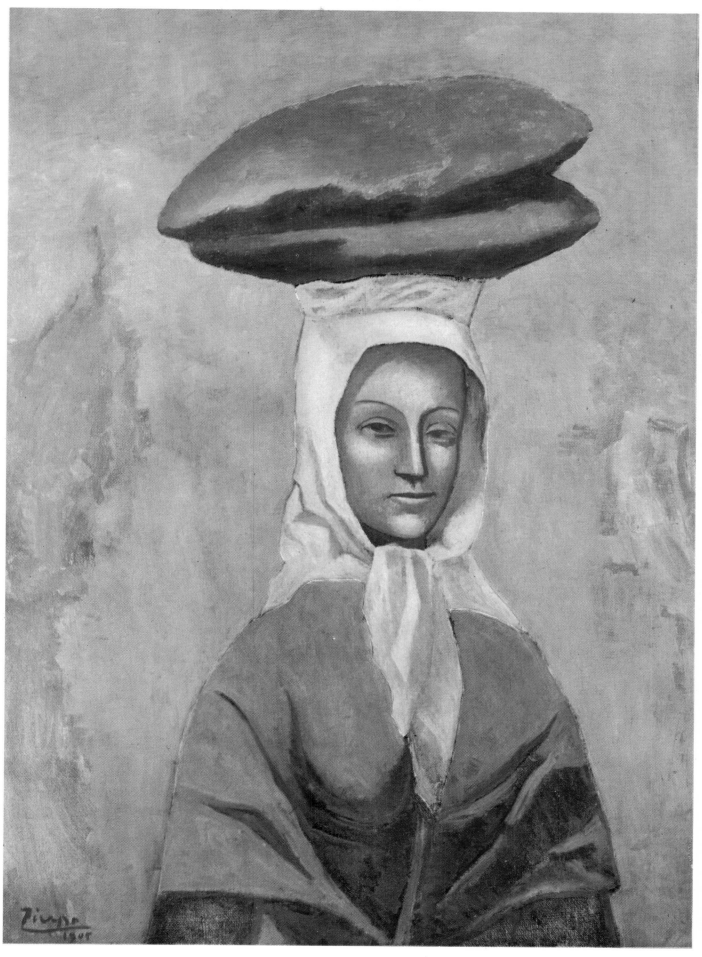

PLATE LXIII THE BREAD CARRIER Philadelphia (Pa.), Museum of Art
Whole (70 cm.)

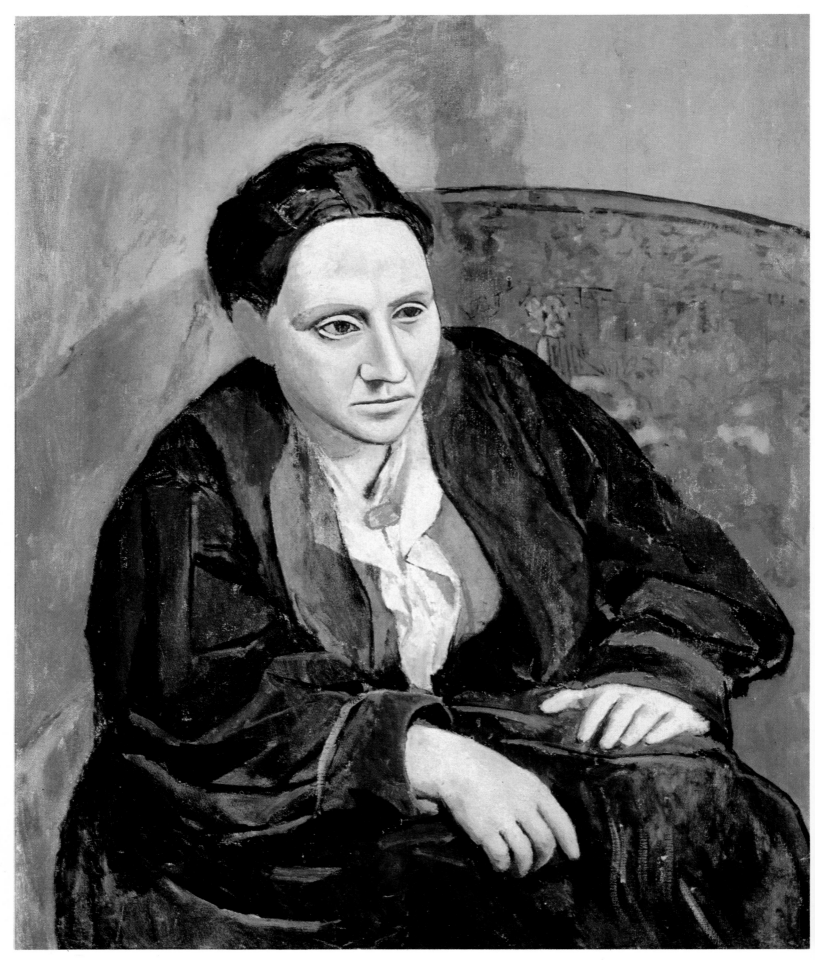

PLATE LXIV PORTRAIT OF GERTRUDE STEIN New York, Metropolitan Museum of Art
Whole (81 cm.)

The works

So that the essential elements in each work may be immediately apparent, each note is headed first by a number (following the most reliable chronological sequence) which is given every time the work is quoted throughout the book, and then by a series of symbols. These refer to: 1) The technique and support used; 2) The presence or absence of signature and date; 3) The whereabouts of the work. The numbers inserted between the first and second symbols indicate, in centimetres or metres, the dimensions of the painting: above, its height; below, its width. Between the second and third symbols are indicated: above, the place where the work was executed; below the date of execution.

Technique and support

⊗ Oil on canvas

⊗ Oil on wood

⊗ Oil on paper or card

⊗ Gouache on canvas

⊗ Gouache on paper or card

⊗ Watercolour on paper or card

⊗ Pastel on paper or card

⊗ Mixed techniques on paper or card indicated in text

Additional data

▤ Unsigned and undated

▤ Signed

▤ Dated

▤ Signed and dated

Whereabouts

⦂ Public collection

⦂ Private collection

82 ⦂ Unknown

Exhibitions

There have been a vast number of exhibitions of Picasso's works, both one-man and combined with the works of other artists, over the last seventy years. They began with the first collections on view in Paris at the Galeries Ambroise Vollard in June and July 1901, and at the Galerie Berthe Weill in April, June, November and December 1902; and culminated in the great *Hommage à Pablo Picasso* held in Paris from November 1966 to February 1967. This exhibition was divided between three buildings; paintings at the Grand Palais, drawings, sculpture and ceramics at the Petit Palais, and typography at the Bibliothèque Nationale. In this monograph, however only twenty of these exhibitions are referred to – the most important, and, above all, those where works belonging to the two periods under consideration here, were extensively represented. The following table indicates the symbols given in the text for those exhibitions referred to in this catalogue.

13 M 1913 Munich, Moderne Galerie H.Thannhauser, *Pablo Picasso.*
32 P 1932 Paris, Galerie G. Petit, *Picasso.*
32 Z 1932 Zurich, Kunsthaus, *Picasso.*
36 NY 1936 New York, J.Seligman & Co. Gallery, *Picasso, Blue and Rose Periods.*
37 C 1937 Chicago (III.), Art Institute. *Watercolors and Gouaches by Picasso.*
38 B 1938 Boston (Mass.), Museum of Modern Art, *Picasso and Matisse.*

39 NY 1939–40 New York, Museum of Modern Art, *Picasso: Forty Years of his Art;* then, in part: Chicago (III.), Art Institute; Boston (Mass.), Museum of Fine Arts; Saint Louis (Miss.) City Art Museum; Cincinnati (Ohio), Museum of Art; Cleveland (Ohio), Museum of Art; San Francisco (Cal.), Museum of Art.
47 NY 1947 New York, Knoedler Gallery, *Picasso before 1907.*
53 L 1953 Lyons, Musée des Beaux-Arts, *Picasso.*
53 M 1953 Milan, Palazzo Reale, *Picasso.*
54 P 1954 Paris, Maison de la Pensée Française, *Picasso, oeuvres des musées de Leningrad et de Moscou, 1900–1914.*
55 P 1955 Paris, Musée des Arts Décoratifs, *Picasso, peintures 1900–1955.*
55 M 1955 Munich, Haus der Kunst, *Picasso 1900–1955.*
57 NY 1957 New York, Museum of Modern Art, *Picasso, 75th Anniversary Exhibition* (then to Chicago, Art Institute).
58 P 1958 Philadelphia (Pa.), Museum of Art, *Picasso, a Loan Exhibition.*
59 M 1959 Marseilles, Musée Cantini, *Picasso.*
60 L 1960 London, Tate Gallery, *Picasso.*
60 P 1960 Paris, Musée National d'Art Moderne, *Les sources du XX^e siècle: les arts en Europe de 1814 à 1914.*
64 T 1964 Toronto, Art Gallery, *Picasso and Man.*
66 P 1966–7 Paris, Grand Palais, Petit Palais and Bibliothèque Nationale, *Hommage à Pablo Picasso.*

Bibliograpny

The literature on Picasso is vast. Even discounting the general works, the list of monographs is certainly impressive. In this catalogue therefore, references are given only to the most important of these works; and those which are concerned specifically with the same period of his art as we are here. The references listed under each work described or cited speak for themselves, but a special mention must be made of the great catalogues of Zervos (1932 and 1954), and also of the work of Daix and Boudaille to whom this book is particularly indebted. Their book *Picasso 1900–1906* is the first systematic study of Picasso's work before Cubism since Cirici Pellicer's great essay on the subject. In view of the importance of these works and in recognition of their authority on the subject, a concordance of them both and the catalogue provided here is given in the tables on pages 114–5. The following is a list of quoted works and their respective symbols.

R 21 Maurice Raynal, *Picasso,* Munich 1921.
L 28 André Level, *Picasso,* Paris 1928.
D 30 Eugenio d'Ors, *Pablo Picasso,* Paris 1930.
Z 32 Christian Zervos, *Pablo Picasso,* vol. 1: *Oeuvres de 1895 à 1906,* Paris 1932.

S 38 Gertrude Stein, *Picasso,* Paris 1938.
B 39 Alfred H.Barr, Jr., *Picasso, Forty Years of his Art* (in catalogue NY 39).
C 40 Jean Cassou, *Picasso,* Paris 1940.
M 42–48 Joan Merli, *Picasso, el artista y la obra de nuestro tiempo,* Buenos Aires 1942 (second edition 1948).
B 46 Alfred H.Barr, Jr., *Picasso, Fifty Years of His Art,* New York 1946.
S 46–53 Jaime Sabartés, *Picasso, portraits et souvenirs,* Paris 1946 (Spanish edition: *Picasso, retratos y recuerdos,* Madrid 1953).
S 48–55 Denys Sutton, *Picasso, Paintings of the Blue and Rose Periods,* London 1948 (second edition 1955).
CP 50 Alejandro Cirici Pellicer, *Picasso avant Picasso* (French edition revised from *Picasso antes de Picasso,* Barcelona 1946).
G 51 Maurice Gieure, *Initiation à l'oeuvre de Picasso,* Paris 1951.
L 52–54 William S. Lieberman, *Picasso, Blue and Rose Periods,* New York 1952 (second edition 1954).
R 53 Maurice Raynal, *Picasso,* Geneva 1953.
S 54 Jaime Sabartés, *Picasso, documents iconographiques,* Geneva 1954.
Z 54 Christian Zervos, *Pablo Picasso,* vol. VI: *Supplément aux volumes I à V,* Paris 1954.
B 55 Wilhelm Boeck, *Picasso,* Paris 1955 (with a preface by Jaime

Sabartés).
EM 55 Frank Elgar and Robert Maillard, *Picasso,* Paris 1955.
KP 55 Daniel-Henry Kahnweiler and Hélène Parmelin, *Picasso, œuvres des musées de Léningrad et Moscou,* Paris 1955.
E 56 Frank Elgar, *Picasso, époques bleue et rose,* Paris 1956.
B 57 Alfred H.Barr, Jr., *Picasso, 75th Anniversary* (in catalogue NY 57).
C 58 Jean Cassou, *Picasso,* Paris 1958.
P 58 Roland Penrose, *Picasso, his Life and Work,* London 1958.
C 59 Raymond Cogniat, *Picasso, figures,* Lausanne 1959.
D 60 Gaston Diehl, *Picasso,* Paris 1960.
D 61 David Douglas Duncan, *Picasso's Picassos,* Lausanne 1961.
BP 62 Anthony Blunt and Phoebe Pool, *Picasso, The Formative Years, A Study of his Sources,* London 1962.
S 63 Jaime Sabartés, *Picasso, les bleus de Barcelone,* Paris 1963.
B 64 Georges Boudaille, *Picasso, sa première époque, 1881–1906,* Paris 1964.
D 64 Pierre Daix, *Picasso,* Paris 1964.
J 64 Hans L.C.Jaffé, *Picasso,* New York 1964.
K 65 Helen Kay, *Picasso's World of Children,* New York 1965.
DB 66 Pierre Daix and Georges Boudaille, *Picasso, 1900–1906,* Neuchâtel 1966.
P 66 Josep Palau i Fabre, *Picasso en Cataluña,* Barcelona 1966.

Outline biography

1881 25 October
Picasso was born in the Merced district of Malaga, at 11.15 p.m., the firstborn son of Don José Ruiz Blasco and Doña Maria Picasso y López. The child was christened Pablo, Diego, José, Francisco de Paula, Juan Nepomuceno, Maria de los Remedios, Crispín, Crispiniano de la Santísima Trinidad Ruiz y Picasso. His father was professor of drawing at the San Telmo school of arts and crafts, and keeper of the local museum.

1884 25 December The birth of his sister Lola.

1887 The birth of his sister Conchita.

1891 September Don José was appointed professor of drawing at the La Guarda school of arts and crafts, at Corunna in Galicia. The family moved to Corunna in September, travelling by sea from Malaga to Vigo. They moved into the second floor of no. 14 Calle Payo Gómez and Pablo was enrolled as a pupil in the junior section of the La Guarda school.

1891 Conchita died soon after the arrival of the family at Corunna.

1891–4 The Ruiz family continued to live in Corunna. Pablo attended the La Guarda school where he designed and edited hand-written newsletters *(La Coruña, Azul y Blanco). He* displayed such a marked pictorial talent that his father decided to give up his own painting, which he personally regarded as mediocre, and concentrate solely on furthering his son's work. He even made him a present of his own palette and brushes.

1895 Don José gave up his appointment at the La Guarda school to his colleague Ramón Navarra García. On 16 April he received instead an appointment to the La Lonja school of fine arts in Barcelona. He moved at once to Barcelona to take up the appointment.

1895 Don José was granted leave of absence, and rejoined his family, who were still living in Corunna.

1895 July The Ruiz family visited Madrid, where Pablo saw the Prado for the first time.

1895 The whole family spent a holiday in Malaga, staying at the house of Don José's mother.

1895 Mid-September The family moved to Barcelona, travelling by sea from Malaga. They lived for a short while in the Calle de la Reina Cristina; but later moved to no. 4 Calle Llauder, which was in the port area not far from the La Lonja school.

1895 September Pablo took the examination for the Senior classes of painting and life-drawing at La Lonja, for which the minimum age of admission was twenty. He passed, and was enrolled as a student despite the fact that he was only fourteen. It is said that he completed the tests, which usually took a whole month, in a single day: this story however is disproved by two drawings, known to have been done for this purpose, dated 25 September and 30 September.

1895–6 Pablo attended the courses at La Lonja and made friends with his classmates Manuel Pallarés y Grau and Manuel Hugué (Manolo), the brothers Angel, Mateu and Wenceslao Fernández de Soto, the brothers Carlo and Sebastián Junyer Vidal, Sebastián Junyent and Carlos Casagemas.

1896 Recognising his son's amazing precocity and independent nature, his father rented a room for him in Calle de la Plata, where Pablo could work by himself. There, among other works he executed a self-portrait dressed in the clothes of an eighteenth-century gentleman.

1896 April His picture *First Communion* is accepted for the municipal exhibition of Barcelona.

1896 25 May The newspaper *Diario de Barcelona* reported favourably on this picture by an artist who was not yet fifteen years old.

1896 At the end of the year the Ruiz family moved into a new house in the same neighbourhood of the port no. 3 Calle de la Merced.

1897 8 June The young man's picture *Science and Charity* was sent to the national exhibition of fine arts in Madrid, where it was well received. (It was later also exhibited at the local exhibition in Malaga, where it was awarded a gold medal.)

1897 12 June Opening of the café "Hostal d'Els Quatre Gats" (abbreviated to "Els 4 Gats"), which became a centre of the young intellectual life of Barcelona. It was built in the neo-Gothic style by the architect Puig y Cadafalch, and was situated in the Carreras' house on the corner of the Calle Montesion and the Calle Patriarca, half-way between the Cathedral and the Plaza de Cataluña This "meeting place of intellectuals with a wine-bar, restaurant and a room for puppet-shows", consisted of a huge room with two arches on one side and five on the other; it extended at the rear to form a salon for exhibitions. It was founded by the ex-painter Pere Romeu in imitation of the "Taverne du Chat-Noir" in Paris, as a rendezvous for the *avant-garde* young artists and writers of the city: which indeed it quickly became. Pere Romeu also started a literary review of the arts, originally also called *Els 4 Gats*, but soon changed to *Pèl i Ploma*. This review was illustrated by Ramón Casas and edited by the Spanish writer and painter Miguel Utrillo (who was later to give his name to Suzanne Valadon's son Maurice Utrillo).

1897 Summer The whole family spent the holiday once again in Pablo's grandmother's house in Malaga.

1897 October Pablo went to Madrid where he successfully passed the entrance examination for the senior classes of the Real Academia de San Fernando, "La Casona". (It is said that in these examinations too, he repeated the exploit which was attributed to him in September 1895.)

1897 October–April **1898** Madrid: the young man changed his lodgings repeatedly. He moved from the Calle de San Pedro Mártir, to the Calle de Jesus y Maria, and finally to the Calle Lavapies. He visited the Prado frequently, studying the masterpieces there at the expense of his courses at the "Casona".

1898 June Madrid; he became ill with scarlet fever.

1898 Mid-June He returned to Barcelona frustrated and exhausted.

1898 Late June He went to Horta de Ebro, travelling there by train as far as Tortosa and the rest of the way on horseback. He went with a friend Manuel Pallarés who was a native of the village and who owned a house there (in the higher part at no. 11 Calle de Grau). The village of Horta de Ebro is situated in the middle of the province of Tarragona, 500 metres above sea-level. In 1919 it was renamed San Juan.

1898 Summer–Winter **1899** Pablo stayed in Horta de Ebro, frequently going off for long spells into the mountains with Pallarés. He sometimes spent the night in caves, drawing and painting from nature. As a result he acquired a freedom he could never have achieved by copying Old Masters in the Prado. (Later he was to acknowledge this himself: "All that I know I learnt in Horta de Ebro".) He became so fluent in the Catalan dialect that he adopted it as if his own. It was during this period that he painted, among other things, the picture *Aragonese Customs*; this was awarded the medal for third place at the national exhibition of fine arts in Madrid, and the gold medal at the local exhibition in Malaga.

1899 April Return to Barcelona

1899 April–December Disagreements with his family caused him to leave their house and share lodgings and a studio

 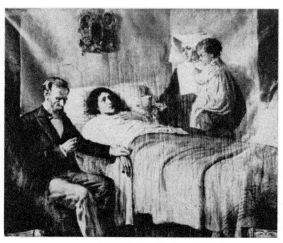

The First Communion *and* Science and Charity, *the pictures painted by Picasso at the ages of fourteen and fifteen, which were accepted for the exhibitions at Barcelona and Madrid (property of the artist).*

 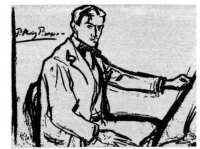

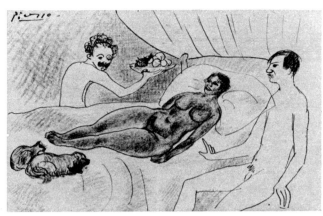

 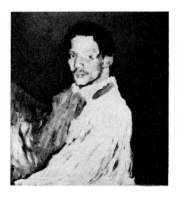 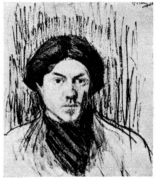 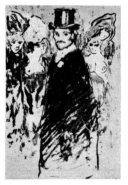

 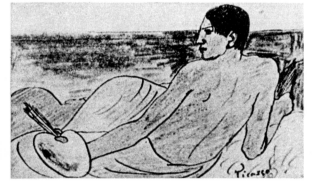

 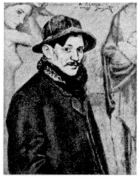

Portraits of Picasso until 1906. (From top to bottom, and left to right, first row.) At the age of fifteen (photograph, Barcelona 1896; self-portrait in the dress of an eighteenth-century gentleman, oil, id.; self-portrait, id.). At the age of seventeen (self-portrait at his easel, charcoal, Barcelona, 1898). (Second row.) At the age of twenty (self-portrait with Sebastián Junyer Vidal in the Parody of Manet's "Olympia", ink and coloured pencil, Barcelona, 1901; self-portrait, charcoal, id.; portrait painted by Ramón Casas, published in Pèl i Ploma, 14–17 June 1901). (Third row.) At the age of twenty (self-portrait in front of the Moulin-Rouge, ink and coloured pencil, Paris 1901; self-portrait: "Yo Picasso", oils id.; self-portrait, chalk and watercolour, id.; self-portrait in top hat, oils, id.). (Fourth row.) At the age of twenty (self-portrait with beard, id.); at twenty-one (self-portrait on the beach, ink and coloured pencil, Barcelona 1902) and at twenty-two (self-portrait with moustache, ink and watercolour, id., 1903). (Bottom row.) At the same age (self-portrait with moustache, ink, 1903), at the age of twenty-three (portrait in front of his picture Life [no. 89] painted by Sebastián Junyer Vidal, Barcelona 1904; photograph, Paris 1904) and at twenty-five (self-portrait, in Paris 1906).

with other artists. Finally he lived in a small room in a studio belonging to the brother of the sculptor José Cardona y Turró, at no. 1 Calle de Escudillers Blancs. Mateu Fernández de Soto brought the young poet Jaime Sabartés (1881–1968) to visit him there. Sabartés was to remain in close contact with Picasso for the rest of his life; for many years he was his private secretary. At this time he was living in considerable poverty among the young Bohemian intellectuals of Barcelona. He frequented "Els 4 Gats" where he made many new acquaintances and friends including Rafael Moragas, Ramón Pitxot and the brothers Ramón and Cinto Reventós. He joined a literary circle which met on Sunday afternoons at the house of Carlos Casagemas and in the evenings at that of Juan Vidal Ventosa. He stayed at a brothel for a few weeks where he decorated the walls of his room.

1900 Barcelona: at the beginning of the year he moved with Carlos Casagemas to a new studio at no. 17 Calle della Riera de Sant Joan, where he stayed until the end of September. The studio was bare; on its walls Picasso painted the furniture it lacked. It was a period of intense activity; he made a living by giving drawing lessons.

1900 1 February A one-man show of his drawings and paintings was opened in the exhibition room of "Els 4 Gats" They consisted largely of portraits of well-known Barcelona characters, executed in pencil, charcoal or water-colour, the subjects included the painters Santiago Rusiñol and Joaquín Mir; and his friends Jaime Sabartés, Cinto Reventós, Juan Vidal Ventosa, Angel and Mateu Fernández de Soto, Alejandro Riera, etc. Some of these were bought, largely by the subjects themselves, for one or two pesetas each.

1900 3 February The Barcelona newspaper *Vanguardia* published a long review of his exhibition at "Els 4 Gats". The review was unsigned but was probably written by Rodriguez Codolá, a professor at La Lonja.

1900 12 July The review *Joventut* (Barcelona, no. 22 page 345) published an illustration of Picasso's for the first time. This illustration was for Juan Oliva Bridgman's short poem *El clam de les verges*. This was followed by a second illustration on 16 August for another poem of Bridgman's, this time entitled *Ser o no ser*.

1900 6 September The review *Catalunya Artística* (Barcelona, no. 13 page 208) published one of his portraits of the poet Antón Busquets y Punset, and on 4 October (no. 17 page 268) an illustration of his for the story *La loca* by Suninyac Senties was published. However other drawings submitted to various periodicals were rejected including one Picasso sent to the review *L'Esquella de la Torratxa*.

1900 Late October Picasso made his first trip to Paris with Carlos Casagemas and Manuel Pallarés. He stayed with the

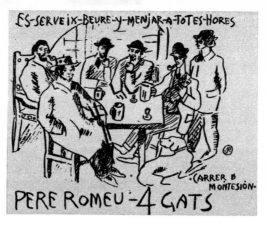

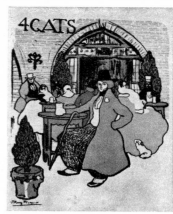

Barcelona painter Isidro Nonell in his studio at 49 Rue Gabrielle. It was during this first period in Paris that Picasso altered his signature from "Pablo Ruiz Picasso" or "P. Ruiz Picasso", to "Pablo R. Picasso" or "P. R. Picasso".

1900 December He returned to Barcelona with Carlos Casagemas.

1900 30 December–January **1901** Picasso visited Malaga with Casagemas in an attempt to get over an unhappy love affair.

1901 January Picasso arrived in Madrid and took lodgings in an attic in no. 4 Calle Caballera de Gracia, but later moved to Calle Zurbaran. He began to adopt the straightforward and definitive signature "Picasso".

1901 February Carlos Casagemas returned alone to Paris, and in despair over an unhappy love affair took his own life in the café "L'Hippodrome" in the Boulevard de Clichy.

1901 31 March Issue of the first of five published numbers of the Madrid review *Arte Joven*, begun and edited by the Catalan writer Francisco de Assis Soler, and illustrated by "Pablo Ruiz Picasso".

1901 Mid-May The experiment of *Arte Joven* failed and Picasso returned to Barcelona.

1901 25 June–14 July An exhibition of Picasso's pastels, executed mostly in Paris, was held in the Sala Parés, the most important gallery in Barcelona. The exhibition was promoted by the review *Pèl i Ploma*.

1901 Review by Miguel Utrillo (under the pseudonym of "Pincell") of the exhibition at the Sala Parés; this appeared in the June number of *Pèl i Ploma*, whose issue was delayed (see page 9).

1901 Mid-June Picasso made his second visit to Paris at the invitation of Pedro Manyac, a young Catalan who lived in Paris and was involved in the world of commercial art. He offered Picasso a contract giving him 150 francs a month in return for exclusive rights to the whole of Picasso's output. He also guaranteed him an exhibition with the important dealer Ambroise Vollard. Manyac installed Picasso, with his friend Jaime Andreu Bonsons who had come with him to Paris, in a studio at no. 130C Boulevard de Clichy, close to the café in which Carlos Casagemas had committed suicide four months earlier.

1901 25 June–14 July Paris: Exhibition at the Galeries Vollard of "Tableaux de F. Iturrino and P. R. Picasso": the latter was represented by 64 paintings, largely in oil, and an unspecified number of drawings. In the exhibition catalogue, which included a preface by the playwright Gustave Coquiot, various pictures appeared as already sold, and the names of the buyers are given (Fabre, Ackermann, Personnas, Virenca, Sainsère, Blot, Coll, Mme Besnard and Mme Kollwitz).

The literary café "Els 4 Gats" at Barcelona. (First row, left to right.) Portrait of Pere Romeu by Picasso (ink); self-portrait (in the foreground) with (from left to right) Pere Romeu, Roquerol, Fontbona, Angel Fernández de Soto, and Sabartés (ink, Barcelona 1902);

Development of Picasso's signature. (From top to bottom.) "Pablo Ruiz ' Picasso", used until October 1900; "P. Ruiz Picasso" or "P.R.Picasso", at the end of 1900, and the final "Picasso", from January 1901.

Many others were sold during the exhibition. Max Jacob visited the exhibition and was interested in getting to know the painter; their friendship dates from this time.

1901 15 July An article by Félicien Fagus, "L'invasion espagnole: Picasso", appeared in the *Revue Blanche* (see page 9).

1901 September A brief review of the exhibition at the Galeries Vollard, signed by François Charles, appeared in the review *L'Ermitage* (see page 9). Picasso met André Salmon at this time.

1901 October Jaime Sabartés arrived in Paris, and was met at the Gare d'Orsay by Picasso (who had now grown a beard).

1901 Autumn The so-called Blue Period of Picasso's work began in Paris with the painting *Seated Child* (no. 19), and the portraits of Jaime Sabartés (no. 22) and Mateu Fernández de Soto (no. 23). This period was to continue until the spring of 1904.

1902 January Picasso returned to Barcelona. In view of his straightened circumstances he went to live with his family, with whom he had become completely reconciled, in the Calle de la Merced. He rented a studio at no. 6 Calle del Conde de Asalto with his friend Angel Fernández de Soto.

1902 Winter–Spring Period of financial difficulties. Picasso frequented the "Guayaba" (Walhalla), a group which met at the studio of the engraver Juan Vidal Ventosa at no. 4 Plaza de l'Oli. Members of the circle included Cinto Reventós (who later became one of the most famous doctors in Barcelona), the narrator Ramón Reventós, the essayist Eugenio d'Ors, the painter Isidro Nonell and the brothers Fernández de Soto. Picasso executed a poster of Harlequin and Columbine for a certain Lecitina Agell and designed a card announcing the birth of their son for Pere and Corina Romeu. His precarious financial position was relieved somewhat by a friend of his, a tailor, J. M. Soler called "Retallet": this man had a shop in the Plaza Santa Maria and sometimes commissioned works from promising young artists and provided clothes in exchange for drawings and paintings.

1902 1–15 April Pedro Manyac organised an exhibition of "Tableaux et pastels de Louis Bernard-Lemaire et de Picasso" at the Galerie Berthe Weill at no. 25 Rue Victor-Massé. Picasso exhibited fifteen paintings which he had left in the care of Manyac on his departure for Barcelona the previous January.

1902 April Jaime Sabartés also

poster designed by Picasso, showing the entrance to "Els 4 Gats" (Barcelona 1899). (Second row.) The interior of the restaurant (photograph); another interior, with the brothers de Soto (far left and right, and Pere Romeu in the centre (photograph).

returned to Barcelona.

1902 2–15 June A "Group Exhibition" was held in Paris again at the Galerie Berthe Weill, including works by Matisse and Picasso's picture *Grand Prix d'Auteuil*, which had been left in the case of Manyac. The catalogue contained a preface by Emile Seyden.

1902 Summer In Barcelona Picasso produced a poster for "Els 4 Gats".

1902 1 September A review by Félicien Fagus of the exhibition held at the Galerie Berthe Weill the preceeding April, appeared in the *Revue Blanche* in Paris.

1902 September Picasso's third visit to Paris accompanied by Sebastián Junyer Vidal. They stayed first in the Hôtel du Maroc (now the Hôtel Louis XV), then at the Hôtel des Ecoles in the Rue Champollion. Picasso finally shared a room with Max Jacob on the fourth floor of a house in the Boulevard Voltaire, which faced the "Paris-France" dress shops where Jacob was working. It was a time of great hardship; they had only one bed and Picasso was forced to work during the night while Jacob slept, and sleep during the day when Jacob went to work in the shop.

1902 15 November–15 December "Exposition: Peintures, pastels et dessins de MM. Girieud, Launay, Picasso et Pichot" again at the Galerie Berthe Weill. Picasso was represented by nine pictures and various drawings. The catalogue opened with a preface signed by "Harlor".

1902 December A review by the symbolist poet Charles Morice, the friend of Gauguin, of the exhibition at the Galerie Berthe Weill (see page 10), appeared in the *Mercure de France*.

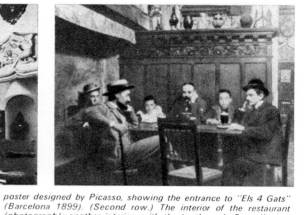

1902 December–January **1903** Exhausted by hardship and cold Picasso decided to return to Barcelona (in Paris he had had to burn numerous works — drawings, watercolours and gouaches in order to heat his room). He succeeded in selling a poster to Mme Besnard, one of his clients (possibly the *Mother and Child on the Sea Shore* [no. 36]) and with the sixty francs he received for it, he bought his railway ticket. He left for Barcelona leaving all his works which had escaped burning in the care of his friend Pichot.

1903 Late January Picasso returned to Barcelona and again stayed with his family in Calle de la Merced and used the studio at no. 17 Riera de Sant Joan, which he had shared with Carlos Casagemas. This time he shared it with Angel Fernández de Soto, called "Patas". He stayed there until the end of the year.

1903 Barcelona: the Blue Period continued. Picasso began to enjoy a certain success.

1904 New Year Picasso succeeded in obtaining his own studio in the Calle del Comercio; and also his own room in the same street where he moved leaving his family's house.

1904 January–April Among other works Picasso decorated the walls of Jaime Sabartés' studio in Barcelona which was situated on the top floor of no. 37 Calle del Consulado. The decoration (now lost) included a virile negro hanging upside down from a tree under which a naked couple were embracing, recalling a current performance of *Othello* in Barcelona given by Ermete Zacconi.

1904 April Picasso returned to Paris again with Sebastián Junyer Vidal: this time he settled there permanently. He

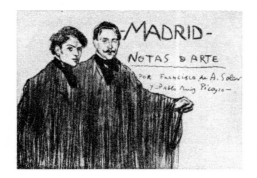

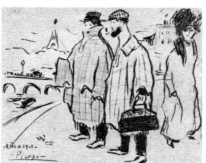

lived in a dilapidated tenement at no. 13 Rue de Ravignan in Montmartre, where his friend, the sculptor Paco Durio was already living. Also lodging there were Kees van Dongen, Pierre Mac Orlan, André Salmon, Max Jacob and Jacques Vaillant. Max Jacob later christened the house "Le Bateau Lavoir" ("The Floating Laundry") and it became a very lively gathering place for young artists. Picasso stayed there until October 1909. The Blue Period came to an end.

1904 Picasso became a friend of a young woman, Fernande Olivier, who also lived in the "Bateau Lavoir". His relationship with her lasted until 1912. She appears in nos. 154, 247–251, 265, 295 and 303 of the *Catalogue*. He executed the engraving *A Frugal Repast*.

1904 24 October–20 November "Exposition de peintures, aquarelles, pastels et dessins par MM. Charbonnier, Clary-Baroux, Dufy (Raoul), Girieud, Picabia, Picasso, Thiesson", at the Galerie Berthe Weill. Picasso was represented by eleven pictures and various drawings, all prior to 1904, except for a drawing entitled *The Fool*. The catalogue included a preface by Maurice Le Sieutre.

1904 10 December In the fifth issue of the review *El poble català* there appeared a forecast about Picasso by Eugenio d'Ors (see page 10).

1905 The so-called Rose Period of Picasso's art began with the picture *The Actor* (no. 154). Picasso and his friends began smoking opium in the studio at the "Bateau Lavoir", but gave it up when one of them, the German painter Wiegels, became an addict. Picasso became a friend of Guillaume Apollinaire and also of the rich Americans Leo and Gertrude Stein, who bought pictures from him for eight hundred francs (see nos. 229 and 306). Picasso produced his series of dry points and etchings of acrobats but a limited printing of them, edited by Delâtre, had little success. The originals were later bought

Friends of the young Picasso. (From top to bottom and left to right; first row.) Self-portrait with Francisco de Asís Soler (publicity drawing in Arte Joven, *Madrid, June 1901); self-portrait with Jaime Andreu Bonsons on their arrival in Paris in June 1901 (ink and coloured pencil). (Second row.) Portrait of Manuel Pallarés (ink, Barcelona 1895); portrait of Carlos Casagemas (charcoal, Barcelona 1900). (Third row.) Portrait of Angel Fernández de Soto (ink and watercolour, Barcelona 1900); portrait of Jaime Sabartés (charcoal and watercolour, Barcelona 1899–1900); portrait of Miguel Utrillo (part of a pen and coloured pencil drawing, Barcelona 1902). (Fourth row.) Portrait of Pedro Manyac (oils, Paris 1901); portrait of Max Jacob (ink, Paris 1904–5); portrait of Guillaume Apollinaire (ink and charcoal, Paris 1905). (Bottom row.) The "Bateau-Lavoir" (photograph, 1905); Fernande Olivier, Picasso and Ramón Reventós at Barcelona (photograph 1906).*

by Ambroise Vollard who had them steel-faced and re-printed them in 1913, together with the *Frugal Repast* of 1904, in a limited edition of 279 copies.

1905 25 February–6 March In Paris, "Exposition des peintres Trachsel, Gérardin, Picasso" took place at the Galerie Serrurier, 37 Boulevard Haussman. Picasso exhibited twenty-eight pictures, six engravings (of acrobats) and a portfolio of drawings, all recent works, executed in 1904 or the first two months of 1905. The catalogue opened with a preface by Charles Morice (see page 10).

1905 Charles Morice also reviewed the Exhibition at the Galerie Serrurier in the *Mercure de France* (see page 10).

1905 *La Revue Immoraliste* published an article by Guillaume

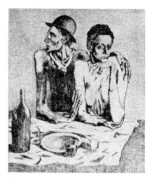

The Frugal Repast *(etching, Paris 1904).*

Apollinaire, "Picasso, peintre et dessinateur" (see p. 11). Another article by Guillaume Apollinaire in the review *La Plume*, "Les jeunes: Picasso peintre" (see p. 11).

1905 Summer Picasso visited Holland as the guest of the writer Tom Schilperoort.

1905 Autumn Picasso met Henri Matisse through Gertrude Stein.

1906 Late April Picasso went to Barcelona with Fernande Olivier.

1906 May–August He stayed with Fernande Olivier in the medieval village of Gósol, at an altitude of 1500 metres in the province of Lérida. They stayed in the Can Tempanada Inn. Picasso did a great deal of work there mostly drawings and gouaches but also a few paintings: among them "*La Toilette*" and *The Harem* (nos. 270 and 274). It was at this time that he produced the album of sketches known as the *Carnet catalán* published in facsimile in 1958 by Berggruen & Co., with notes by Douglas Cooper (see nos. 239, 254, 255 and 265). The original is in the possession of the author.

1906 Mid-August An epidemic of typhoid broke out and Picasso and Fernande Olivier left Gósol for Paris.

1906 Autumn End of the Rose Period. The novel *Sandricourt* by Eugène Marsan appeared, in which a reference to Picasso testifies to the popularity he had achieved before his Cubist phase (see page 11).

Catalogue of works

The present *Catalogue* lists the pictorial works of Picasso between 1901 and 1906.

In the period we are concerned with at the beginning of his working life, his work can be broadly grouped into two "periods", both stylistically and chronologically: first the Blue Period which lasted roughly from the autumn of 1901 to the spring of 1904 — and then the Rose Period whose development can be traced between the early months of 1905 and the autumn of 1906.

Of the three hundred and seven works described in this book, the one hundred and twenty-four pictures here catalogued from no. 19 to no. 142 are assignable to the first period; while the hundred and thirty-two, here catalogued from no. 158 to no. 289, can be classified as belonging to the second. These include all the known works. However the catalogue also lists works which do not strictly belong to either period — the first eighteen pictures described here precede those which are truly of the Blue Period; the fifteen from no. 143 to no. 157 illustrate the transition between the two phases belonging absolutely to neither, and the final eighteen works here, catalogued as no. 290 to no. 307, were painted after the conclusion of the true Rose Period and herald the beginnings of a new stylistic approach. There are also another fifty-one pictures included here, which cannot strictly be classified as belonging to either of the two periods, but which nevertheless are relevant in some way.

In the years with which we are concerned, there is a definite Pre-Blue Period which is already Blue in some way, and a Post-Rose Period which is still Rose in certain respects; and there are also pictures which demonstrate characteristics of both periods yet belong to neither. It is also impossible to impose absolute limits chronologically; since quite often a painting is quite different in mood from those executed before and after — which may be similar in both style and feeling and can quite naturally be grouped together.

In the *Catalogue*, as we have said, the entire known output of Picasso relevant to the Blue and Rose Periods is listed. This does not, however, exclude the possibility that he executed other relevant works in the early years of the century; which for one reason or another have remained unknown, possibly in the artist's own possession.

We have also said "pictorial works". In fact although drawings (executed without any subsidiary media in pencil, charcoal or pen) and etchings have been excluded, the term "pictorial" has nevertheless been interpreted in a very wide sense. It includes not only oils and tempera (i.e. gouaches) but also pastels, watercolours and works executed in mixed media, as well as drawings heightened with colour. Several drawings have also been included in the *Catalogue* and reproduced, whenever they seem in some way relevant to the paintings, or capable of being related to them.

1 🌀 82 / 66 ▤ Paris 1901 ⋮

Portrait of Jaime Sabartés
Moscow, Pushkin Museum.
Previous owners: Kahnweiler, Paris; Shchukine, Moscow; Museum of Modern Western Art, Moscow.
Exhibitions: 54 P, 66 P.
Bibliography: R 21, Z 32 no. 97, S 46–53, CP 50, B 55, KP 55, P 58, D 64, DB 66 VI no. 19.

Jaime Sabartés, in his *Picasso, Retratos y recuerdos*, relates:
"Without knowing it, I was serving as a model for a picture. . . . Picasso finished painting me as he saw me at the café. The canvas was turned towards the wall when I entered. In the mirror over the easel, I was surprised to see myself just as he had caught me unaware, in a fleeting moment of my journey through life. I saw myself, I gazed at myself fixed upon the canvas, and I understood what I had suggested to the restless observation of my friend: the vision of my solitude, seen from without. The look is lost in a gloom which it does not succeed in penetrating, the thought wanders uncertainly; and both the look and the thought unite in losing themselves in vacuity, because the eyes, myopic and blank, do not see, and the thought does not reveal itself in the look. The effect upon me of looking at myself in this marvellous blue mirror was profound: it was as if the waters of a great lake retained something of myself because I found my reflection in it."

2 🌀 63 / 46 ▤ Paris 1901 ⋮

Portrait of Mateu Fernández de Soto
Winterthur, Oskar Reinhart Foundation.
Previous owner: Private collection, Hamburg.
Bibliography: Z 32 no. 94, S 48–55, CP 50, DB 66 VI no. 21.

3 🌀 80 / 60,5 ▤ Paris 1901 ⋮

Harlequin Leaning on his Elbow
New York, Metropolitan Museum of Art.
Previous owners: Suermondt, Aachen; Neuer Kunstsalon, Munich; Quinn, New York; Anderson, New York; McIlhenny, Philadelphia (Pa.); Clifford, Radnor (Pa.); Loeb, New York.
Exhibitions: 13 M, 36 NY, 38 B, 39 NY, 59 M.
Bibliography: Z 32 no. 79, S 38, B 39, M 42–48, B 46, L 52–54, EM 55, P 58, C 59, DB 66 VI no 22.

It would appear that the signature and date were added by the artist in 1927. See Plate I. The painting was given to the Metropolitan by Mrs Loeb.

4 🌀 73 / 60 ▤ Paris 1901 ⋮

Harlequin and his Companion
Moscow, Pushkin Museum.
Previous owners: Vollard, Paris; Morosov, Moscow; Museum of Modern Western Art, Moscow.
Exhibitions: 54 P.
Bibliography: Z 32 no. 92, S 48–55, KP 55, D 60, D 64, DB 66 VI no. 20.
Bought in 1908 for 300 francs.

5 🌀 73 / 54 ▤ Paris 1901 ⦂

Child Holding a Dove
London, The Dowager Lady Aberconway Collection.
Previous owners: Rosenberg, Paris; Reid, London; Workman, London; Courtauld, London.
Exhibitions: 60 L, 64 T, 66 P.
Bibliography: L 28, Z 32 no. 83, S 48-55, CP 50, B 55, EM 55, C 58, J 64, K 65, DB 66 VI no. 14.
See plate II.

6 🌀 41,5 / 33 ▤ Paris 1901 ⦂

Woman in a Bonnet
Property of the artist.
Bibliography: Z 32 no. 101, C 40, DB 66 VI no. 12.

7 🌀 81,5 / 54 ▤ Paris 1901 ⦂

Exhausted Nude
Paris, Private collection.
Previous owners: Vollard, Paris; Joseph von Sternberg, Hollywood; Sarlie, New York; Maguy, Paris.
Bibliography: Z 32 no. 104, DB 66 VI no. 18.
Sold at Parke-Bernet's, New York in 1949 for $3,500 and at Sotheby's, London, on 12 October 1960 for £30,000.

8 🌀 46,5 / 33 ▤ Paris 1901 ⦂

Nude with Bathrobe
Property of the Artist.
Bibliography: Z 32 no. 102, M 42-48, DB 66 VI no. 13.

9 🌀 51 / 62,5 ▤ Paris 1901 ⋮

The Blue Room
Washington, DC, Phillips Collection.
Previous owners: Uhde, Paris; Bignou, Paris; Reid, London.
Exhibitions: 36 NY, 39 NY, 47 NY.
Bibliography: Z 32 no. 103, B 39, B 46, L 52-54, R 53, B 55, EM 55, P 58, DB 66 VI no. 15.

The painting depicts Picasso's studio in the Boulevard de Clichy. On the back wall, at the right-hand side, is a poster done by Toulouse-Lautrec for May Milton.

10 🌀 75 / 51 ▤ Paris 1901 ⋮

Woman with a Chignon
Cambridge (Mass.), Harvard University, Fogg Art Museum.
Previous owners: Quinn, New York; Bakwin, New York; Wertheim, New York.
Exhibitions: 36 NY.
Bibliography: Z 32 no. 96, DB 66 VI no. 23.

On the back of the canvas is the oil-painting *Child in a Bonnet*, painted shortly before.

11 🌀 73 / 54 ▤ Paris 1901 ⋮

The Aperitif
Leningrad, Hermitage.
Previous owners: Shchukine, Moscow; Museum of Modern Western Art, Moscow.
Bibliography: Z 32 no. 98, S 48-55, CP 50, KP 55, DB 66 VI no. 24.

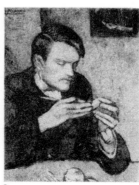

1

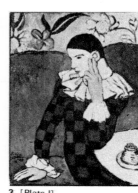

2

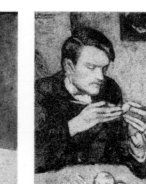

3 [Plate I]

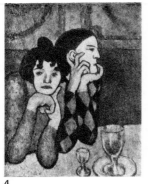
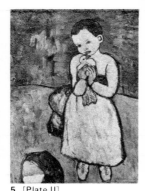

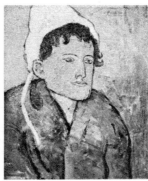
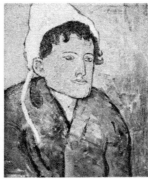

4

5 [Plate II]

6

7

8

9

13

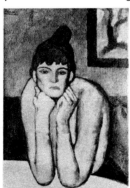
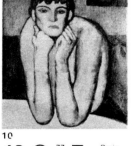
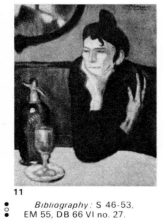
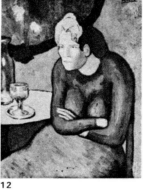
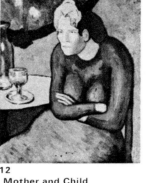
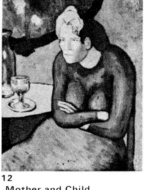
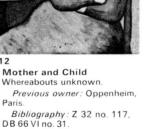

10

11

12

19

20

17 ⊗ 46,5/31 ▤ Paris 1901

Mother and Child
Küsnacht, Private collection.
Previous owners: Thannhauser, Munich; Laya, Geneva; Georg Reinhart, Winterthur.
Exhibitions: 32 Z.
Bibliography: Z 32 no. 110, CP 50, DB 66 VI no. 29.
Sold by the Peau de l'Ours, Paris, on 2 March 1914, for 1,350 francs.

18 ⊗ 91,5/60 ▤ Paris 1901

Mother and Child
Los Angeles (Cal.), Goetz Collection.
Previous owners: Vollard, Paris; Bernheim de Villiers, Paris; Salz, New York.
Exhibitions: 32 P, 32 Z, 60 L.
Bibliography: Z 32 no. 109, CP 50, G 51, B 55, EM 55, K 65, DB 66 VI no. 28.
See Plate III.

19 ⊗ 65/54,5 ▤ Paris 1901

Seated Child
Merion (Pa.), Barnes Foundation.
Bibliography: Z 32 no. 116, K 65, DB 66 VI no. 32.
This is the first painting which can be ascribed without qualification to the Blue Period.

20 ⊗ 52/60 ▤ Paris 1901

Woman with a White Mantilla
New York, Lasker Collection.
Previous owners: Guillaume, Paris; Mme Walter, Paris.
Bibliography: Z 54 no. 733, DB 66 XV no. 42.
Acquired by the present owner in 1950, for $22,000.

21 ⊗ 81/60 ▤ Paris 1901

Self-Portrait with Cloak
Property of the Artist.
Exhibitions: 32 P, 32 Z, 60 L, 66 P.
Bibliography: Z 32 no. 91, CP 50, G 51, S 54, EM 55, P 58, D 61, BP 62, B 64, DB 66 VI no. 35.

22 ⊗ 44,5/37 ▤ Paris 1901

Portrait of Jaime Sabartés
Property of the Artist.
Bibliography: Z 32 no. 87, M 42-48, S 46-53, DB 66 VI no. 34.

23 ⊗ 45/37 ▤ Paris 1901

Portrait of Mateu Fernández de Soto
Property of the Artist.
Bibliography: Z 32 no. 86, CP 50, DB 66 VI no. 33.

24 ⊗ 63,5/50 ▤ Barcelona 1902

Crouching Woman
Stockholm, Nathhorst Collection.
Previous owners: Vollard, Paris; Lewisohn, New York; Sarlie, New York.
Exhibitions: 36 NY.
Bibliography: Z 32 no. 160, R 53, DB 66 VII no. 4.
Sold at Sotheby's, London, on 12 October 1960 for £48,000.

12 ⊗ 77/61 ▤ Paris 1901

The Absinthe Drinker
Geneva, Obersteg Collection.
Previous owners: Bollag, Zurich.
Bibliography: Z 32 no. 100, C 40, CP 50, DB 66 VI no. 25.
On the back of the canvas is the oil-painting *Woman in a Theatre Box*, painted shortly before.

13 ⊗ 49,5/25,5 ▤ Paris 1901

The Laundress
New York, Metropolitan Museum of Art, Stieglitz Collection.
Previous owners: Sabartés, Paris; Stieglitz, New York.

Bibliography: S 46-53, EM 55, DB 66 VI no. 27.
The dedication in the top right-hand corner reads: "a Jacobus Sabartés".

14 ⊗ 100/73 ▤ Paris 1901

Mother and Child
Paris, Niarchos Collection.
Previous owners: Vollard, Paris; Schmits, Wuppertal; Thannhauser, New York; Kirkeby, New York.
Bibliography: K 65, DB 66 X no. 9.

15 ⊗ 92/65 ▤ Paris 1901

Mother and Child
Whereabouts unknown.
Previous owner: Oppenheim, Paris.
Bibliography: Z 32 no. 117, DB 66 VI no. 31.

16 ⊗ 110,5/96,5 ▤ Paris 1901

Mother and Child
Cambridge (Mass.), Harvard University, Fogg Art Museum.
Previous owners: Quinn, New York; Fukushima, Paris; Wertheim, New York.
Exhibitions: 39 NY.
Bibliography: D 30, Z 32 no. 115, B 39, B 46, CP 50, B 55, P 58, BP 62, K 65, DB 66 VI no. 30.

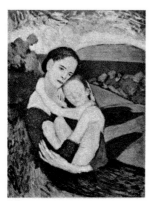
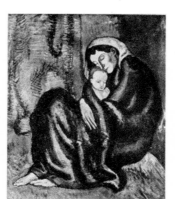
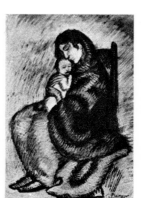
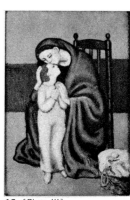

88

14

15

16

17

18 [Plate III]

25 ⊘ 101/66 ▤ Barcelona 1902 ⋮

Crouching Beggar
Toronto, Art Gallery.
Previous owners: Thann-hauser, Munich; Mendel, Saskatoon (Canada).
Exhibitions: 64 T.
Bibliography: Z 32 no. 121, BP 62, D 64, DB 66 VII no. 5.

26 ⊘ 90/71 ▤ Barcelona 1902 ⋮

Crouching Woman
Stuttgart, Staatsgalerie.
Previous owners: Gertrude Stein, Paris; Gaspari, Munich; Muthmann, Nassau; Nathan, Zurich.
Exhibitions: 55 M.
Bibliography: R 21, Z 32 no. 119, S 48-55, CP 50, BP 62, DB 66 VII no. 2.
On the back of the canvas is painted the gouache *Mother and Child* of 1905 (no. 167).

27 ⊘ 80/62 ▤ Barcelona 1902 ⋮

Sleeping Drinker
Glarus (Switzerland), Huber Collection.
Previous owners: Gertrude Stein, Paris; Troplowitz, Hamburg; Kunsthalle, Hamburg.
Exhibitions: 53 M.
Bibliography: Z 32 no. 120, CP 50, EM 55, DB 66 VII no. 3, P 66.
This picture which was con-fiscated by the Nazis in 1937, was auctioned on 30 June 1939 at the Fischer Gallery of Lucerne in the sale of pictures and sculptures by modern masters from German museums, and was bought for 80,000 Swiss francs. See Plate IV.

28 ⊘ 100/69 ▤ Barcelona 1902 ⋮

Seated Woman with a Scarf on her Shoulders
Detroit (Mich.), Private collection.
Previous owner: Guillaume, Paris.
Exhibitions: 32 P, 32 Z, 36 NY.
Bibliography: Z 32 no. 133, S 48-55, CP 50, DB 66 VII no. 6.

29 ⊘ 81/60 ▤ Barcelona 1902 ⋮

Seated Woman with Arms Crossed
Chicago (Ill.), McCormick Collection.
Previous owner: Private collection, Berlin.
Exhibitions: 32 Z, 36 NY, 39 NY.
Bibliography: R 21, Z 32 no. 105, B 39, B 46, S 48-55, CP 50, Z 54 no. 543, DB 66 VII no. 7.

30 ⊘ 60/49 ▤ Barcelona 1902 ⋮

Portrait of Corina Romeu
Property of the Artist.
Exhibitions: 32 P, 32 Z, 66 P.
Bibliography: Z 32 no. 130, CP 50, G 51, EM 55, DB 66 VII no. 15.
Corina was the wife of the painter Pere Romeu, landlord of the literary café of Barcelona "Els 4 Gats". See Plate V.

31 ⊘ 46/41 ▤ Barcelona 1902 ⋮

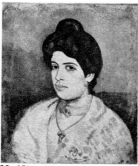

30 [Plate V]

Portrait of Germaine Pichot
New York, Jonas Collection.
Previous owner: Guillaume, Paris.
Bibliography: DB 66 VII no. 8.
The subject was the wife of the Catalan painter Ramón Pichot.

32 ⊘ 60/49 ▤ Barcelona 1902 ⋮

Woman with a Fringe
Baltimore (Md.), Museum of Art, Cone Collection.
Previous owners: Gertrude Stein, Paris; Cone, Baltimore.
Bibliography: R 21, Z 32 no. 118, S 48-55, DB 66 VII no. 10.

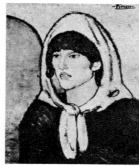

31

33 ⊘ 65/54 ▤ Barcelona 1902 ⋮

Woman with a Scarf on her Shoulders
Property of the Artist.
Exhibitions: 32 P, 32 Z, 66 P.
Bibliography: Z 32 no. 155, DB 66 VII no. 9.

34 ⊘ 37/45 ▤ Barcelona 1902 ⋮

The Offering
Toronto, Crang Collection.
Previous owners: Gertrude Stein, Paris; Sternheim, Paris; Von Ripper, Paris; Knoedler, New York.
Exhibitions: 47 NY, 64 T.
Bibliography: Z 32 no. 131,

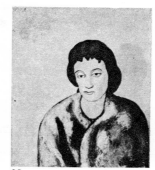

32

Some preliminary drawings of this picture are known, which present three variations on the theme. In the first, 34 A (Z 32 no. 192, pencil, 24 × 29·5 cm), a small sheet with more sketches, the offering is given by a man, and the scene in the background conceived with three people. In the second, 34 B (DB 66 VII no. D1, Indian ink, 25 × 26 cm, signed and dated 1902), to which Daix and Boudaille gave the title *L'Offrande*, a man and a young girl are depicted. In the third, 34 C, and the fourth, 34 D (Z 54 nos. 418 and 420, both pen drawings and 24 × 24 cm

S 38, S 48-55, CP 50, K 65, DB 66 VII no. 11.

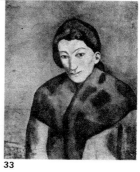

33

and 24 × 19 cm respectively), the offering is made by a woman to a little boy and a little girl. The second belongs to Berggruen, Paris; the where-abouts of the other three is not given by Zervos.

35 ⊘ 40.5/33 ▤ Barcelona 1902 ⋮

Mother and Child
Edinburgh, Scottish National Gallery of Modern Art.
Previous owners: Gaffé, Brussels; Berggruen, Paris; Tooth, London; Maitland, Edinburgh; National Gallery of Scotland, Edinburgh.
Bibliography: DB 66 VII no. 18.
See Plate VI.

36 ⊘ 46/31 ▤ Barcelona 1902 ○○

Mother and Child on the Seashore
Whereabouts unknown.
Previous owners: Besnard, Paris; Rosenberg, Paris.
Exhibitions: 32 Z.
Bibliography: Z 32 no. 381, CP 50, DB 66 VII no. 21.
This is probably the pastel painting which Picasso succeeded in selling in January 1903 in Paris, to a certain Mme Besnard, the wife of a paint merchant (and already a client of his since his first exhibition at Vollard's in June–July 1901), for sixty francs, with which he was able to buy his railway ticket and return to Barcelona.

37 ⊘ 83/60 ▤ Barcelona 1902 ○○

Mother and Child on the Seashore
New York, Private collection.
Previous owners: Fontbona, Barcelona.
Bibliography: CP 50, Z 54 no. 478, K 65, DB 66 VII no. 20.
The dedication, not in Picasso's hand, is to "Dr Fontbona". Sold at Sotheby's, London, on 26 April 1967, for £190,000, the largest sum ever realised for a work by a living artist. A drawing, 37 A, in ink and coloured pencil on a sheet of notepaper, 14 × 9 cm, dating from the same period, and signed over the cancellation of a previous signature of doubtful authenticity (Z 32 no. 151 and DB 66 VII D 9; *Miséreuse au bord de la mer*; CP 50: *Mendiante à la plage*), is reminiscent of this picture. The former property of Junyer Vidal, Barcelona, it now belongs to Gustave Kahnweiler, London.

38 ⊘ 46.5/38 ▤ Barcelona 1902 ○○

Farewell to the Fisherman

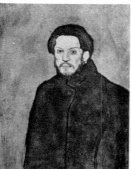

21

22

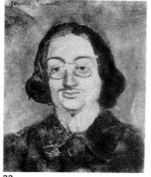

23

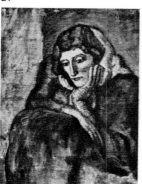

24

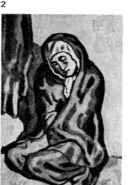

25

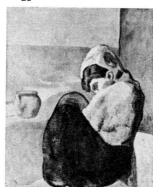

26

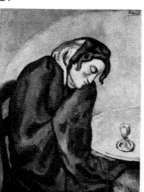

27 [Plate IV]

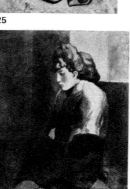

28

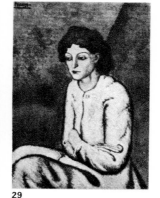

29

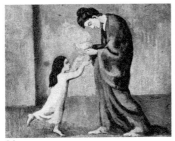
34

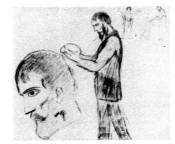
34 A

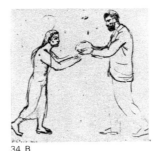
34 B

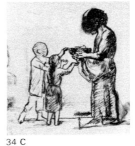
34 C

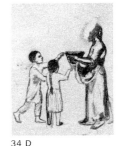
34 D

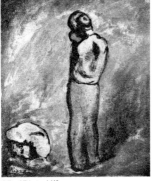
35 [Plate VI]
Küsnacht, Private collection.
Previous owner: Doetsch-Benzinger, Basle.
Bibliography: DB 66 VII no. 19.

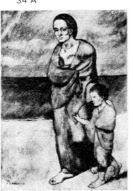
36

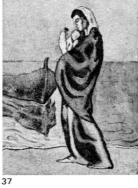
37

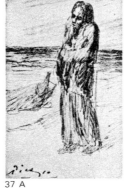
37 A

39 A

39 B

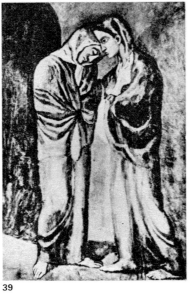
39

40

40

41

Column 1

39 ⊘ 152/100 ▤ Barcelona 1902

The Two Sisters
Leningrad, Hermitage.
Previous owners: Shchukine, Moscow; Museum of Modern Western Art, Moscow.
Exhibitions: 64 T.
Bibliography: Z 32 no. 163, CP 50, KP 55, DB 66 VII no. 22.
Two drawings for this picture are known. The first, 39 A (Z 54 no. 436; DB 66 VII no. D 4), in sepia, 29 × 13·5 cm, with the inscription *Les deux sœurs* was formerly at the Rosengart Gallery, Lucerne; the actual whereabouts of the second, 39 B (Z 54 no. 435; DB 66 VII no. D 6), in pencil, 16 × 11 cm, is not known.

40 ⊘ 27,5/20 ▤ Barcelona 1902

Crouching Nude with Green Stocking
Paris, Private collection.
Previous owners: Gertrude Stein, Paris; Schoeller, Paris.
Bibliography: B 55, EM 55, DB 66 VII no. 16.
See also, for comparison, no. 68.

41 ⊘ 46/40 ▤ Barcelona 1902

Nude Woman from Behind
Paris, Private collection.
Previous owner: Rothschild, Paris.
Exhibitions: 53 L, 55 P.
Bibliography: CP 50, Z 54 no. 449, EM 55, D 60, B 64, DB 66 VII no. 17, P 66.

42 ⊘ 30,5/38,5 ▤ Barcelona 1902

Couple in a Café
New York, Ault Collection.
Bibliography: DB 66 VII no. 12.
Authenticated by Picasso on 3 September 1965.

Column 2

43 ⊘ 43/33 ▤ Barcelona 1902

Seated Couple from Behind
Buenos Aires, De Ganay Collection.
Exhibitions: 55 P, 55 M.
Bibliography: DB 66 VII no. 14.
Authenticated by Picasso on 3 September 1965.

44 ⊘ 80/91,5 ▤ Barcelona 1902

Two Women at a Bar
New York, Chrysler Collection.

Column 3

45 ⊘ 50,5/40,5 ▤ Barcelona 1902

The Blue House
New York, owned by the heirs of Gertrude Stein.

Previous owner: Gertrude Stein, Paris.
Exhibitions: 38 B, 39 NY, 60 L.
Bibliography: Z 32 no. 132, S 38, B 39, B 46, S 48-55, CP 50, EM 55, BP 62, DB 66 VII no. 13.
See Plate VII.

Column 4

Previous owner: Gertrude Stein, Paris.
Exhibitions: 32 P, 32 Z.
Bibliography: S 48-55, DB 66 VII no. 1.
Sold at the Peau de l'Ours, Paris, on 2 March 1914, for 550 francs.

46 ⊘ 88,5/76,5 ▤ Barcelona 1902

Man in Blue
Property of the Artist.
Exhibitions: 32 P, 32 Z.
Bibliography: L 28, Z 32 no. 142, C 40, CP 50, G 51, DB 66 VIII no. 1.

47 ⊘ 31/23,5 ▤ Paris 1902

Portrait of the Poet Cornuti with Female Figure
Whereabouts unknown.
Previous owner: Lefèvre, Paris.
Bibliography: Z 32 no. 182, CP 50, DB 66 VIII no. 2.
On the back of this watercolour the following note is handwritten by Max Jacob: "This portrait depicts a poet called Cornuty [sic] whom Picasso had known in Barcelona, and whom I too had known, emaciated and starving beneath his locks of hair; he enunciated his words in a hollow voice, and extended a slender hand with the fingers pointing forward to the infinite. He had an admiration for Flaubert, which he pronounced 'Flobert': 'If only Flobert had translated Gorki. . . .' he said to me at the time when Gorki was all the rage, about 1900. His father was the director of a store at Montpellier, and Cornuty despised him because he used to scratch himself in an indecent manner. He had abandoned his family, and armed with a cudgel, a Lavallière cravat, a cloak and a soft hat, went on foot to attend a socialist meeting in the city. There had been a gendarme to inform them to ask for alms at the farmhouses: 'There can't be all that many like him' he exclaimed, clearing his throat and placing the stress of the

Column 5

sentence on 'all that many', while the 'like him' was lost in a sort of heavy breathing. He spent a night out in the countryside, with frozen feet, and his companions of the haystacks carried him to a blacksmith's fire, 'at the risk of killing me', he said. One day he met his uncle, who went round selling lengths of cloth to the singers at the café-concerts of the period, and who invited him to dine at the Alcazar. Because his uncle had introduced him as a poet, a woman singer wished to drink a toast to 'The Arts'. I do not record Cornuty's verses, but he had written a comedy in which the leading character was an impoverished nobleman who took the part of his own valet and of himself alternately. Cornuty died at a very early age: he died of starvation, in Catalonia I think." Sold at the Peau de l'Ours, Paris, on 2 March 1914, for 400 francs.

48 ⊘ 37/46 ▤ Paris 1902

The Two Mothers
Paris, Private collection.
Previous owner: Level, Paris.
Exhibitions: 55 P.
Bibliography: Z 32 no. 180, CP 50, C 58, DB 66 VIII no. 3.
Sold at the Peau de l'Ours, Paris, on 2 March 1914, for 700 francs.

49 ⊘ 37,5/27 ▤ Paris 1902

The Mistletoe Seller
Paris, Berggruen Collection.
Bibliography: DB 66 VIII no. 5.
Indian ink and watercolour on paper. A study for the gouache is given under the following number.

50 ⊘ 55/38 ▤ Paris 1902

The Mistletoe Seller
Paris, Private collection.
Previous owner: Pellequer, Paris.
Exhibitions: 55 P.
Bibliography: Z 32 no. 123, CP 50, B 55, DB 66 VIII no. 4.

See also the previous number, as well as no. 212.

51 ⊘ — ▤ Barcelona 1903?

Prone Nude
Whereabouts unknown.
Previous owner: Dutilleul, Paris.
Bibliography: Z 54 no. 413, DB 66 X no. 7.
Dimensions unknown. Zervos gives the date as 1902 or 1903; Daix and Boudaille were inclined to date it even later than 1903. Sold by auction in Paris on 9 December 1960, for 95,000 francs.

52 ⊘ 45,5 ▤ Barcelona 55 1903

Nude Lying on her Side
Worcester (Mass.), Higgins Collection.
Previous owner: Bucher, Paris.
Bibliography: Z 54 no. 479, DB 66 X no. 8.
Executed on a canvas already painted on by others. High up in the background of the picture there was another female figure belonging to a previous picture; Picasso disowned it in May 1935, but he had already written on the back of the canvas a signed declaration: "Bien entendu ce tableau est de moi, Picasso, Paris le 17 Novembre XXXIV".

53 ⊗ 55 ▤ Barcelona 38 1903

Seated Woman
Zurich, Bollag Collection.
Exhibitions: 32 Z.
Bibliography: Z 54 no. 476, DB 66 IX no. 10.
Gouache and watercolour or glued paper.

54 ⊘ 46 ▤ Barcelona 38 1903

Profile of a Woman
Solothurn, Private collection.
Previous owner: Müller, Solothurn.
Bibliography: Z 54 no. 467, C 59, DB 66 X no. 10.
Signed on the back of the frame.

55 ⊗ 29 ▤ Barcelona 28,5 1903

Head of a Woman
New York, J.K. Thannhauser Collection.
Bibliography: Z 32 no. 206, S 48-55, DB 66 IX no. 8.

56 ⊗ 61 ▤ Barcelona 38 1903

Street in Barcelona
London, Private collection.

42

43

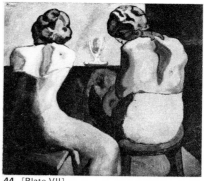

44 [Plate VII]

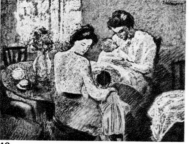

45

47

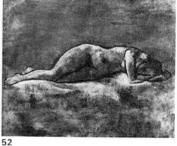

Autograph of Max Jacob on reverse of no. 47.

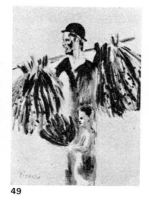

48

Previous owners: Stransky, New York; Astor, London.
Exhibitions: 60 L.
Bibliography: Z 32 no. 122, DB 66 IX no. 1.
In the background, the old Palace of Fine Arts, which was demolished in 1940 and stood in the Paseo de la Industria, opposite the Parque de la Ciudadela.

57 ⊗ 67 ▤ Barcelona 50 1903

Barcelona at Night
Zurich, Bührle Foundation.

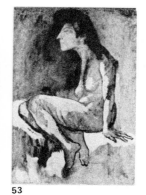

51

Previous owners: Wildenstein, Paris—New York; Schweppe, New York.
Exhibitions: 55 P, 55 M.
Bibliography: DB 66 IX no. 3, P 66.
Like the *Roofs of Barcelona* (no. 58), this also is a view from the studio in the Riera de Sant Joan; in the middle ground on the left is the roof of the Church of Santa Marta. According to a report noted in the book *Festschrift zu Ehren von Emil G. Bührle zur Eroffnung des Kunsthaus-Neubaus und Katalog der Sammlung Emil G. Buhrle*, Kunsthaus—Zurich,

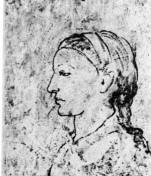

52

June—September 1958, this painting belonged originally to Picasso's mother. See Plate XI.

58 ⊗ 70 ▤ Barcelona 110 1903

Roofs of Barcelona
Property of the Artist.
Exhibitions: 32 P, 32 Z, 66 P.
Bibliography: L 28, Z 32 no. 207, CP 50, DB 66 IX no. 2.
This view, like that of the preceeding picture, was taken from Picasso's studio in the Riera de Sant Joan, which has now disappeared.
See plate X.

59 ⊗ 26 ▤ Barcelona 35 1903

Guitar Player at the Inn
Zurich, Bührle Foundation.
Previous owners: Junyer Vidal, Barcelona; Dereppe, Lugano.
Bibliography: Z 32 no. 178, CP 50, DB 66 IX no. D 18.
Indian ink and coloured pencil on card. An authentic signature; cancellation of an earlier signature of doubtful authenticity.

60 ⊗ 37 ▤ Barcelona 27 1903

46

49

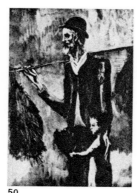

50

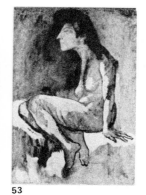

53

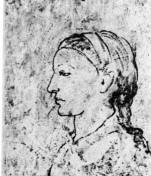

54

91

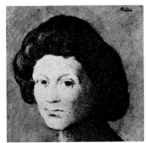

55

Peasants
Wuppertal, Von der Heydt-Museum.
Previous owners: Lefèvre, Paris; Bernados, Geneva; Von der Heydt, Ascona.
Bibliography: DB 66 IX no. D 19.
Indian ink and watercolour on yellow card. On the back, drawing of a nude woman, and sketches of figures.

61 ⊕ 26 / 35 ▤ Barcelona 1903 ⦂

Peasants Dancing the Jota
Whereabouts unknown.
Previous owner: Viñes, Paris.
Bibliography: Z 32 no. 186, DB 66 IX no. D 20.
The pair of dancers on the left appear in the *Peasants* described above. A pen and ink sketch of the man in a hood in the centre, 61 A, 29 × 12 cm (DB 66 IX no. D 21), is in the hands of a private collector in Lausanne.

62 ⊕ 31,5 / 22,5 ▤ Barcelona 1903 ⦂

Catalan Peasants
San Antonio (Tex.), Koogler McNay Collection.
Previous owners: Bignou, Paris; Quest, Chicago.
Bibliography: Z 32 no. 376, DB 66 IX no. D 16.

63 ⊕ 31,5 / 22 ▤ Barcelona 1903 ⦂

The Idiot
Zurich, Private collection.
Previous owner: Bollag, Zurich.
Bibliography: Z 54 no. 482, DB 66 IX no. D 17.
Indian ink and watercolour on paper.

64 ⊕ 31 / 22 ▤ Barcelona 1903 ⦂

Strolling Guitar Player
Turgovia (Switzerland), Private collection.
Previous owners: Bollag, Zurich; Lion, Steckborn (Switzerland).
Bibliography: Z 54 no. 481, DB 66 IX no. D 15.

65 ⊖ 81,5 / 65,5 ▤ Barcelona April 1903 ⦂

Couple in a Cafe
Oslo, Nasjonalgalleriet
Previous owners: Vilaro, Barcelona; Flechtheim, Düsseldorf; Gold, Copenhagen.
Bibliography: Z 32 no. 167, S 48-55, DB 66 IX no. 9.
In the top right-hand corner is signed and dated: "Picasso, 1903, avril".

66 ⊕ 23,5 / 17 ▤ Barcelona May 1903 ⦂

Blind Woman
Heino (Holland), Hannema-De Stuers Foundation.
Bibliography: DB 66 IX no. D 6.
Indian ink and watercolour on paper; dated on the back: "23 Mayo 1903". A pen and ink drawing, 66 A, 23 × 17 cm, whereabouts unknown (Z 54 no. 451), has a comparable theme.

67 ⊕ — ▤ Barcelona 1903 ○/○

Nude with Flowing Hair
Whereabouts unknown.
Previous owner: Junyent, Barcelona.

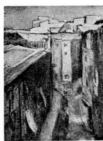

56

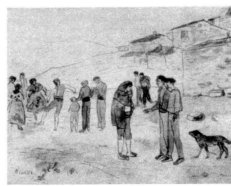

57 [Plate XI] 58 [Plate X]

Bibliography: CP 50, Z 54 no 462, DB 66 IX no 18. Dimensions unknown; it does not appear to be signed.

68 ⊕ — ▤ Barcelona 1903 ○/○

Nude with Crossed Legs
Whereabouts unknown.
Bibliography: Z 32 no. 181, CP 50, DB 66 IX no. 19.
The dimensions are variously given as 58 × 44 and 60 × 46 cm. See no. 40.

69 ⊕ 40,5 / 35,5 ▤ Barcelona 1903 ⦂

Head of a Woman
New York, on loan from the Milton de Groot Collection to the Metropolitan Museum of Art.
Previous owners: Fukushima, Paris; Milton de Groot, New York.
Bibliography: Z 54 no. 548, DB 66 IX no. 16.

70 ⊖ 50 / 36 ▤ Barcelona 1903 ⦂

Woman with a Kerchief round her Neck
Leningrad, Hermitage.
Previous owners: Shchukine, Moscow; Museum of Modern Western Art, Moscow.
Bibliography: Z 32 no. 166, BP 62, B 64, DB 66 IX no. 14.

71 ⊕ 50 / 37 ▤ Barcelona 1903 ⦂

Woman with Lock of Hair
Barcelona, Picasso Museum.
Previous owners: Plandiura, Barcelona; Museo de Arte Moderno, Barcelona.
Exhibitions: 60 P.
Bibliography: Z 32 no. 165, CP 50, S 63, DB 66 IX no. 15, P 66.
See Plate XVIII.

72 ⊖ 125,5 / 91,5 ▤ Barcelona June 1903 ⦂

Portrait of Sebastián Junyer Vidal with Female Figure
Los Angeles (Cal.), Museum of Art.
Previous owners: Junyer Vidal, Barcelona; Bright, Los Angeles.
Exhibitions: 32 P, 57 NY, 66 P.
Bibliography: Z 32 no. 174, CP 50, B 57, DB 66 IX no. 21, P 66.
The dedication at the bottom right-hand corner reads: "A Sebastián Juñer/Picasso/Junio 1903".

73 ⊕ 27 / 20 ▤ Barcelona 1903 ⦂

Portrait of Angel Fernández de Soto with Female Figure
Düsseldorf, Forberg Collection.
Previous owners: Junyent, Barcelona; Rosengart, Lucerne.
Bibliography: DB 66 IX no.

D 9.
Indian ink, watercolour and coloured pencil on paper. Signature of doubtful authenticity on the right. Authenticated by Picasso on 10 November 1955, and signed on the left.

74 ⊕ 69,5 / 55 ▤ Barcelona 1903 ⦂

Portrait of Angel Fernández de Soto
New York, Stralem Collection.
Previous owners: Mendelssohn, Berlin; Thannhauser, Lucerne; Taylor, Lucerne.
Exhibitions: 47 NY, 64 T.
Bibliography: Z 32 no. 201, S 48-55, EM 55, DB 66 IX no. 20.

75 ⊕ 36 / 27 ▤ Barcelona 1903 ⦂

Head of a Woman
Paris, owned by the heirs of Guillaume Apollinaire.
Previous owner: Guillaume Apollinaire, Paris.
Bibliography: Z 32 no. 205, S 48-55, CP 50, DB 66 IX no. 17.

76 ⊕ 21,5 / 14 ▤ Barcelona 1903 ○/○

Man with a Dog
Whereabouts unknown.
Previous owner: Junyer Vidal, Barcelona.
Bibliography: Z 32 no. 194,

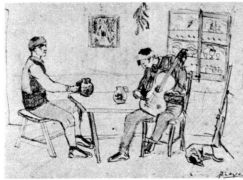

59

60

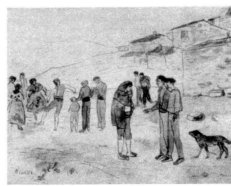

61

61 A

62

63

64

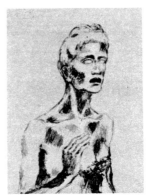

66

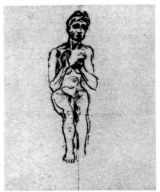

66 A

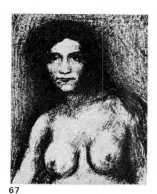
67

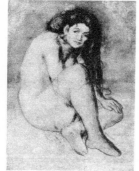
68

69

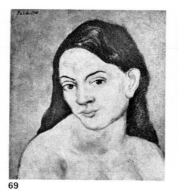
70

71 [Plate XVIII]

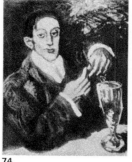
73

74

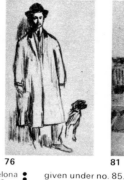
75

76

81

CP 50, DB 66 IX no. D 8.
Indian ink and watercolour on paper.

77 ⊕ 21/15 ▤ Barcelona 1903

Portrait of the Tailor Soler Dressed in Riding Clothes
Pittsburgh (Pa.), Heinz Collection.
Previous owners: Soler, Barcelona; Berggruen, Paris.
Bibliography: DB 66 IX no. D 7.
Indian ink and watercolour on paper; the signature is of doubtful authenticity. See no. 80.

78 ⊕ 100/70 ▤ Barcelona 1903

Portrait of the Tailor Soler
Leningrad, Hermitage.
Previous owners: Soler,

80 ⊕ 150/200 ▤ Barcelona Summer 1903

The Soler Family
Liège, Musée des Beaux-Arts.
Previous owners: Soler, Barcelona; Kahnweiler, Paris; Wallraf-Richartz-Museum, Cologne.
Exhibitions: 53 L, 60 L, 66 P.
Bibliography: Z 32 no. 203, CP 50, EM 55, P 58, K 65, DB 66 IX no. 23, P 66.
This picture originally had a plain background. At the request of Soler (a tailor of Barcelona with whom Picasso exchanged paintings for clothing), the artist agreed that Sebastián Junyer Vidal should set the group in a landscape. We reproduce here a photograph (published in Z 32 no. 204) of the picture altered in this way. Picasso altered it again in 1913 when the painting was hung in the Museum at Cologne, restoring the original background. The picture was confiscated by the Nazis in 1937 and was auctioned on 30 June 1939 at the Fischer Gallery in Lucerne, at a sale of pictures and sculptures of modern masters coming from German museums. See the article "Les aventures d'un tableau de Picasso" in *Arts* of 15 November 1946; see also the two previous numbers. Finally, see Plates VIII–IX.

Barcelona; Shchukine, Moscow; Museum of Modern Western Art, Moscow.
Bibliography: Z 32 no. 199, S 48-55, CP 50, B 64, DB 66 IX no. 22, P 66.
See also the two following numbers.

79 ⊕ 100/73 ▤ Barcelona 1903

Portrait of Madame Soler
Munich, Neue Pinakothek.
Previous owners: Soler, Barcelona; Kahnweiler, Paris; Thannhauser, New York.
Bibliography: Z 32 no. 200, S 48-55, DB 66 IX no. 24, P 66.
See also the two preceding numbers and the following one. Bought in 1964 by the Bavarian state for 1,200,000 francs.

81 ⊕ 31,5/43 ▤ Barcelona 1903

Family at Table
Buffalo (NY), Albright-Knox Art Gallery.
Previous owners: Gertrude Stein, Paris; Perls, Paris; Watson, London; French Art Galleries, New York.
Bibliography: CP 50, Z 54 no. 563, K 65, DB 66 IX no. D 13.
Indian ink and watercolour on paper.

82 ⊕ 47/36 ▤ Barcelona 1903

The Poor Wretches
Wuppertal, Von der Heydt-Museum.
Previous owners: Von der Heydt, Ascona.
Bibliography: DB 66 IX no. D 1.
A study for the oil painting

given under no. 85.

83 ⊕ 37,5/26,5 ▤ Barcelona 1903

The Poor Wretches
University of Manchester, Whitworth Art Gallery.
Previous owners: Anderson, New York.
Bibliography: DB 66 IX no. 4.
Indian ink and watercolour on paper: sketch for the oil painting given under no. 85.

84 ⊕ ▤ Barcelona 1903

The Poor Wretches
Whereabouts unknown.
Bibliography: Z 32 no. 198.
Dimensions unknown. See the two previous numbers and the two following numbers.

85 ⊕ 59,5/49,5 ▤ Barcelona 1903

Poor Wretches on the Seashore
Northampton (Mass.), Smith College, Museum of Art.
Previous owners: Stransky, New York; Dexter, Abbott (Maine).
Bibliography: Z 32 no. 197, DB 66 IX no. 5.
See also the three previous numbers and the following number. Sold in 1933 for $3,000.

86 ⊕ 105,5/69 ▤ Barcelona 1903

Poor People on the Seashore
Washington, DC, National Gallery of Art, Dale Collection.
Previous owners: Schubert, Bochum (Germany); Dale, New York.
Bibliography: Z 32 no. 208,

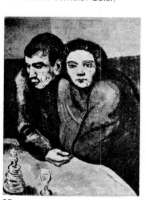
65

72

77

78

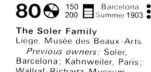
79

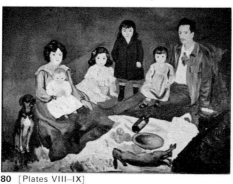
80 [Plates VIII–IX]

No. 80 with background landscape painted by Sebastián Junyer Vidal.

93

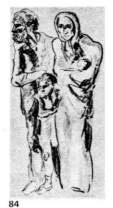
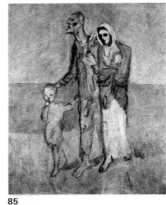
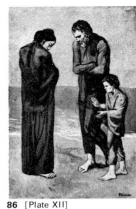

82 83 84 85 86 [Plate XII]

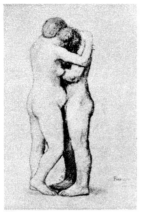
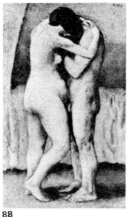

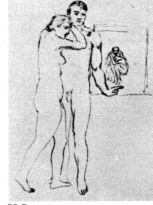

87 88 89 [Plate XIII] 89 A 89 B

87

S 38, C 40, S 48-55, CP 50, G 51, EM 55, K 65, DB 66 IX no. 6.

See the four previous numbers and Plate XII, for which the photographic originals were kindly supplied by the National Gallery of Art in Washington.

87 ⊗ — 🔲 Barcelona 1903

The Embrace
Whereabouts unknown.
Previous owner: Thann-hauser, Paris.
Bibliography: Z 32 no. 162, DB 66 IX no. 11.
Dimensions unknown. A study in pastels for the following picture.

88 ⊗ 98/57 🔲 Barcelona 1903

The Embrace
Paris, Musée de l'Orangerie, Walter-Guillaume Collection.
Previous owners: Vollard, Paris; Guillaume, Paris; Walter, Paris.
Exhibitions: 60 P, 66 P.
Bibliography: Z 32 no. 161, S 48-55, CP 50, EM 55, DB 66 IX no. 12, P 66.
See the previous number.

89 ⊗ 197/127,5 🔲 Barcelona 1903

Life
Cleveland (Ohio), Museum of Art, Hanna Collection.
Previous owners: Vollard, Paris; Bignou, Paris; Thann-hauser, Lucerne; Rhode Island School of Design, Providence (R.I.).
Exhibitions: 32 P, 32 Z, 39 NY, 47 NY, 60 L, 66 P.
Bibliography: D 30, Z 32 no. 179, B 39, C 40, B 46, S 48-55, CP 50, G 51, L 52-54, B 55, EM 55, P 58, BP 62, J 64, DB 66 IX no. 13, P 66.

At least two preparatory sketches are known for this picture, which ranks among Picasso's most important works: the first, 89 A (Z 54 no. 534; DB 66 IX D 4; P 66), in ink, 15·7 × 11 cm, its whereabouts is unknown; the second, 89 B (DB 66 IX D 5; P 66), in pencil, 26·7 × 19·7 cm, is in London, owned by Penrose. The latter, drawn on the back of a letter, bears the date 2 May 1903 in Picasso's handwriting; in the

sketch, the male figure has the features of Picasso himself, while in the finished picture on the other hand it has those of Casagemas (this was noted by Pierre Daix in an article "La période bleue de Picasso et le suicide de Carlos Casagemas" in *Gazette des Beaux-Arts* of April 1967). See Plate XIII.

90 ⊗ — 🔲 Barcelona 1903

The Blind Beggar
Whereabouts unknown.
Previous owners: Pellequer, Paris.
Bibliography: Z 32 no. 188.
Dimensions unknown.

91 ⊗ 125/92 🔲 Barcelona 1903

Blind Old Man and Boy
Moscow, Pushkin Museum.
Previous owners: Shchukine, Moscow; Museum of Modern

Western Art, Moscow.
Exhibitions: 54 P, 60 L.
Bibliography: L 28, Z 32 no. 175, EM 55, KP 55, P 58, DB 66 IX no. 30.

On the back of the picture is written: "Picasso / calle de la Merced 3 / piso 2° / Barcelona". A preparatory design for this painting, 91 A, in coloured pencil (in blue and rose tones), 35 × 26 cm, signed over the cancellation of an earlier signature (Z 32 no. 170; DB 66

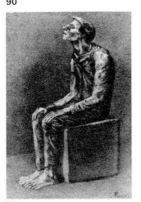
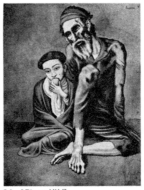
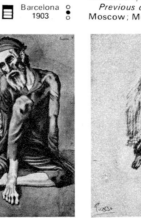
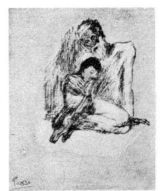

90 91 [Plate XIV] 91 A 92 [Plate XV]

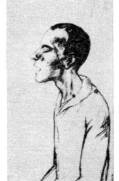
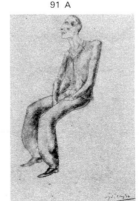

93 93 A 93 B 94 [Plate XVI]

94

IX no. 29), is in existence and belongs to a private collector living in Switzerland. See Plate XIV.

92 [⊕] 121 / 82 [▤] Barcelona 1903 [⋮]

The Old Blind Guitar Player
Chicago (Ill.), Art Institute, Bartlett collection.
Previous owners: Vollard, Paris; Quinn, New York; Bartlett, Chicago.
Exhibitions: 36 NY, 39 NY.
Bibliography: Z 32 no. 202, B 39, B 46, CP 50, L 52-54, P 58, BP 62, B 64, DB 66 IX no. 34, P 66.
See Plate XV.

93 [⊕] 51,5 / 34,5 [▤] Barcelona 1903 [⋮]

The Blind Man
Cambridge (Mass.), Harvard University, Fogg Art Museum.

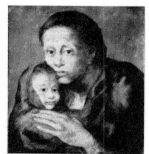

100 [Plate XIX]

Previous owners: Kahnweiler, Paris; Museum of Art, Toledo (Ohio); Wertheim, New York.
Bibliography: R 21, Z 32 no. 172, M 42-48, DB 66 IX no. 31.
Several sketches relating to this picture are known. One of them, 93 A (Z 54 no. 533), in ink, 11·5 × 6·5 cm, present location unknown, is dated by Zervos October 1903. It shows only the head and shoulders of the blind man. Another, 93 B (DB 66 IX no D 23), in pencil and pastel, 36 × 26 cm, owned by Maguy, Paris, is rather closer to the finished painting. It was recently signed and authenticated by the artist.

94 [⊕] 95 / 94,5 [▤] Barcelona 1903 [⋮]

The Blind Man's Meal
New York, Metropolitan Museum of Art.
Previous owners: Vollard, Paris; Thannhauser, Munich and then New York; Private collection, Westphalia; Haupt, New York.
Exhibitions: 13 M, 57 NY, 58 F, 60 L.
Bibliography: Z 32 no. 168, CP 50, L 52-54, P 58, DB 66 IX no. 32, P 66.
We learn from a letter of Picasso's, now in the possession of the Barnes Foundation, Merion (Pa.), that in the early stages of the execution of this picture, the figure of a dog gazing at the blind man was introduced. Compare with no. 106. See also Plate XVI. The painting was donated to the Metropolitan Museum in 1950 by Mrs Ira Haupt.

95 [⊕] 130 / 97 [▤] Barcelona 1903 [⋮]

The Ascetic

Merion (Pa.), Barnes Foundation.
Previous owner: Guillaume, Paris.
Bibliography: Z 32 no. 187, CP 50, DB 66 IX no. 33.

96 [⊕] 32 / 18 [▤] Barcelona 1903 [⋮]

Old Woman with a Shawl
Whereabouts unknown.
Bibliography: Z 32 no. 230, S 48-55, DB 66 IX no. 27.
The picture does not appear to be signed.

97 [⊕] 32,5 / 24 [▤] Barcelona 1903 [⋮]

Old Woman with a Hat
Buffalo, Kenefick Collection.
Previous owners: Junyent, Barcelona; Goodyear, New York.
Exhibitions: 36 NY.
Bibliography: CP 50, Z 54 no. 600, DB 66 IX no. 28, P 66.
Indian ink and watercolour on paper. The subject is a native of Horta de Ebro.

98 [⊕] 55 / 37 [▤] Barcelona 1903 [⋮]

Old Woman with Nude Figures
Küsnacht, Kirchheimer Collection.
Previous owners: Bollag, Zurich.
Bibliography: Z 54 no. 578, DB 66 IX no. D 11.
Indian ink and watercolour on paper.

99 [⊕] 70 / 56 [▤] Barcelona 1903 [⋮]

Celestina
Paris, Private collection.
Previous owner: Pellequer, Paris.
Exhibitions: 32 P, 32 Z, 66 P.
Bibliography: Z 32 no. 183, CP 50, G 51, B 55, EM 55, D 64, J 64, DB 66 IX no. 26, P 66.
On the back of the picture, on the frame, is written: "Carlota Valdivia/Calle Conde Asalto 12/4°/1ª Escalera interior", and the date, March 1904, which is not however that of the picture. There is a sketch for this famous painting in charcoal and coloured pencil, 99 A 27 × 23·5 cm, signed over the cancellation of an earlier apocryphal signature, formerly the property of Junyer Vidal, Barcelona, and now of Motte, Geneva (Z 32 no 191; DB 66 IX no. 25; P 66). In this sketch (where the subject appears to be far more sordid and to have more in common with the character of the comedy of Fernando de Rojas, compared with the idealisation of the subject in the picture) there are two other figures: another woman on the

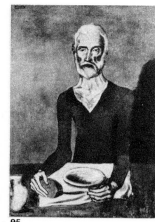

95 96 97

98

99 [Plate XVII]

99 A

left, and on the right a caricature of Sebastián Junyer Vidal. See Plate XVII.

100 [⊕] 47,5 / 41 [▤] Barcelona 1903 [⋮]

Mother with Sick Child
Barcelona, Picasso Museum.
Previous owners: Plandiura, Barcelona; Museum of Modern Art, Barcelona.
Bibliography: Z 32 no. 169, CP 50, D 60, BP 62, S 63, DB 66 IX no. 7, P 66.
See Plate XIX.

101 [⊕] 31,5 / 22 [▤] Barcelona 1903 [⋮]

Beggar Man and Child
Whereabouts unknown.
Bibliography: Z 54 no. 483.

102 [⊕] 26 / 36 [▤] Barcelona 1903 [⋮]

"Caridad"
Brussels, Mabille Collection.
Previous owner: Junyer Vidal, Barcelona.
Bibliography: CP 50, Z 54 no. 438, DB 66 IX no. D 22.
Indian ink and coloured pencil on paper. Authentic signature; cancellation of an earlier apocryphal signature. The sheet contains various brief sketches:

the subject in the left background, with the classical wreath, has the profile of Picasso himself; on the right-hand side is a sketch of the *Beggar Man with Dog*, which relates to the following picture.

103 [⊕] 29 / 21 [▤] Barcelona 1903-4 [⋮]

Beggar Man with Dog
New York, J. K. Thannhauser Collection.
Previous owners: Vines, Paris.
Bibliography: Z 32 no. 184, DB 66 X no. 5.
The inscription in the top right-hand corner reads: "El loco" (the madman). A sketch for this watercolour is on the sheet mentioned under the previous number. See Plate XX, for which the photographic originals were kindly furnished by the Guggenheim Museum, with the permission of the Thannhauser Foundation.

104 [⊕] — [▤] Barcelona 1903-4 [⋮]

Head of a Poor Man
Whereabouts unknown.
Bibliography: Z 54 no. 544, DB 66 X no. 4.
Dimensions unknown.

Possibly a sketch for the paintings given under the three following numbers. It is comparable, however, also to nos. 101 to 103 and no. 108.

105 [⊕] 24,5 / 34,5 [▤] Barcelona 1903-4 [⋮]

The Poor Man's Meal
Paris, Private collection.
Previous owners: Gertrude Stein, Paris; Seligmann, New York; Sachs, Paris.
Bibliography: S 38, Z 54 no. 684, DB 66 X no 3.
The signature was added later. See also the previous number and the following two numbers.

106 [⊕] 24 [▤] Barcelona 1903-4 [⋮]

The Poor Man's Meal
Whereabouts unknown.
Previous owners: Level, Paris; Lefèvre, Paris.
Bibliography: Z 32 no. 209, K 65, DB 66 X no. 1.
See the two previous numbers. It is possible that this was the first version of the watercolour described under the following number. See also no. 94.

107 [⊕] 27 / 35 [▤] Barcelona 1903-4 [⋮]

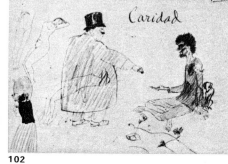
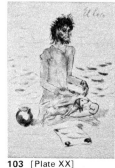
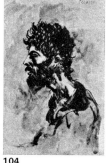

101 102 103 [Plate XX] 104

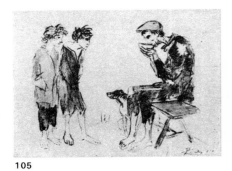

105

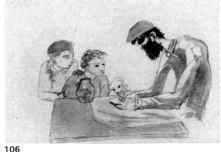

106

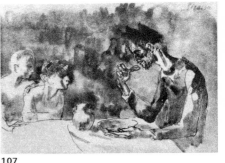

107

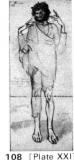

108 [Plate XXI]

The Poor Man's Meal
Detroit (Mich.), Private collection.
Previous owner: Pellequer, Paris.
Bibliography: L 28, Z 32 no. 210, DB 66 X no. 2.
Indian ink and watercolour on paper. See the three previous numbers.

108 ⊗ 86 36 🗒 Barcelona 1904 ⁝

The Madman
Barcelona, Picasso Museum.
Previous owners: Junyent, Barcelona; Plandiura, Barcelona; Museo de Arte Moderno, Barcelona.
Exhibitions: 60 P.
Bibliography: Z 32 no. 232, CP 50, B 55, S 63, D 64, DB 66 X no. 6, P 66.
The dedication on the left reads: "A mi buen/amigo Sebastián/Junyent/Picasso" Executed on two sheets of yellowish paper gummed together. See Plate XXI.

109 ⊗ 49,5 38 Barcelona 1904 ⁝

Portrait of Jaime Sabartés
Oslo, Private collection.
Previous owner: Sabartés, Paris.
Bibliography: Z 54 no. 653, DB 66 X no. 11.

109

110

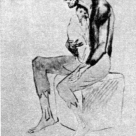

111

112

The dedication in the top left-hand corner reads: "Al amigo Sabartés/Picasso 1904".

110 ⊗ 45 24,5 🗒 Barcelona March 1904 ⁝

Portrait of Luis Vilaro
Switzerland, Private collection.
Previous owners: Vilaro, Barcelona; has been on loan to the Kunsthaus, Zurich, since 1965, from the present owner.
Bibliography: Z 32 no. 164, S 48-55, DB 66 X no. 12.
The inscription on the back reads: "Al amigo/recuerdo de/Picasso/15 Mz 1904".

111 ⊗ 36 26 🗒 1904 ⁝

Solitude
New York, Chrysler Collection.
Previous owner: Perls, New York.
Bibliography: DB 66 XI no. D 2.
Executed in Barcelona or Paris.

112 ⊗ 36 26 🗒 Paris 1904 ⁝

Old Man with Child
Whereabouts unknown.
Previous owner: Lefèvre, Paris.
Bibliography: Z 32 no. 237, DB 66 XI no. D 3.

113 ⊗ 36 26,5 🗒 1903 o 1904 ⁝

Poor Children
New York, J. K. Thannhauser Collection.
Previous owner: Thannhauser, Lucerne.
Bibliography: Z 32 no. 185, DB 66 XI no. D 1.
Executed in Barcelona or Paris.

114 ⊗ 🗒 Paris 1904 ⁝

Boy with Bucket
New York, owned by the heirs of Gertrude Stein.
Previous owner: Gertrude Stein, Paris.
Bibliography: Z 32 no. 227, S 48-55, DB 66 XI no. 1.
Dimensions not given.

115 ⊗ 🗒 Paris 1904 ⁝

Poor Children
Whereabouts unknown.
Previous owner: Vömel, Düsseldorf.
Bibliography: Z 32 no. 219, DB 66 XI no. 2.
Indian ink and watercolour on paper. Dimensions unknown. It is similar in composition to the watercolour described under the following number.

116 ⊗ 37 27 🗒 Paris 1904 ⁝

Poor Children
New York, Museum of Modern Art.
Previous owners: Level, Paris; Leperrier, Paris; Pellequer, Paris; Eumorphopoulos, London; Thannhauser, New York; Knoedler, New York; Josten, New York.
Exhibitions: 57 NY.
Bibliography: L 28, Z 32 no. 218, B 57, K 65, DB 66 XI no. 3.
The same composition as the painting described above. On the back of the sheet which is used the other way up, is the watercolour *Woman Leaning on Folded Arms*, which is described here under the following number. Sold at Sotheby's, London, in 1940 for £210.

117 ⊗ 27 37 🗒 Paris 1904 ⁝

Woman Leaning on Folded Arms
New York, Museum of Modern Art.
Exhibitions: 57 NY.
Bibliography: L 28, Z 32 no. 231, B 57, DB 66 XI no. 4.
On the back of the watercolour *Poor Children* described above, where the list of previous owners is given. The sheet, here, is used the other way up.

118 ⊗ 36 26 🗒 Paris 1904 ⁝

The Suicide
Zurich, Bollag Collection.
Bibliography: Z 54 no. 617, DB 66 XI no. D 9.
Indian ink and watercolour on paper.

119 ⊗ 100 81 🗒 Paris 1904 ⁝

The Couple
Ascona, Private collection.
Previous owners: Thannhauser, Munich; Mayer, Zurich.
Exhibitions: 32 Z, 53 M.
Bibliography: L 28, Z 32 no. 224, C 40, S 48-55, R 53, EM 55, DB 66 XI no. 5.
See Plate XXII.

120 ⊗ 34,5 23,5 🗒 Paris 1904 ⁝

Couple with Child
Whereabouts unknown.
Previous owner: Lefèvre, Paris.
Bibliography: Z 32 no. 238, DB 66 XI no. D 4.
Indian ink and watercolour on paper.

121 ⊗ 37 26 🗒 Paris 1904 ⁝

Couple with Children
Whereabouts unknown.
Previous owner: Dutilleul,

124

125 [Plate XXIII]

Paris.
Bibliography: Z 54 no. 615, DB 66 XI no. D 5.
Indian ink and watercolour on paper.

122 ⊗ 35,5 26 🗒 Paris 1904 ⁝

Couple with Child
Marseille, Private collection.
Exhibitions: 59 M.
Pencil and watercolour on paper.

123 ⊗ 🗒 Paris 1904 ⁝

The Eviction
Paris, Private collection.
Previous owner: Lewisohn, New York.
Bibliography: DB 66 XI no. D 7.
Indian ink and gouache on card: dimensions not known.

124 ⊗ 37 51,5 🗒 Paris 1904 ⁝

The Laundress
New York, Chrysler Collection.
Previous owner: Hessel, Paris.
Bibliography: Z 32 no. 248, DB 66 XI no. D 11.

125 ⊗ 116 72,5 🗒 Paris 1904 ⁝

The Laundress
New York, J. K. Thannhauser Collection.
Previous owner: Thannhauser, Munich.
Exhibitions: 39 NY, 57 NY.
Bibliography: L 28, Z 32 no. 247, B 39, B 46, CP 50, L 52-54, B 57, B 64, D 64, DB 66 XI no. 6.
See Plate XXIII for which the photographic originals were kindly provided by the Guggenheim Museum with the permission of the Thannhauser Foundation.

126 ⊗ 46 31 🗒 Paris 1904 ⁝

The Blind Old Man and Little Girl, Both Nude
Küsnacht, Burgauer Collection.
Previous owner: Bollag, Zurich.
Bibliography: G 51, Z 54 no. 631, DB 66 XI no. D 20.
Indian ink and watercolour on paper.

127 ⊗ 35 26,5 🗒 Paris 1904 ⁝

Nude Woman and Child
Cambridge (Mass.), Harvard University, Fogg Art Museum.
Previous owners: Matisse, New York; Wertheim, New York.
Bibliography: Z 32 no. 239, K 65, B 66 XI no. D 19.
Coloured pencil and watercolour on paper.

128 ⊗ 35,5 25,5 🗒 Paris 1904 ⁝

Mother and Child
Budapest, Szépművészeti Múzeum.
Previous owner: Hatvany, Budapest.
Bibliography: DB 66 XI

no. 21.
Indian ink and watercolour on paper.

129 ⊗ 63 48 ▤ Paris 1904 ⦂

Mother and Child Adorned with Garlands
Paris, Private collection.
Previous owner: Pellequer, Paris.
Bibliography: Z 32 no. 229, DB 66 XI no. 20.

130 ⊗ 58 47 ▤ Paris 1904 ⦂

Portrait of Sebastián Junyer Vidal
Barcelona, Picasso Museum.
Previous owners: Plandiura, Barcelona; Museo de Arte Moderno, Barcelona.
Exhibitions: 53 L.
Bibliography: Z 32 no. 214, M 42-48, CP 50, S 63, DB 66 XI no. 15, P 66.
This picture bears an apocryphal signature.

131 ⊗ 43 31 ▤ Paris 1904 ⦂

Woman with her Hair Up
Chicago (Ill.), Art Institute.
Previous owners: Gold, Berlin; Johnson, Chicago; Brewster, Chicago.
Exhibitions: 36 NY, 37 C, 39 NY, 57 NY.
Bibliography: R 21, Z 32 no. 233, B 39, B 46, S 48-55, CP 50, B 55, EM 55, B 57, DB 66 XI no. 7.
See Plate XXIV.

132 ⊗ 65 49,5 ▤ Paris 1904 ⦂

Girl Child with Crow
Toledo (Ohio), Museum of Art.
Previous owners: Guillaume, Paris; Drummond Libbey, Toledo (Ohio).
Exhibitions: 32 P, 32 Z, 36 NY, 37 C, 39 NY, 53 L, 53 M, 57 NY.
Bibliography: Z 32 no. 240, B 39, B 46, CP 50, EM 55, DB 66 XI no. 10.
Gouache and pastel on paper stuck to cardboard. The model for it was the young girl Margot, daughter of the landlord of the "Lapin Agile", Frédé (see no. 197), who later married Pierre Mac Orlan, and died in 1963. See also the following number. See Plate XXV, for which the photographic originals were kindly provided by the Museum of Art at Toledo, to which the painting was donated by Mr Edward Drummond Libbey.

133 ⊗ 60,5 40,5 ▤ Paris 1904 ⦂

Girl with Crow
Whereabouts unknown.
Previous owner: Sainsère, Paris.
Exhibition: 66 P.
Gouache and pastel on paper. A copy of the work described above, executed "after a few days' interval", according to the catalogue of a show in Paris in 1966–7, where this painting was mentioned for the first time.

134 ⊗ 101,5 75,5 ▤ Paris 1904 ⦂

Portrait of Gaby Baur
Paris, Private collection.
Previous owners: Junyer Vidal, Barcelona; Matthiesen London.
Exhibitions: 60 L.

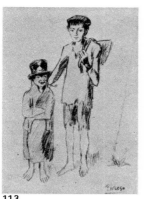

113

114

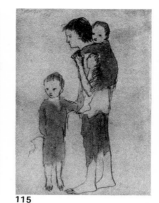

115

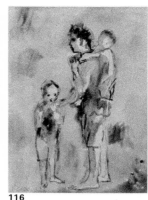

116

117

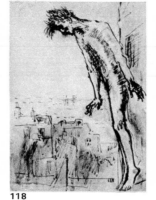

118

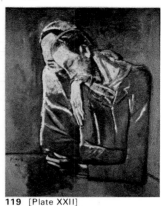

119 [Plate XXII]

120

121

122

123

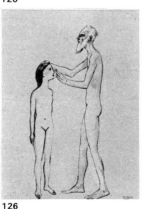

126

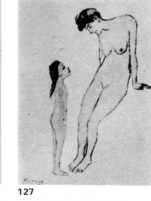

127

128

129

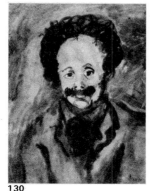

130

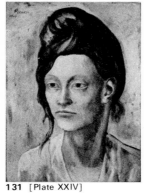

131 [Plate XXIV]

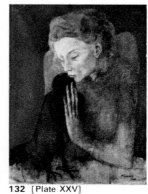

132 [Plate XXV]

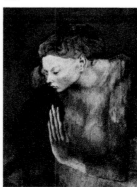

133

97

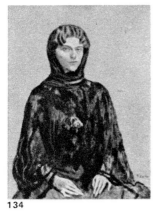

134

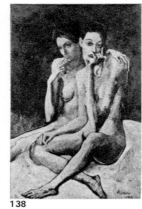

137

138

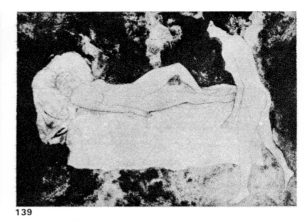

139

140

141

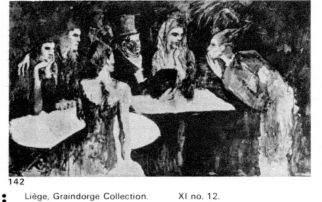

142

147

Bibliography: Z 32 no. 215, CP 50, DB 66 XI no. 17.

This picture bears an apocryphal signature. The subject depicted was the wife of the actor Harry Baur.

135 ⊕ 14,5 / 13,5 ▤ Paris 1904 ⋮

Portrait of Suzanne Bloch
Ascona, Neuburg-Coray Collection.

Bibliography: DB 66 XI no. 16.

Indian ink and watercolour on paper. This picture is also called, wrongly, *Portrait of Colette.* See the following number.

136 ⊕ 65 / 54 ▤ Paris 1904 ⋮

Portrait of Suzanne Bloch
São Paulo, Museu de Arte.

Previous owners: Sichowski, London; Bieber, Lugano.

Exhibitions: 13 M.

Bibliography: D 30, Z 32 no. 217, S 48-55, C 58, C 59, DB 66 XI no. 18.

Suzanne Bloch was the sister of the violinist Henri Bloch and a well known Wagnerian singer. See Plate XXVI.

137 ⊕ 34 / 24 ▤ Paris 1904 ⋮

Kneeling Nude

Liège, Graindorge Collection.

Previous owners: Poissonnier, Paris; Thompson, Pittsburgh (Pa.).

Bibliography: Z 54 no. 632, DB 66 XI no. D 21.

Coloured pencil and watercolour on paper.

138 ⊕ 55 / 38 ▤ Paris 1904 ⋮

The Friends
Paris, Private collection.

Previous owner: Richet, Paris.

Exhibition: 55 P.

Bibliography: S 48-55, Z 54 no. 652, EM 55, DB 66 XI no. 8.

A variation of the theme is shown in the watercolour under the following number.

139 ⊕ — ▤ Paris 1904 ⋮

The Friends
Whereabouts unknown.
Bibliography: DB 66 XI no. 9.
Dimensions unknown. See also the preceding number.

140 ⊕ 36 / 26 ▤ Paris 1904 ⋮

Contemplation
Paris, Helft Collection.

Bibliography: Z 32 no. 234, DB 66 XI no. 11.

Indian ink and watercolour on paper signed in 1924. The same theme with variations is depicted in the painting given under the following number.

141 ⊕ 37 / 27 ▤ Paris 1904 ⋮

Contemplation
New York, Bertram Smith Collection.

Previous owners: Pellequer, Paris; Furthman, New York.

Exhibitions: 36 NY, 57 NY, 58 F, 64 T.

Bibliography: L 28, Z 32 no. 235, CP 50, B 57, P 58, DB 66

XI no. 12.

Indian ink and watercolour on paper: the male figure is a self-portrait. See also the preceeding number.

142 ⊕ 95 / 145 ▤ Paris 1904 ⋮

"Les Noces de Pierrette"
Whereabouts unknown.

Previous owners: Stransky, New York; Renand, Paris.

Bibliography: Z 32 no. 212, BP 62, DB 66 XI no. 22.

With this picture which, according to information given in DB 66, has in fact been destroyed, the Blue Period ends.

143 ⊕ 61,5 / 47 ▤ Paris 1904 ⋮

Vase with Flowers
Los Angeles (Cal.), Goetz Collection.

Previous owner: Salz, New York.

Bibliography: DB 66 XI no. 14.

Written on the back in Picasso's own hand is the inscription "Collection privée de l'artiste".

144 ⊕ 61,5 / 47 ▤ Paris 1904 ⋮

Vase with Flowers
Rochester (NY), Rochester University, Memorial Art

135 1904

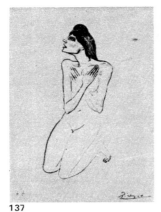

136 [Plate XXVI]

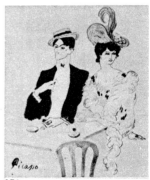

146

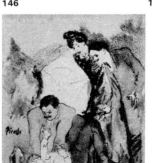

151

143

144

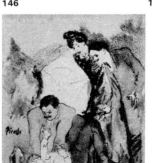

148

149

Gallery.

Previous owners: Guillaume, Paris; Stransky, New York; Sibley Watson, Rochester.

Bibliography: Z 32 no. 241, DB 66 XI no. 13.

Gouache and watercolour on paper.

145 ⊘ 36/26 ▤ Paris 1904 ⦂

Profile of a Woman
New York, J. K. Thannhauser Collection.

Previous owner: Gaffé, Brussels

Bibliography: Z 32 no. 221, DB 66 XI no. D 12.

146 ⊘ 37,5/26,5 ▤ Paris 1904 ⦂

The Kiss
Göteborg, Konstmuseum.

Previous owner: Turitz, Göteborg.

Bibliography: DB 66 XI no. 19.

On the painting, in Picasso's own hand, is the date "7 Septiembre 1904".

147 ⊘ 54,5/44 ▤ Paris 1904 ⦂

"Hôtel de l'Ouest"
Los Angeles (Cal.), Goetz Collection.

Previous owners: Libaude, Paris: Perls, Paris; Chrysler, New York.

Bibliography: Z 32 no. 213, DB 66 XI no. D 16.

Pencil and watercolour on paper. An inscription in the artist's hand in the bottom left-hand corner: "Esquisse pour/ Hôtel de l'Ouest, Chambre 22". This project for a poster, which was not carried out, was for the comedy of the same name by G. Coquiot and J. Lorrain, given at the Grand Guignol, Paris, on 28 May 1904.

148 ⊘ 73/60 ▤ Paris 1904 ⦂

"Sainte Roulette"
USA, Private collection.

Previous owner: Perls, New York.

Bibliography: Z 54 no. 616, DB 66 XI no. D 14.

This project was for a poster, which was not carried out, for the comedy *Sainte Roulette* by G. Coquiot and J. Lorrain, given in Paris at the Théâtre Molière, on 10 October 1904. See also the following number.

149 ⊘ — ▤ Paris 1904 ⦂

"Sainte Roulette"
Whereabouts unknown.

Bibliography: DB 66 XI no. D 15.

Dimensions unknown. See the poster given under the preceeding number. This is a second sketch for the same project.

150 ⊘ 37/27 ▤ Paris 1904 ⦂

Portrait of Manuel Hugué
Property of the artist.

Bibliography: L 28, Z 32 no. 211, CP 50, D 61, DB 66 XI no. D 10.

Indian ink with a watercolour background on paper. Manuel (Manolo) Hugué, a long standing friend of Picasso, was a Spanish sculptor who had made his home among the artists of Montmartre.

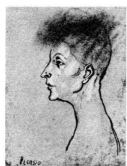

145

150 152

153

151 ⊘ 43,5/34,5 ▤ Paris 1904 ⦂

Portrait of Angel Fernández de Soto with Female Figure
Columbus (Ohio), Gallery of Fine Arts.

Previous owners: Dudensing, New York; Howald, Columbus (Ohio).

Bibliography: DB 66 XI no. D 18.

The signature is possibly apocryphal.

152 ⊘ — ▤ Paris 1904 ⦂

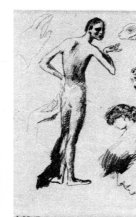

154 [Plate XXVII]

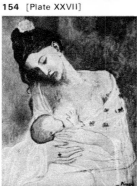

155

Self-Portrait with Pipe
Whereabouts unknown.

Previous owner: Junyent, Barcelona.

Bibliography: S 54, DB 66 XI no. D 28.

Indian ink and watercolour on paper. Dimensions unknown. The inscription at the top reads: "A Sebastiá Junyent/Picasso"; and the one at the bottom left reads: "Paris Diciembre/1904"; and below that is written: "Mi retrato".

153 ⊘ 17/10,5 ▤ Paris ⦂

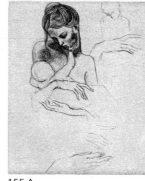

154 A

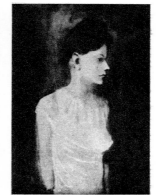

155 A

Self-Portrait with Pipe
Paris, whereabouts unknown.

Previous owner: Maar, Paris.

Bibliography: DB 66 XI no. D 29.

Indian ink and watercolour on paper. Executed in the winter of 1904–5.

154 ⊘ 194/112 ▤ Paris ⦂

The Actor
New York, Metropolitan Museum of Art.

Previous owners: Leffmann, Cologne; Private collection, Germany; Perls, New York; Rosenberg, Paris; Knoedler, New York; Chrysler Foy, New York.

Exhibition: 39 NY.

Bibliography: R 21, Z 32 no. 291, B 39, L 52-54, EM 55, P 58, B 64, DB 66 XII no. 1.

Executed in the winter of 1904–5.

A sketch for this painting, 154 A, in pencil, 47 × 31·5 cm, signed, previously belonging to Gertrude Stein (Paris), Alice Toklas (Paris), Valentin (New York) and Rockefeller (New York), and now in the hands of a private collector in New York, was shown in the exhibitions 57 NY and 58 F, and was published in Z 54 no. 681, B 57, BP 62 and DB 66 XII no. 2. On the same sheet, together with other brief sketches, are two female profiles: these are the first known sketches of Fernande Olivier (see no. 247). See Plate XXVII. The painting was donated to the Metropolitan Museum by Mrs Thelma Chrysler Foy in 1952.

155 ⊘ 65/50,5 ▤ Paris 1905 ⦂

Mother and Child
Paris, Private collection.

Previous owners: Sainsère, Paris: Richet, Paris.

Exhibition: 66 P.

Bibliography: S 48-55, B 55, B 64, K 65, DB 66 XII no. 4.

Related to this picture is the sketch, 155 A, in pencil, *Mother and Child with a study of hands,* 34·4 × 26·6 cm which is well known and more often illustrated (Z 32 no. 220; K 65: DB 66 XI no. D 26), and is today in the Fogg Art Museum, Harvard University, Cambridge (Mass.). It is signed and dated 1904.

156 ⊘ 106/76 ▤ Paris 1905 ⦂

Seated Nude
Paris, Musée National d'Art Moderne.

Previous owners: Gertrude Stein, Paris; Matisse, New York; Chrysler, New York.

Bibliography: Z 32 no. 257,

C 40, S 48-55, C 59, D 60, DB 66 XII no. 3.

157 ⊘ 72,5/60 ▤ Paris 1905 ⦂

Woman Wearing a Chemise
London, Tate Gallery.

Previous owners: Kahnweiler, Paris; Flechtheim, · Berlin; Stoop, London.

Exhibitions: 32 P, 32 Z, 60 L, 66 P.

Bibliography: Z 32 no. 307, S 48-55, G 51, EM 55, C 58, K 65 DB 66 XII no. 5.

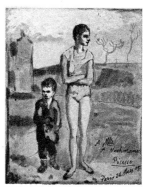

158 [Plate XXX]

158 ⊘ 23,5/18 ▤ Paris 1905 ⦂

Young Acrobat and Child
New York, J. K. Thannhauser Collection.

Bibliography: Z 54 no. 718, K 65, DB 66 XII no. 15.

Gouache and watercolour on paper. The inscription at the bottom right reads: "A Mlle./A. Nachmann/Picasso/Paris 26 March 05". This is the first painting which belongs completely to the Rose Period. See Plate XXX, for which the photographic originals were kindly provided by the Guggenheim Museum, with the

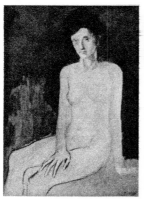

156

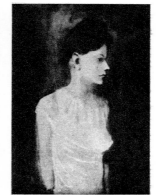

157

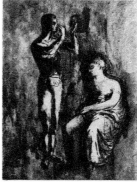

159

99

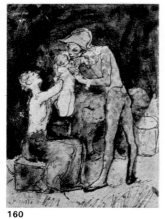
160

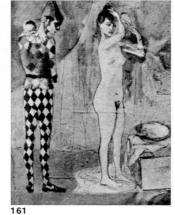
161

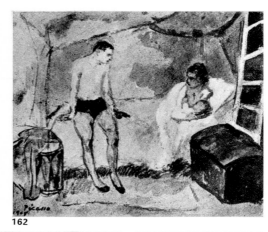
162

163

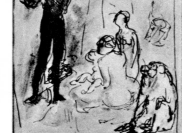
164

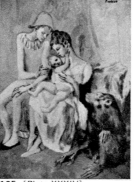
165 [Plate XXXIV]

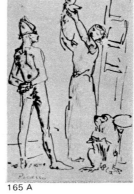
165 A

Paris, Private Collection.
Previous owners: Bignou, Paris; Rothschild, Paris.
Bibliography: DB 66 XII no. 10.
Indian ink and watercolour on paper. Dimensions unknown. Reproduced in the periodical *La Plume* of 15 May 1905.

169 ⊗ 31,5 / 23,5 ⊟ Paris 1905 ⦂

The Acrobat's Meal
New York, Private collection.
Previous owners: Reber, Lausanne; Clark, New York.
Exhibition: 36 NY.
Bibliography: Z 32 no. 292, DB 66 XII no. 14.
Gouache and watercolour on paper.

170 ⊘ 105 / 76 ⊟ Paris 1905 ⦂

Acrobat and Young Harlequin
Belgium, Private collection.
Previous owner: Städtisches Museum, Wuppertal.
Exhibition: 66 P.
Bibliography: Z 32 no. 297, C 59, DB 66 XII no. 9.
This picture was reproduced in *La Plume* of 15 May 1905. It was confiscated by the Nazis in 1937 and was put on sale on 30 June 1939 at the Fischer Gallery, Lucerne, in an auction sale of paintings and sculptures of modern masters from German museums. See Plate XXIX.

171 ⊘ 57 / 41 ⊟ Paris 1905 ⦂

Small Child with Dog
Leningrad, Hermitage.
Previous owners: Shchukine, Moscow; Museum of Modern Art, Moscow.
Bibliography: Z 32 no. 306, K 65, DB 66 XII no. 16.

permission of the Thannhauser Foundation.

159 ⊗ 69 / 54 ⊟ Paris 1905 ⦂

Harlequin and his Companion
USA, Private collection.
Previous owner: Fleischmann, Zurich.
Bibliography: Z 54 no. 702, DB 66 XII no. 12.

160 ⊗ 29,5 / 21 ⊟ Paris 1905 ⦂

Harlequin's Family
New York, Payson Collection.
Previous owners: Private collection, Cologne; Knoedler, New York.
Bibliography: Z 32 no. 244, BP 62, DB 66 XII no. 11.
Indian ink and watercolour on paper. Sold at Sotheby's, London, on 25 November 1959, for £12,000.

161 ⊗ 58 / 43,5 ⊟ Paris 1905 ⦂

Harlequin's Family
Washington, DC, Eisenstein Collection.
Previous owner: Lewisohn, New York.
Exhibitions: 36 NY, 39 NY.
Bibliography: D 30, Z 32 no. 298, B 39, L 52-54, B 55, EM 55, K 65, DB 66 XII no. 6.
Indian ink and gouache on paper. Picasso made the etching *La Toilette de la mère* in 1905 on the same theme.

162 ⊘ 22 / 29 ⊟ Paris 1905 ⦂

A Family of Acrobats
Germany, Private collection.
Previous owner: Schnitzler, Frankfurt.
Bibliography: Z 32 no. 289, DB 66 XII no. 13.

163 ⊗ 50 / 32 ⊟ Paris 1905 ⦂

The Ape
Baltimore (Md.), Museum of Art, Cone Collection.
Previous owner: Cone, Baltimore.
Exhibitions: 57 NY, 58 F.
Bibliography: B 57, DB 66 XII no. D 1.
Indian ink and watercolour on paper. This could be a study for no. 165.

164 ⊗ 16 / 14 ⊟ Paris 1905 ⦂

166

166 ⊗ 16,5 / 10 ⊟ Paris 1905 ⦂

Actress with Child at her Breast
Preston, Kessler Collection.
Previous owner: Stoop, London.
Bibliography: DB 66 XII no. D 8.
Indian ink and watercolour on paper.

167 ⊘ 90 / 71 ⊟ Paris 1905 ⦂

Mother and Child
Stuttgart, Staatsgalerie.
Previous owners: Gertrude

Violinist with Family and Ape
Baltimore (Md.), Museum of Art, Cone Collection.
Previous owner: Cone, Baltimore.
Bibliography: DB 66 XIII no. 7.
Indian ink and watercolour on paper.

165 ⊗ 104 / 75 ⊟ Paris 1905 ⦂

Family of Acrobats with Ape
Göteborg, Konstmuseum.
Previous owner: Pineus, Göteborg.
Exhibition: 66 P.
Bibliography: Z 32 no. 299, S 38, S 48-55, EM 55, P 58, BP 62, K 65, DB 66 XII no. 7.
Indian ink, gouache, watercolour and pastel on cardboard. There could well be a relationship between this painting and the ink drawing, 165 A, signed, 18·5 × 12·5 cm, owned by a private collector in the United States (DB 66 XII no. D 3), from which in the same year 1905 Picasso incised on the reverse a dry point with the title *La Famille de Saltimbanques au macaque*. See also the previous two numbers. See Plate XXXIV.

Stein, Paris; Gaspari, Munich; Muthmann, Nassau; Nathan, Zurich.
Exhibition: 55 M.
Bibliography: R 21, Z 32 no. 296, S 48-55, B 55, K 65, DB 66 XII no. 8.
On the back of the canvas is painted the oil painting *Crouching Woman* of 1902 (no. 26). See Plate XXVIII.

168 ⊗ — ⊟ Paris 1905 ⦂

Seated Harlequin

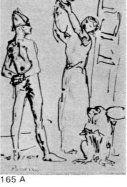
167 [Plate XXVIII]

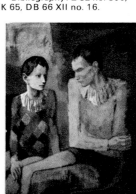
170 [Plate XXIX]

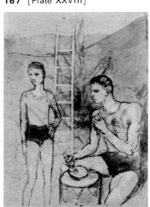
169

174 [Plate XXXIII]

172 ⊘ 105,5/75 ▤ Paris 1905 ⦂

Young Harlequin and Child with Dog
New York, Burden Collection.
Previous owners: Thannhauser, Paris; Ludington, Santa Barbara (Cal.).
Exhibitions: 39 NY, 57 NY.
Bibliography: Z 32 no. 300, B 39, B 46, L 52-54, EM 55, B 57, K 65, DB 66 XII no. 17.
Reproduced in the periodical *La Plume* of 15 May 1905.

173 ⊘ 54/44 ▤ Paris 1905 ⦂

The Athlete
Paris, Private collection.
Previous owners: Sainsère, Paris; Richet, Paris.
Exhibitions: 55 P, 66 P.
Bibliography: EM 55, DB 66 XII no. 20.
The dedication in the top left-hand corner reads: "A Paul Fort/Picasso". There is a signed study for this picture in the Museum of Art in Baltimore, 173 A (DB 66 XII no. D 21), in pen and watercolour, 31 × 24 cm.

174 ⊘ 147/95 ▤ Paris 1905 ⦂

Acrobat and Young Equilibrist
Moscow, Pushkin Museum.
Previous owners: Gertrude Stein, Paris; Kahnweiler, Paris; Morosov, Moscow; Museum of Modern Western Art, Moscow.
Exhibitions: 54 P, 60 L.
Bibliography: R 21, L 28, Z 32 no. 290, S 38, S 48-55, EM 55, KP 55, P 58, D 60, BP 62, B 64, D 64, K 65, DB 66 XII no. 19.
In 1913 this picture was sold for 16,000 francs. See Plate XXXIII.

175 ⊘ 70/54 ▤ Paris 1905 ⦂

Young Clown
Paris, Private collection.
Previous owner: Rothschild, Paris.
Bibliography: Z 32 no. 293, DB 66 XII no. 26.
He also depicted this sitter in one of his first bronzes, modelled in the same year, 1905 – 175 A, the *Tête de Fou*, 41 cm. high (Z 32 no. 322).

176 ⊘ — ▤ Paris 1905 ⦂

Young Clown with Child
Paris, owned by the heirs of Guillaume Apollinaire,
Previous owner: Guillaume Apollinaire, Paris.
Bibliography: DB 66 XII no. D 4.
Indian ink and coloured pencil on paper. Dimensions not given. A dedication in the artist's hand reads: "Picasso/à Guillaume/Apollinaire/1905".

177 ⊘ 16,5/12.5 ▤ Paris 1905 ⦂

The Clown's Family with Accordion
Washington DC, Bliss Collection.
Previous owners: Fernande Olivier, Paris; Sarah Stein, Paris.
Bibliography: DB 66 XII no. D 5.
Indian ink, coloured pencil and watercolour on paper. The

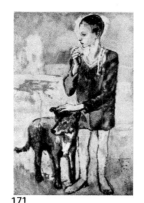
171

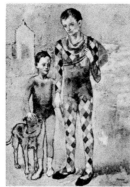
172

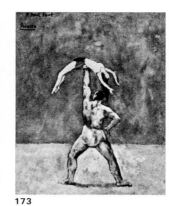
173

173 A

dedication in the top right-hand corner reads: "Pour Fernande/Pablo".

178 ⊘ 190,5/108 ▤ Paris 1905 ⦂

Young Clown and Small Harlequin
Merion (Pa.), Barnes Foundation.
Bibliography: Z 32 no. 301, DB 66 XII no. 25.

179 ⊘ 51/39,5 ▤ Paris 1905 ⦂

The King
Stuttgart, Staatsgalerie.
Previous owner: Borst, Stuttgart.
Bibliography: Z 32 no. 245, BP 62, DB 66 XII no. 21.
In Z 32 no. 246 is published a sketch in pencil, 17 × 10 cm, formerly in the Museum of Modern Western Art and now in the Pushkin Museum in Moscow. This deals with the same subject, but in this case the crown, which is closed in on top almost in the form of a tiara, is decorated with nude figures.

See Plate XLII.

180 ⊘ 24/30,5 ▤ Paris 1905 ⦂

Family of Acrobats
Baltimore (Md.), Museum of Art, Cone Collection.
Previous owner: Cone, Baltimore.
Exhibitions: 57 NY, 58 F.
Bibliography: L 52-54, R 53, EM 55, B 57, K 65, DB 66 XII no. 18.
Indian ink and watercolour on paper. Engraved by Picasso as a

dry point in same year of 1905. See Plate XXXV. See also no. 182.

181 ⊘ 18/11,5 ▤ Paris 1905 ⦂⦂

Young Clown and Actress with Amphora
New York, Lehman Collection.
Previous owner: Knoedler, New York.
Bibliography: DB 66 XII no. D 6.
Indian ink and watercolour on paper.

175

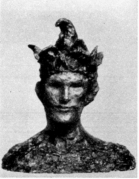
175 A

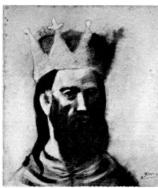
179 [Plate XLII]

179 A

176

177

178

181

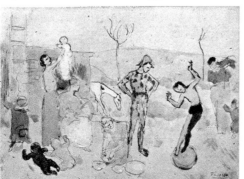
180 [Plate XXXV]

182

183

101

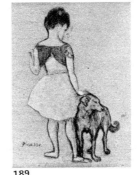

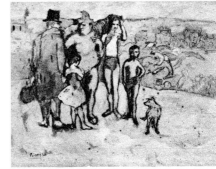

185

185 A

189

190

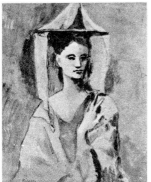

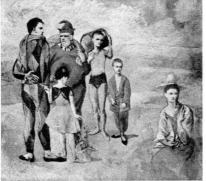

191

192 [Plates XXXVI–XXXVII]

192 A

192 B

193 [Plate XXXI]

182 ⊕ 9,5 / 10,5 ▤ Paris 1905 ⁝

Family of Acrobats
Wuppertal, Von der Heydt-Museum.
Previous owner: Flechtheim, Düsseldorf.
Bibliography: Z 32 no. 281, CP 50, DB 66 XII no. D 2.
Indian ink and watercolour on paper. Zervos lists it as a study for painting no. 180.

183 ⊕ 19 / 13 ▤ Paris 1905 ⁝

Ex-Libris of Guillaume Apollinaire
Whereabouts unknown.
Previous owners: Guillaume Apollinaire, Paris; Flechtheim, Berlin; Cooper, London; Buchholz, New York; Chrysler, New York.
Exhibitions: 32 Z, 39 NY.
Bibliography: Z 32 no. 225, B 39, BP 62, DB 66 XII no. D 9.
Indian ink and watercolour on paper. It is signed with the words "Picasso/fecit" and is inscribed along the bottom "Ex-libris". In the top right-hand corner there also appears the name "Apollinaire". It is possible that the photograph does not reproduce the entire page, and it is probable that "Guillaume" was written in the top left-hand corner, before the surname.

184 ⊕ 23 / 15 ▤ Paris 1905 ⁝

Seated Clown
Whereabouts unknown.
Previous owner: Perls, New York.
Bibliography: Z 54 no. 734, B 55, DB 66 XII no. D 18.
Indian ink and watercolour on paper. The same composition was incised by Picasso, in the same year of 1905, as a dry point entitled *Le Saltimbanque au repos*. As in nos. 186, 188, 190 and 192, the figure of the clown is drawn from real life in the circus. In DB 66 XII no. 30 is reproduced an ink sketch, 184 A, 25·5 × 21·5 cm, owned by Hault, New York. In this sketch the same subject appears brandishing a rapier (whence the title *Bouffon à la rapière*),

and there is an inscription in Picasso's hand reading "Eltio Pepe Don José/a 40 años". In addition, and apart from the one indicated in no. 188 A, three other designs in which the same model appears are known: 184 B, in pencil, signed, and authenticated by the artist on 17 October 1960, 14·5 × 12 cm, once the property of Bollag, Zurich, then of the Rosengart Gallery, Lucerne, and now owned by Sprengel, Hanover. The clown is depicted full-length, giving a sweeping gesture with his right arm (DB 66 XII no. D 20); 184 C, in pencil and indian ink, 31 × 20 cm, in an unknown collection, where Uncle Pepe, without his clown's cap, is drawn seated (Z 54 no. 691); 184 D, in ink, 19 × 17·5 cm, this is also in an unknown collection, and shows a family scene, with Uncle Pepe without his cap, and three or four other figures.

185 ⊕ 32,5 / 24 ▤ Paris 1905 ⁝

Family with Crow
New York, Museum of Modern Art, Newberry Collection.
Previous owners: Berggruen, Paris; Private collection, Basle; Newberry, New York.
Exhibition: 64 T.
Bibliography: Z 54 no. 703, B 55, DB 66 XII no. D 7.
Indian ink and coloured pencil on paper. The same group can be seen, together with another figure relative to the acrobats no. 192, in a pencil sketch, 185 A, 30·5 × 23·5 cm, in an unknown collection (Z 32 no. 279).

186 ⊕ 66 / 56 ▤ Paris 1905 ⁝

Clown and Young Acrobat
USA, Private collection.
Previous owners: Lichnowsky, Kuchelna (Czechoslovakia); Perls, New

York.
Bibliography: Z 32 no. 284, DB 66 XII no. 28.
Gouache and pastels on paper. See no. 184.

187 ⊕ 60 / 47 ▤ Paris 1905 ⁝

Clown and Young Acrobat
Baltimore (Md.), Museum of Art, Cone Collection.
Previous owners: Thannhauser, Lucerne; Rosengart, Lucerne; Cone, Baltimore.
Bibliography: Z 32 no. 283, EM 55, BP 62, K 65, DB 66 XII no. 29.
Charcoal, pastel and watercolour on paper. See no. 184 and also Plate XXXII.

188 ⊕ 29 / 18.5 ▤ Paris 1905 ⁝

Clown and Young Girl
New York, J. K.

Thannhauser Collection.
Bibliography: Z 54 no. 697, DB 66 XII no. D 19.
See no. 184. In Z 54 no. 689 is published an ink sketch, 188 A, 31 × 24 cm, in an unknown collection, which relates to this watercolour.

189 ⊕ 70,5 / 47,5 ▤ Paris 1905 ⁝

Girl Child with Dog
Los Angeles (Cal.), Goetz Collection.
Previous owners: Thannhauser, Lucerne; Sykes, Cambridge; Kaye, London; Beatty, London; Salz, New York.
Exhibition: 32 Z.
Bibliography: Z 32 no. 286, K 65, DB 66 XII no. 31.
Gouache and pastel on paper. A study for no. 192.

190 ⊕ 51 / 61 ▤ Paris 1905 ⁝

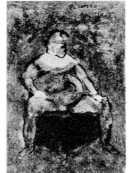

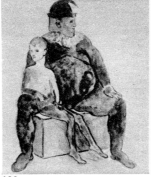

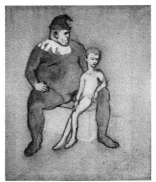

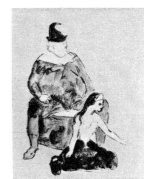

184

186

187 [Plate XXXII]

188

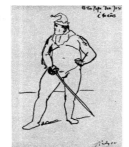

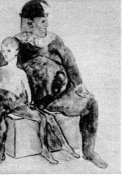

184 A

184 B

184 C

184 D

188 A

Sketch for "The Acrobats"
Moscow, Pushkin Museum.
Previous owners: Shchukine,
Moscow; Museum of Modern
Western Art, Moscow.
Bibliography: Z 32 no. 287,
DB 66 XII no. 33.
See no. 192.

191 ⊘ 67 51 ▤ Paris 1905 ⋮

Young Woman from Majorca
Moscow, Pushkin Museum.
Previous owners: Shchukine,
Moscow; Museum of Modern
Western Art, Moscow.
Exhibition: 54 P.
Bibliography: Z 32 no. 288,
KP 55, DB 66 XII no. 34.
A study for *The Acrobats*
described under the following
number.

192 ⊘ 213 229,5 ▤ Parigi 1905 ⋮

The Acrobats
Washington, DC, National
Gallery of Art, Dale Collection.
Previous owners: Level,
Paris; La Peau de l'Ours, Paris;
Koenig, Munich; Dale, New
York.
Bibliography: L 28, Z 32 no.
285, B 46, S 48-55, CP 50,
G 51, L 52-54, B 55, EM 55,
C 58, BP 62, K 65, DB 66 XII
no. 35.
For the forerunners of this
painting, which ranks as one of
the most important of Picasso's
early period, see previous
numbers, from no. 189
onwards. Another sketch, 192 A,
appears in red chalk, *Young
boy with Wine Cask*, signed,
49·5 × 31·5 cm, formerly the
property of Suermondt, Aachen,
and Fine Arts Associates, New
York, and now in the possession
of Pulitzer, St Louis (Mo.)
(DB 66 XII no. 32). Yet another
sketch, 192 B, is related to this
picture. This is published in
Z 32 no. 280, accompanied by
the information that it was once
in the possession of Level,
Paris. See Plates XXXVI–
XXXVII.

193 ⊘ 100 70 ▤ Paris 1905 ⋮

**The Hurdy-Gurdy Player and
Young Harlequin**
Zurich, Kunsthaus.
Exhibitions: 53 M, 60 P, 66 P.
Bibliography: Z 54 no. 798,
EM 55, BP 62, K 65, DB 66
XII no. 22.
Ths traditional date is 1906,
but stylistically it relates to 1905.
The title assigned to it at the
big exhibition in Milan in 1953
was: *Seated Acrobat with
Young Boy.* Bought in 1942 for
10,000 Swiss francs. See
Plate XXXI.

194 ⊘ 59 78 ▤ Paris 1905 ⋮

Young Equestrienne
Property of the Artist.
Exhibitions: 32 P, 32 Z, 66 P.
Bibliography: G 51, DB 66
XII no. D 15.
An ink sketch of the same
subject, 23·9 × 30·9 cm
(DB 66 XII no. D 14), is to be
found in the Cone Collection at
the Museum of Art in Baltimore.
(Md.). See Plate XXXIX.

195 ⊘ 22 13 ▤ Paris 1905 ⋮

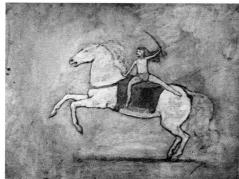

194 [Plate XXXIX]

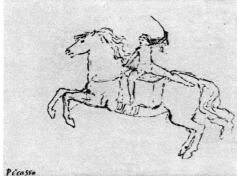

Picasso

194 A

Harlequin on Horseback
Whereabouts unknown.
Previous owner: Lefèvre,
Paris.
Bibliography: DB 66 XII no.
D 11.
A study for the painting
described under the following
number.

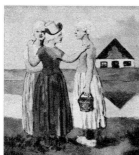

199 [Plate XLIII]

200

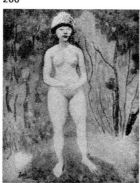

201

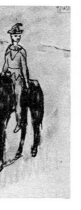

195

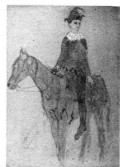

196 [Plate XXXVIII]

196 ⊘ 100 69 ▤ Paris 1905 ⋮

Harlequin on Horseback
Washington, DC, Mellon
Collection.
Previous owners: Level,
Paris; Mermod, Lausanne.
Exhibitions: 32 Z.
Bibliography: L 28, Z 32
no. 243, S 48-55, B 55, C 58,
C 59, DB 66 XII no. 24.
See also the previous number
as well as Plate XXXVIII.

197 ⊘ 99 100,5 ▤ Paris 1905 ⋮

At the "Lapin Agile"
New York, Payson Collection.
Previous owners: Gérard,
Paris; Flechtheim, Berlin;
De Maré, Stockholm.
Exhibition: 59 M.
Bibliography: Z 32 no. 275,
S 48-55, P 58, C 59, BP 62,
DB 66 XII no. 23.
This picture was given by the
artist to Frédé, the proprietor of
the "Lapin Agile" (who is
depicted in the background
playing the guitar). It remained
for a long time hung on the wall
of the well-known café in
Montmartre. This picture is
referred to in *Sandricourt* by
Eugène Marsan, where,
however, due to a slip of the
writer's memory, the woman is
called "Columbine". The extract
is reproduced on page 11. See
Plate XL.

198 ⊘ 65 95 ▤ Paris 1905 ⋮

The Death of Harlequin
Washington, DC, Mellon
Collection.
Previous owners: Bought
from the artist himself in 1905–6
by W. Uhde, who lent it to
Rainer Maria Rilke; then to a
private collector in Westphalia;
Thannhauser, New York;
Somerset Maugham, Cap-
Ferrat.
Exhibition: 13 M.
Bibliography: Z 32 no. 302,
S 48-55, EM 55, BP 62, K 65,
DB 66 XII no. 27.
The signature appears to date
from 1911. On the back is an
oil painting of 1901 of a *Seated
Woman in a Garden.* It was sold

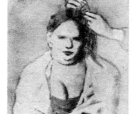

197 [Plate XL]

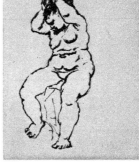

198 [Plate XLI]

at Sotheby's, London, on 10
April 1962 for £80,000. See
Plate XLI.

199 ⊘ 76 66 ▤ Schoorldam 1905 ⋮

Three Dutch Women
Paris, Musée National d'Art
Moderne.

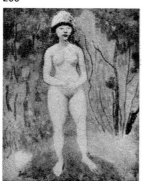

202

203

204

205

Previous owners: La Peau de
l'Ours, Paris; Level, Paris;
Lefèvre, Paris.
Exhibition: 66 P.
Bibliography: L 28, Z 32
no 261, DB 66 XIII no. 2.
Written on the back is:
"Picasso/Schoorl/1905". See
Plate XLIII.

200 ⊘ 78 67,5 ▤ Schoorldam 1905 ⋮

**Nude of Young Dutch Girl
with Cap**

Brisbane, Queensland Art
Gallery.
Previous owners: Durio,
Barcelona; Thannhauser, Paris;
Stang, Oslo; Freshfield, London;
Gollancz, London; De Vahl
Rubin, London.
Exhibition: 60 L.

Bibliography: Z 32 no. 260,
B 46, S 48-55, B 55, DB 66
XIII no. 1.
Oil, gouache and blue gesso
on paper. The dedication in the
top left-hand corner reads: "A
mi querido amigo/Paco Durio/
Picasso/Schoorl".

201 ⊘ 75,5 60 ▤ Schoorldam 1905 ⋮

Full Length Nude with Cap
Whereabouts unknown.
Previous owner:

103

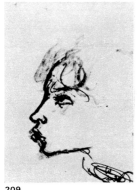

209

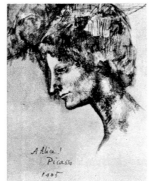

210

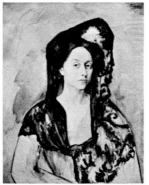

211 [Plate XLIV]

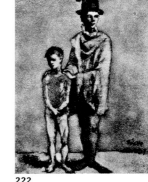

222

208 ⊘ 12/19 ▤ Paris 1905 ⦂

The Lovers
New York, Serger Collection.
Previous owners: Christian Diòr, Paris; Dubourg, Paris.
Bibliography: DB 66 XIII no. D 5.
Authenticated by the artist on 14 March 1960. It was a sketch for the etching *L'étreinte* executed by Picasso in the same year of 1905. The watercolour, which is not reproduced here, is given in DB 66 page 281.

209 ⊘ — ▤ Paris 1905 ⦂

Profile of a Woman
Baltimore (Md.), Museum of Art, Cone Collection.
Previous owner: Cone, Baltimore.
Bibliography: DB 66 XIII no. D 9.
Indian ink and watercolour on paper.

210 ⊘ 36/26,5 ▤ Paris 1905 ⦂

Portrait of Alice Derain
Lucerne, Rosengart Collection.
Previous owner: Von der Heydt, Ascona.
Exhibition: 32 Z.
Bibliography: Z 32 no. 251, D 60, B 64, DB 66 XIII no. D 6.
Indian ink and watercolour on paper. There is an autographed dedication in the bottom left-hand corner: "A Alice!/ Picasso/1905".

211 ⊘ 90,5/70,5 ▤ Paris 1905 ⦂

Portrait of Benedetta Canals
Barcelona, Picasso Museum.
Previous owners: Canals, Barcelona; Plandiura, Barcelona; Museo de Arte Moderno, Barcelona.
Exhibition: 66 P.
Bibliography: Z 32 no. 263, DB 66 XIII no. 9, P 66.

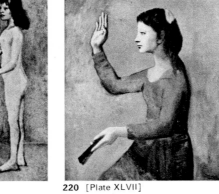

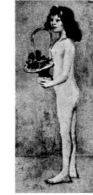

218

219

220 [Plate XLVII]

223

Thannhauser, Paris.
Bibliography: Z 32 no. 255, DB 66 XIII no. 4.
The signature in the bottom left-hand corner is possibly apocryphal.

202 ⊘ 81/65 ▤ Paris 1905 ⦂

"La Coiffure"
Baltimore (Md.), Museum of Art, Cone Collection.
Previous owners: Sainy, Paris; Rosenberg, Paris; Cone, Baltimore.
Exhibitions: 32 P, 32 Z.
Bibliography: L 28, Z 32, no 309, G 51, DB 66 XIII no. 3.

203 ⊘ 55/50 ▤ Paris 1905 ⦂

Nude with her Hand in her Hair
Whereabouts unknown.
Previous owner: Gertrude Stein, Paris.
Bibliography: Z 32 no. 259, S 48-55, EM 55, DB 66 XIII no. 5.

204 ⊘ 41/27 ▤ Paris 1905 ⦂

Nude Woman Dressing her Hair
Basle, Staechelin Collection.
Bibliography: DB 66 XIII no. D 3.

205 ⊘ 39,5/27 ▤ Paris 1905 ⦂

Seated Nude Dressing her Hair
Baltimore (Md.), Museum of Art, Cone Collection.
Previous owner: Cone, Baltimore.
Exhibition: 64 T.
Bibliography: DB 66 XIII no. D 1.

206 ⊘ 26,5/21 ▤ Paris 1905 ⦂

Nude Figures Embracing

Copenhagen, Statens Museum for Kunst.
Previous owners: Guillaume, Paris; Tetzen, Lund (Switzerland).
Bibliography: Z 32 no. 228, DB 66 XIII no. 6.
Gouache and watercolour on paper. This painting, which is not reproduced here, is shown in DB 66 page 276.

207 ⊘ — ▤ Paris 1905 ⦂

The Lovers
Paris, owned by heirs of

Guillaume Apollinaire.
Previous owner: Guillaume Apollinaire, Paris.
Bibliography: DB 66 XIII no. 7.
Dimensions not given. The dedication in the artist's own hand in the bottom right-hand corner reads: "A mon cher ami/ Guillaume Apollinaire/Picasso/ 1905". This painting which is not reproduced here is given in DB 66 page 276. Two studies in watercolour, signed, 11·5 × 18 cm, are in the possession of Poissonnier, Paris.

The beautiful Benedetta, who came from Rome, was the wife of the Catalan painter Ricardo Canals who lived in Montmartre. She had already been a model for Degas and Paul-Albert Bartholomé, and in 1895 had posed for the celebrated *Monument to the dead*, now at Père-Lachaise. See Plate XLIV.

212 ⊘ 45/37 ▤ Paris 1905 ⦂

Profile of a Young Boy
Property of the Artist.
Bibliography: Z 32 no. 216,

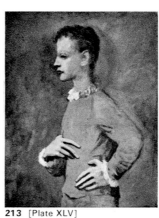

212

213 [Plate XLV]

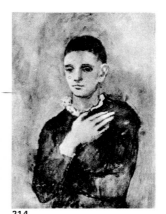

214

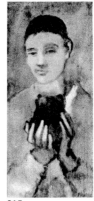

215

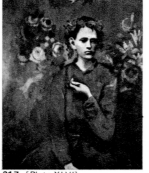

216

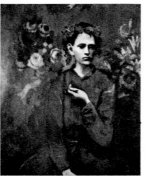

217 [Plate XLVI]

217 A

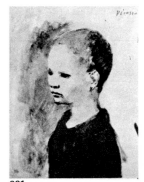

221

S 48-55, D 61, DB 66 XIII no. D 11.

Under this painting, but with the sheet used the other way up, there are traces of earlier figures, among which is a sketch of the *Mistletoe Seller* of 1903, described under no. 50.

213 ⊕ 79,5 59,5 ▤ Paris 1905 ⋮

Profile of a Young Man with a Lace Collar
Worcester (Mass.), Art Museum, on loan from the Dial Collection.
Previous owners: Guillaume, Paris; Dial, Boston.
Exhibitions: 36 NY, 37 C.

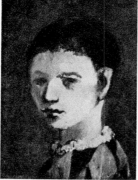

225

226

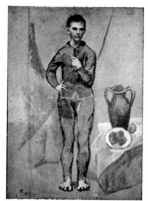

224 [Plate XLVIII]

Bibliography: Z 32 no. 276, S 48-55, EM 55, DB 66 XIII no. 19.
See Plate XLV for which the photographic originals were kindly provided through the Art Museum in Worcester

214 ⊕ 77,5 65,5 ▤ Paris 1905 ⋮

Young Man with a Lace Collar
New York, Meyer Collection.
Previous owner: Haldsdurk, Berlin.
Bibliography: Z 32 no. 273, DB 66 XIII no. 18.

215 ⊕ 54 34 ▤ Paris 1905 ⋮

Young Man with Vase
Glens Falls (NY), Hyde Collection.
Previous owners: Durio, Barcelona; Flechtheim, Düsseldorf.
Bibliography: Z 32 no. 272, S 48-55, DB 66 XIII no. 17.

216 ⊕ 64,5 54 ▤ Paris 1905 ⋮

Young Man with Bunch of Flowers
Villanova (Pa.), Wintersteen

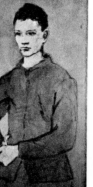

227 [Plate IL]

228

Collection.
Previous owner: McIlhenny, Philadelphia (Pa.).
Exhibitions: 47 NY, 58 F, 64 T.
Bibliography: Z 32 no. 262, DB 66 XIII no. 12.

217 ⊕ 99 79 ▤ Paris 1905 ⋮

Young Man with Garland of Roses
New York, Whitney Collection.
Previous owner: Mendelssohn, Berlin.
Exhibitions: 57 NY, 58 F, 60 L, 66 P.
Bibliography: Z 32 no. 274, S 48-55, L 52-54, B 57, C 58, DB 66 XIII no. 13.

This was painted originally as a portrait of a young Paris worker. André Salmon in *La jeune peinture française*, Paris 1912, recounts that: "One evening Picasso left his friends and returned to his studio where he took up a canvas which had been left neglected for a month, and added to the figure a crown of roses. By a sublime caprice, he had transformed the work into a masterpiece." An ink sketch, 217 A, 30 × 23 cm, signed (DB 66 XIII no. D 10), is

to be found in the Cone Collection in the Museum of Art in Baltimore. See Plate XLVI.

218 ⊕ 14 12 ▤ Paris 1905 ⋮

Nude Mother with Child
Baltimore (Md.), Museum of Art, Cone Collection.
Previous owner: Cone, Baltimore.
Bibliography: K 65, DB 66 XIII no. D 8.
Indian ink and watercolour on paper.

219 ⊕ 152 65 ▤ Paris 1905 ⋮

Nude Girl with Basket of Flowers
New York, owned by the heirs of Gertrude Stein.
Previous owners: Leo and Gertrude Stein, Paris.
Exhibitions: 32 P, 32 Z, 54 P, 59 M, 60 L.
Bibliography: R 21, Z 32 no. 256, S 38, C 40, S 48-55, EM 55, KP 55, D 60, D 64, DB 66 XIII no. 8.
The picture is signed. On the back of the canvas is the inscription: "Picasso/13 rue

Ravignan/1905". Bought from Clovis Sagot in 1905 for 150 francs.

220 ⊕ 99 81,5 ▤ Paris 1905 ⋮

Woman with a Fan
New York, Harriman Collection.
Previous owners: Gertrude Stein, Paris; Rosenberg, Paris.
Exhibitions: 32 P, 36 NY, 39 NY, 60 L, 66 P.
Bibliography: R 21, Z 32 no. 308, B 39, G 51, B 55, EM 55, P 58, DB 66 XIII no. 14.
See Plate XLVII.

221 ⊕ 51 41 ▤ Paris 1905 ⋮

Head and Shoulders of a Young Boy
Baltimore, Museum of Art, Cone Collection.
Previous owner: Cone, Baltimore.
Bibliography: Z 54 no. 688, K 65, DB 66 XIII no. 10.

222 ⊕ 70,5 52 ▤ Paris 1905 ⋮

Actor and Young Boy
New York, Clark Collection.
Bibliography: Z 32 no. 295, L 52-54, B 64, DB 66 XIII no. 11.

223 ⊕ 17,5 15,5 ▤ Paris 1905 ⋮

Sheet of Sketches
Property of the artist.
Bibliography: DB 66 XIII no. D 12.
Indian ink and watercolour on paper. On the back is the inscription in the artist's own hand: "Paris 24 décembre 1905/media noche/Paris Paris Paris". The sheet contains the sketch of an acrobat surrounded by sketches of various other people, among which is a caricature of Guillaume Apollinaire.

224 ⊕ 100 70 ▤ Paris 1905 ⋮

Acrobat and Still Life
Washington, DC, National Gallery of Art, Dale Collection.
Previous owner: Dale, New York.
Bibliography: Z 32 no. 294, DB 66 XIII no. 20.
See Plate XLVIII for which the photographic originals were kindly provided by the National Gallery of Art in Washington.

225 ⊕ 35 24 ▤ Paris 1905 ⋮

Head of a Young Harlequin
Düsseldorf, Private collection.

Previous owner: Vömel, Düsseldorf.
Exhibitions: 32 Z, 55 M.
Bibliography: L 28, Z 32 no. 252, DB 66 XIII no. 16.

226 ⊕ 41,5 32 ▤ Paris 1905 ⋮

Head of a Young Harlequin
Detroit (Mich.), Private collection.
Previous owners: Doucet, Paris; Seligmann, New York.
Exhibition: 32 P.
Bibliography: G 51, Z 54 no. 686, DB 66 XIII no. 15.

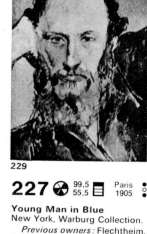

229

227 ⊕ 99,5 55,5 ▤ Paris 1905 ⋮

Young Man in Blue
New York, Warburg Collection.
Previous owners: Flechtheim, Berlin; Lichnowsky, Kuchelna (Czechoslovakia); the German Embassy in London; on loan to the Kronprinz Palace, Berlin; Valentin, New York.
Exhibitions: 13 M, 32 P, 36 NY, 38 B, 39 NY.
Bibliography: Z 32 no. 271, B 39, DB 66 XIII no. 21.
See Plate XLIX.

228 ⊕ 74 59,5 ▤ Paris 1906 ⋮

Portrait of Allan Stein
Baltimore (Md.), Museum of Art, Cone Collection.
Previous owners: Michael Stein, Vaucresson (Paris); Cone, Baltimore.
Bibliography: Z 32 no. 353, S 48-55, K 65, DB 66 XIV no. 2.
Allan was the son of Michael Stein the brother of Leo and Gertrude. See also the following number.

229 ⊕ 27,5 17 ▤ Paris 1906 ⋮

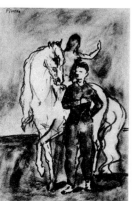

230

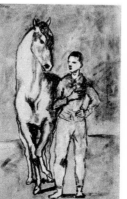

231

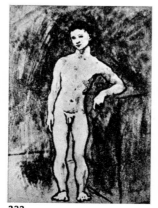

232

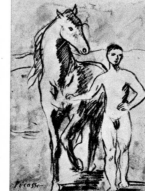

233

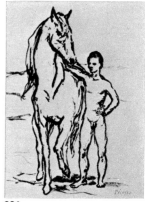

234

Portrait of Leo Stein
Baltimore (Md.), Museum of Art, Cone Collection.
Previous owners: Leo and Gertrude Stein, Paris; Cone, Baltimore.
Exhibitions: 57 NY, 58 F, 64 T.
Bibliography: Z 32 no. 250, S 48-55, B 57, DB 66 XIV no. See also *Outline biography,* 1905.

230 ⊕ 51/34,5 ▤ Paris 1905-6 ⦂

235 [Plate L]

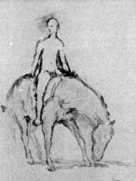

236

Young Equestrienne and Young Man
Whereabouts unknown.
Previous owner: Tietz, Cologne.
Bibliography: Z 32 no. 269, M 42-48, S 54, DB 66 XIV no. 3.

231 ⊕ 50/32 ▤ Paris 1905-6 ⦂

Young Man with a Horse
London, Tate Gallery.
Previous owner: Stoop, London.
Exhibition: 60 L.

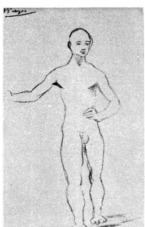

235 A

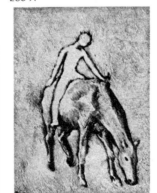

237

Bibliography: Z 32 no. 270, E 56, DB 66 XIV no. 4.

232 ⊕ 68/52 ▤ Paris 1905-6 ⦂

Nude Young Man
Leningrad, Hermitage.
Previous owner: Museum of Modern Western Art, Moscow.
Bibliography: Z 32 no. 268, DB 66 XIV no. 8.
See also the following numbers up to no. 239.

233 ⊕ 23,5/16,5 ▤ Paris 1905-6 ⦂

Nude Young Man with Horse
Baltimore (Md.), Museum of Art, Cone Collection.
Previous owner: Cone, Baltimore.
Bibliography: DB 66 XIV no. 5.
Pencil and watercolour on paper. A sketch for the composition *Horses Bathing,* no. 239.

234 ⊕ 49/32 ▤ Paris 1905-6 ⦂

Nude Young Man with Horse
Baltimore (Md.), Museum of Art, Cone Collection.
Previous owners: Michael Stein, Vaucresson (Paris); Cone, Baltimore.
Bibliography: G 51, L 52-54, DB 66 XIV no. 6.
A sketch for the composition *Horses Bathing,* no. 239.

235 ⊕ 221/130 ▤ Paris 1905-6 ⦂

Boy Leading a Horse
New York, Paley Collection.
Previous owners: Vollard, Paris; Thannhauser, Lucerne.
Exhibitions: 39 NY, 57 NY.
Bibliography: L 28, Z 32 no. 264, S 38, B 39, C 40, M 42-48, S 48-55, B 55, EM 55, B 57, P 58, BP 62, K 65, DB 66 XIV no. 7.
The first detailed working out of a study for the *Horses Bathing,* no. 239. In Z 32 no. 266 is published a sketch, signed, 24 × 16 cm, of unknown date and whereabouts. See Plate L.

240

241

242

236 ⊕ 44/30 ▤ Paris 1906 ⦂

Nude Young Man on Horseback
Küsnacht, Kirchheimer Collection.
Previous owner: Bollag, Zurich.
Exhibition: 32 Z.
Bibliography: Z 54 no. 683, DB 66 XIV no. 10.
A study for the composition *Horses Bathing,* no. 239.

237 ⊕ 55/38 ▤ Paris 1906 ⦂

Nude Young Man on Horseback
France, Private collection.
Previous owner: Van Dongen,

Monte-Carlo.
Bibliography: S 48-55, DB 66 XIV no. 9.
A study for the composition *Horses Bathing,* no. 239.

238 ⊕ 31/49 ▤ Paris 1906 ⦂

Horses Bathing
Paris, Berggruen Collection.
Bibliography: DB 66 XIV no. 15.
A final study before the painting described under the following number.

239 ⊕ 37,5/58 ▤ Paris 1906 ⦂

Horses Bathing
Worcester (Mass.), Art Museum lent by the Dial Collection.
Previous owners: Flechtheim, Berlin; Dial, Boston.
Exhibitions: 37 C, 39 NY.
Bibliography: Z 32 no. 265, B 39, B 46, EM 55, E 56, DB 66 XIV no. 16.
This picture is the last known stage of the preparatory studies for a projected picture *The Watering-Place* (which was never executed). Apart from the other studies described above (from no. 232 onwards), four other preparatory studies are known. Two of these, 239 A

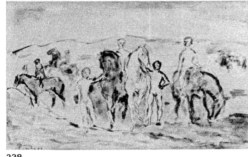

238

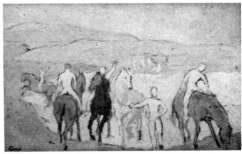

239 [Plates LII–LIII]

239 D

239 A

239 B

239 C

239 E

239 F

243

244 [Plate LI]

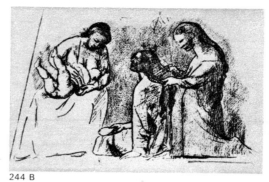

244 A

244 B

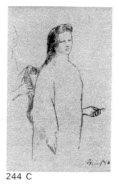

244 C

245

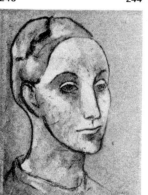

245 A

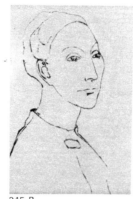

245 B

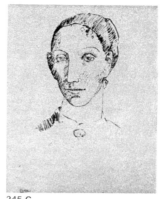

245 C

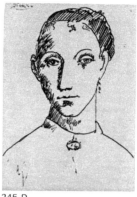

245 D

and B are found on pages 23 and 25 of the *Carnet Catalan* (DB 66 XIV nos. 12 and 13). See also the *Outline biography*. **1906.** The other two are: 239 C, *Horseman from Behind* in charcoal on grey paper, 46·5 × 30·5 cm, signed, once in the possession of Matisse, New York, and now owned by Warrington, Cincinnati (Ohio), exhibited in 39 NY, 57 NY, 58 F and 64 T, published in B 39 and 46, L 52-54, Z 54 no. 682 and DB 66 XIV no. 11; and 239 B *Nude Figures and Horses,* in pencil, 29 × 49·5 cm, once the property of Lewisohn, New York, and now of Chrysler, New York, published in L 52-54 and DB 66 XIV no. 14. Further in

Z 32 no. 267, is published another drawing, 239 E, of a young nude horseman, 30·5 × 23·5 cm, with no indication of the medium, formerly in the possession of Liebman, New York. Lastly a sheet of ink sketches, 239 F, signed and dated "P. 06", 40·5 × 32·5 cm, formerly owned by Gertrude Stein, Paris, then by Curt Valentin, New York, and now by a private collector in New York. It is published in Z 54 no. 864 and DB 66 XIV no. D 1, and includes two caricatures and a brief sketch of a naked horseman which suggests that it may have been executed in relation to this series. From this *Horses Bathing* Picasso made a dry point. See Plates LII-LIII.

240 ⊕ 62/45 ▤ Paris 1906

Vase with Roses
Whereabouts unknown.
Previous owner: Bollag, Zurich.
Bibliography: DB 66 XIV no. D 7.

241 ⊕ 26/21 ▤ Paris 1906

Nude Figures with Child
Whereabouts unknown.
Previous owner: Bollag, Zurich.
Bibliography: DB 66 XIV no. D 5.
Indian ink and coloured pencil on paper. A sketch for the *Blue Vase* described under the following number.

242 ⊕ 31,5/24,5 ▤ Paris 1906

The Blue Vase
Zurich, Bollag Collection.
Bibliography: DB 66 XIV no. D 6.
Indian ink and blue pencil on yellow paper. See also the preceding number which is also possibly a preparatory study for a picture which was never executed.

243 ⊕ 25/17 ▤ Paris 1906

"La Coiffure"
Los Angeles (Cal.), Private collection.
Previous owner: McLane, Los Angeles.
Bibliography: Z 54 no. 744, DB 66 XIV no. 19.
Gouache and pencil on paper. Possibly a preliminary idea for the painting next described.

244 ⊕ 175/99,5 ▤ Paris 1906

"La Coiffure"
New York, Metropolitan Museum of Art.
Previous owners: Vollard, Paris; Perls, Paris; Matisse, New York; Clark, New York; Museum of Modern Art, New York.
Exhibitions: 39 NY, 66 P.
Bibliography: L 28, Z 32 no. 313, B 39, M 42-48, EM 55, BP 62, B 64, DB 66 XIV no. 20.
Although traditionally dated 1905, on stylistic grounds the more probable date is the summer of 1906. The Barnes Foundation in Merion (Pa.) possesses two preparatory sketches for this painting which are still unpublished. Two other sketches relate to this painting: 244 A, ink on paper, signed, 30·9 × 23·9 cm, Cone Collection, Museum of Art, Baltimore (DB 66 XIV no. 17), where only the seated woman with long hair is shown; and 244 B, in pencil and Indian ink on grey paper, signed, 18 × 30

cm, once the property of Jarvis, Portland (GB), and now in the possession of Michael Smith, London (Z 54 no. 741 and DB 66 XIV no. 18). In this study there is a third woman with a child at her breast in addition to the two female figures. Lastly, in Z 32 no. 282 is published a sketch, 244 C, 16·5 × 10·5 cm, once owned by Level, Paris, which is of the same theme, but here the woman is standing. See also the preceding number and Plate LI.

245 ⊕ — ▤ Gósol 1906

Head of a Peasant Woman
Whereabouts unknown.
Previous owner: Stevenson,

246

246 A

246 B

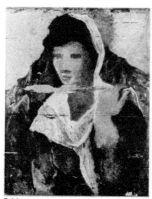

247

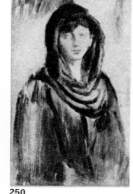

249

250

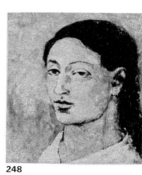

248

Chicago.
Bibliography: Z 54 no. 763, DB 66 XV no. 55.
Gouache and ink on paper: dimensions unknown. Sold at Parke-Bernet's, New York on 4 May 1967 for $6,000. There are four ink sketches relating to this gouache which have been published: 245 A, 21 × 13·5 cm, in the possession of the artist (Z 54 no. 762); 245 B, whose dimensions are not given, also in the possession of the artist (Z 54 no. 764); 245 C, 59 × 43 cm, signed, once the property of Bollag, Zurich, and now in an unknown collection (DB 66 XV no. D 38); 245 D,

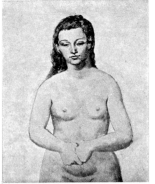

251 [Plate LIV]

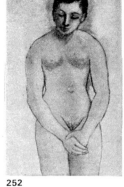

252

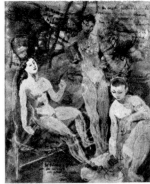

253

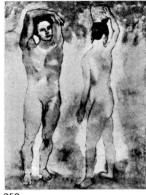

259

21 x 13·5 cm, signed, in the ownership of Berggruen, Paris (DB 66 XV no. D 37).

246 ⊕ 40/30 ▤ Gósol 1906

Profile of a Woman
Paris, Berggruen Collection.
Bibliography: DB 66 XV no. D 33.

Indian ink and watercolour on paper. The same profile is found in two published sketches: 246 A, in black gesso, 59·5 × 45 cm, signed twice on the back, once the property of Huldschinsky (Berlin), Furstenberg (Amsterdam), Wildenstein (London), and since 1953 in the National Gallery of Canada in Ottawa, which was exhibited in 64 T and reproduced in DB 66 XV no. D 36, where there is a full-length portrait of the complete female figure; 246 B, ink, 23·5 × 32 cm, signed, and owned (in 1962) by Marlowe, New York, and reproduced in Z 54 no. 633, a sheet of sketches depicting the head and shoulders of a woman, and various other figures.

247 ⊕ 100/81 ▤ Gósol 1906

Portrait of Fernande Olivier Bareheaded
Cambridge (Mass.), Private collection.
Previous owner: Saint, Paris.
Exhibition: 39 NY.
Bibliography: L 28, Z 32 no. 254, B 39, B 46, S 48-55, EM 55, DB 66 XV no. 41.

Signed on the back. For other portraits of the same subject see nos. 154, 248–51, 265, 295 and 303, and the *Outline biography*, **1904**.

248 ⊕ 37,5/33 ▤ — 1906

Portrait of Fernande Olivier Bareheaded

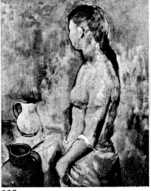

260

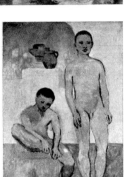
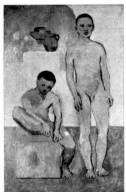

261 [Plate LV]

USA, Private collection.
Bibliography: S 48-55, Z 54 no. 749, DB 66 XV no. 21.
Probably painted at Gósol.

249 ⊕ 81,5/60 ▤ Gósol 1906

Portrait of Fernande Olivier with White Headdress
Whereabouts unknown.
Bibliography: Z 54 no. 893, DB 66 XV no. 44.

250 ⊕ 100/81 ▤ Gósol 1906

Portrait of Fernande Olivier with Black Headdress
New York, J. K. Thannhauser Collection.
Bibliography: Z 32 no. 253, DB 66 XV no. 43.

This picture is mentioned in Z 32 (and from that reference in S 54 and in DB 66) with no indication whether it is signed.

251 ⊕ 96/75,5 ▤ Gósol 1906

Nude of Fernande Olivier with Clasped Hands
Toronto, Zacks Collection.
Previous owner: Rosengart, Lucerne.
Exhibition: 64 T.
Bibliography: R 21, Z 32 no. 310, M 42-48, S 48-55, DB 66 XV no. 28.

The dedication on the back reads: "A mon vrai ami/ Picasso/ 1er Janvier 1907" The person to whom this dedication was intended is not known. The painting can be assigned to the summer of 1906 although it is more usually dated in 1905. See Plate LIV.

252 ⊕ 48,5/29 ▤ Gósol 1906

Nude with Clasped Hands
London, Private collection.
Previous owner: Vollard, Paris.
Bibliography: Z 32 no. 258, P 58, DB 66 XV no. 19.

253 ⊕ 63/48,5 ▤ Gósol 1906

Three Nude Figures
New York, Hillman Collection.
Previous owner: Pellequer, Paris.
Bibliography: Z 32 no. 340, M 42-48, DB 66 XV no. 18.

It includes the following rough notes, in Picasso's hand, for a projected picture never in fact carried out. "The walls decorated with murals of landscapes, flowers and fruit"; "a room painted pink – with curtains – a cane sofa such as one finds in Maña – on it large purple cushions – a marble topped table – on it some glasses and a small mirror"; "maybe some muslin drapes"; "the woman holds a cigarette in her hand"; "he has a wine flask in his hand – there a plate of fruit".

254 ⊕ — ▤ Gósol 1906

Nude Young Man
Paris, Berggruen Collection.
Bibliography: Z 54 no. 662, DB 66 XV no. 2.

Indian ink and watercolour on paper: dimensions not given. A study for *The Two Brothers*, no. 258 and for *The Young Men*, no. 259. A preparatory sketch for this is given on page 16 of the *Carnet Catalan* (DB 66 XV no. 1).

255 ⊕ 18/12 ▤ Gósol 1906

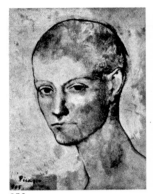

256

Nude Young Man and Children
London, Roland Collection.
Previous owners: Mayor, London; Coltman, London.
Bibliography: Z 54 no. 713, DB 66 XV no. 4.

Pencil and watercolour on paper. A study for *The Two Brothers*, no. 258. A preparatory sketch is given on page 27 of the *Carnet Catalan* (DB 66 XV no. 3).

254

254 A

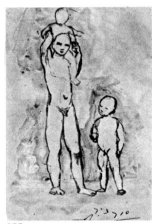

255

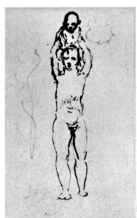

255 A

257 [Plate LVI]

258 [Plate LVII]

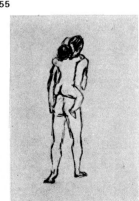

258 A

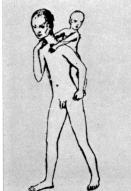

258 B

256 ⊗ 31/24 ▤ Gósol 1906 ⋮

Head of a Young Man
Cleveland (Ohio), Museum of Art, Hanna Collection.
Previous owners: Gertrude Stein, Paris; Bohrmann, Berlin; Doucet, Paris; Hanna, New York.
Bibliography: Z 32 no. 303, DB 66 XV no. 7.
On the picture is written the date 1905, but it was probably added by the artist at a later time, and may well be erroneous, since this gouache, because of the subject's identity, would seem to relate rather to the time of the sketches of the *Two Brothers* (no. 258).

257 ⊗ 80,5/60 ▤ Gósol 1906 ⋮

The Two Brothers
Property of the artist.
Exhibitions: 32 P, 32 Z, 66 P.
Bibliography: Z 54 no. 720, DB 66 XV no. 8.
A sketch for *The Two Brothers* described under the following number. See Plate LVI.

258 ⊗ 142/97 ▤ Gósol 1906 ⋮

The Two Brothers
Basle, Kunstmuseum, lent by the Staechelin Foundation.
Exhibition: 55 M.
Bibliography: Z 32 no. 304, M 42-48, D 64, K 65, DB 66 XV no. 9.
This picture is traditionally dated 1905, but it also relates to the time Picasso spent in Gósol. Apart from the other sketches previously given here beginning with no. 254, two other studies relative to this picture are known: 258 A, Indian ink on paper with a red background, 32·5 × 25·5 cm, signed, in the hands of a private Swiss collector (DB 66 XV no. 5), where the two young men are portrayed from behind; 258 B, Indian ink, 30 × 24 cm, signed, once the property of Cone, Baltimore, and now in the Cone Collection at the Museum of Art in that same city (DB 66 XV no. 6), where the two figures are sketched in the same pose in which they are depicted in this oil painting. See Plate LVII.

259 ⊗ 157/117 ▤ Gósol 1906 ⋮

The Young Men
Paris, Walter-Guillaume Collection.
Previous owners: Vollard, Paris; Guillaume, Paris; Walter, Paris.
Exhibitions: 32 P, 32 Z, 36 NY.

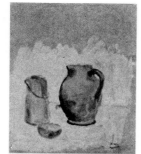

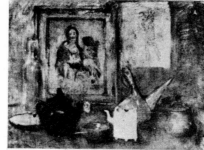

262

263

264

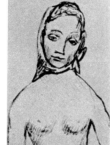
265 [Plate LVIII]

265 A

265 B

265 C

265 D

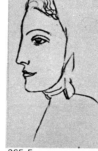
265 E

265 F

265 G

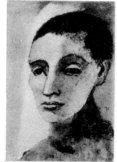
.266

267 [Plate LIX]

Bibliography: Z 32 no. 324, M 42-48, S 48-55, DB 66 XV no. 11, P 66.
See the preceding numbers, beginning with no. 254.

260 ⊗ 100/81 ▤ 1906 ⋮

Nude Figure with Pottery
Whereabouts unknown.
Previous owner: Engelhorn, Ziegelhausen (Heidelberg).
Exhibition: 55 M.
Bibliography: DB 66 XV no. 24.
Probably painted at Gósol.

261 ⊗ 151,5/93,5 ▤ Gósol 1906 ⋮

Two Naked Youths
Washington, DC, National Gallery of Art, Dale Collection.
Previous owners: Vollard, Paris; Helft, Paris; Dale, New York.
Exhibition: 32 P.
Bibliography: L 28, Z 32 no. 305, C 40, M 42-48, Z 54 no. 715, BP 62, DB 66 XV no. 10.
Whether or not this picture was the last in chronological order, it concludes the series of nude male youths begun in no. 254. See Plate LV.

262 ⊗ 42/29 ▤ Gósol 1906 ⋮

Still Life with Pottery and Milk Jug
Basle, Staechelin Collection.
Bibliography: DB 66 XV no. 12.

263 ⊗ 82/100,5 ▤ Gósol 1906 ⋮

Still Life with Pictures
Washington, DC, Phillips Collection.
Previous owners: Kahnweiler, Paris; Robeyn, Brussels.
Bibliography: Z 32 no. 342, DB 66 XV no. 14.
On the wall to the right is a sketch for *The Two Brothers*, no. 258, which, as it includes (as does the previous and the following numbers) a *porrón*, the typical Catalan wine flask, is clearly related to the series of nude male youths (nos. 254-61) of the time of Gósol.

264 ⊗ 38,5/56 ▤ Gósol 1906 ⋮

Still Life with Wine Flask
Leningrad, Hermitage.
Previous owners: Shchukine, Moscow; Museum of Modern Western Art, Moscow.
Bibliography: Z 32 no. 343, S 48-55, KP 55, DB 66 XV no. 13.
The date was added to the picture by the artist in 1911.

265 ⊗ 66/49,5 ▤ Gósol 1906 ⋮

Portrait of Fernande Olivier with Headscarf
Richmond (Va.), Virginia Museum of Fine Arts, Catesby Jones Collection.
Previous owners: Dudensing, New York; Catesby Jones, New York.
Exhibitions: 39 NY, 47 NY, 64 T.
Bibliography: Z 32 no. 319, B 39, S 48-55, DB 66 XV no. 45.
Gouache and charcoal on paper. In Z 54 nos. 754, 755, 756 and 760 are published four preparatory sketches, 265 A, B, C and D, in the possession of the artist of which only the dimensions of the second one are given: 21 × 13 cm. Three other studies for this portrait, 265 E, F and G are given on pages 10, 47 and 70 of the

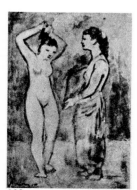
268

269

270 [Plate LX]

270 A

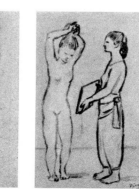
270 B

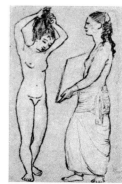
270 C

271 **272** 272 A **273**

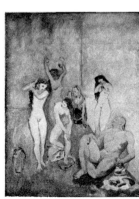

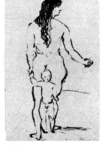

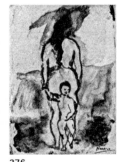

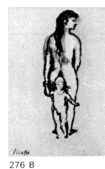

275 275 A 275 B 275 C

Right column:

Bibliography: DB 66 XV
no. D 13.
 This picture relates in some
degree to the watercolour given
under the following number.

272 ⊘ 146 / 114 ▤ Gósol 1906 ⋮

**Nude Young Woman with
Goat and Child**
Merion (Pa.), Barnes
Foundation.
 Bibliography: L 28, Z 32 no.
249, M 42-48, DB 66 XV no. 35.
 A sketch in pencil, 272 A, of a
*Nude Young Woman Doing Her
Hair*, 12 × 7·5 cm, in the
possession of the artist (DB 66
XV no. 36), is related to this
picture. The figure of the young
girl to be found in *The Harem*,
no. 274.

273 ⊗ 64 / 49 ▤ Gósol 1906 ⋮

**Nude Woman Leaning
Forward**
Cleveland (Ohio), Museum of
Art, Hurlbut Collection.
 Previous owner: Hurlbut,
Cleveland.
 Exhibitions: 36 NY, 39 NY.
 Bibliography: Z 32 no. 320,
B 39, M 42-48, B 46, DB 66
XV no. 38.
 This figure is to be found in
the centre of the picture *The
Harem*, no. 274.

274 ⊘ 154·5 / 109·5 ▤ Gósol 1906 ⋮

The Harem
Cleveland (Ohio), Museum of
Art, Hanna Collection.
 Previous owners: Quinn,
New York; Hanna, New York.
 Exhibition: 36 NY.
 Bibliography: Z 32 no. 321,
M 42-48, DB 66 XV no. 40,
P 66.
 There is a well-known design
in pencil, 247 A, 57·5 × 46 cm,
in an unknown collection
(Z 54 no. 657; EM 55; DB 66
XV no. 39), which contains a
complete sketch of this painting.



Carnet Catalan (DB 66 XV
nos. D 25, D 26, D 27). See
Plate LVIII.

266 ⊗ 38 / 25,5 ▤ Gósol 1906 ⁝

Head of a Young Man
New York, Ault Collection.
 Previous owners: Saint,
Paris; Dudensing, New York.
 Bibliography: Z 32 no. 331,
Z 54 no. 781, B 55, BP 62,
DB 66 XV no. 17.

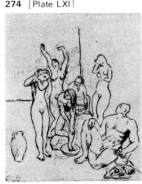

274 [Plate LXI]



267 ⊗ 61,5 / 48 ▤ Gósol 1906 ⋮

**Head and Shoulders of a
Young Spaniard**
Goteborg, Konstmuseum.
 Previous owner: Halvorsens,
Oslo.
 Bibliography: Z 32 no. 318,
DB 66 XV no. 37, P 66.
 Gouache and watercolour on
paper; signed on the back.
Wrongly believed to be a portrait
of Fernande Olivier, it depicts in
fact a young peasant of Gósol.
See Plate LIX.

268 ⊗ 25,5 / 16,5 ▤ Gósol 1906 ⁝

Sketch for "La Toilette"
New York, Chrysler Collection.
 Previous owners: Leo Stein,
Paris; Sullivan, New York.
 Bibliography: DB 66 XV
no. 31.
 See no. 270.

269 ⊗ 52 / 31 ▤ Gósol 1906 ⋮

"La Toilette"
São Paulo, Museu de Arte.
 Previous owners: Stang,
Oslo; Warburg, New York.
 Exhibition: 36 NY.
 Bibliography: Z 54 no. 736,
DB 66 XV no. 33.
 The first completed version of
the important work described
under the following number.

270 ⊗ 151 / 99 ▤ Gósol 1906 ⋮

"La Toilette"
Buffalo (NY), Albright-Knox
Art Gallery.
 Previous owner: Quinn, New
York.
 Exhibitions: 36 NY, 38 B,
39 NY, 60 L, 64 T, 66 P.
 Bibliography: L 28, Z 32 no.
325, B 39, M 42-48, L 52-54,
EM 55, C 58, B 64, D 64,

Fourth column (under 275 B):

DB 66 XV no. 34, P 66.
 Apart from the paintings given
under the two previous numbers,
three sketches relating to this
picture are also known: the
first, 270 A, in ink, signed,
25 × 17 cm (DB 66 XV no. 29);
the second, 270 B, in charcoal,
signed, 24 × 15 cm (DB 66 XV
no. 30); both previously in the
ownership of Bollag, Zurich,
and now in an unknown
collection. A third sketch, 270 C,
in charcoal on beige paper,

Fifth column (under 275 C):

62 × 40·5 cm, signed and dated
1906 (L 52-54; DB 66 XV no.
32), once the property of
Flechtheim and then Stinnes
(both of Berlin), is now in the
collection of the Hillmann
Corporation in New York. See
Plate LX.

271 ⊗ 41 / 27 ▤ Gósol 1906 ⁝

**Nude Figure seen from
Behind Doing her Hair**
Basle, Staechelin Collection.

276 276 A 276 B 276 C

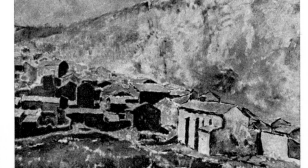

278 **279**

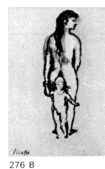

274 A

110

See also the two preceding numbers. See Plate LXI.

275 ⊕ 37 / 24,5 ▤ Gósol 1906

Nude Woman from the Side
Whereabouts unknown.
Previous owner: Guillaume, Paris.
Bibliography: Z 32 no. 226, M 42-48, DB 66 XV no. D 7.
In DB 66 are published, among others, three very convincing sketches relating to this watercolour: 275 A, pencil, 16·5 × 10·5 cm, signed, once the property of Cherbsky, Paris and now belonging to Georges Charensol, Paris (XV no. D 4; but see also in this catalogue under no. 271), on the back of

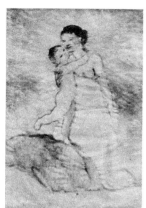
277

which is the painting given under no. 298; 275 B, in black gesso work, 31·5 × 25 cm, signed, once the property of Brewster, Chicago, and now in the Art Institute of the same city (XV no. D 5), in which there is also a sketch of two joined hands, like those of the woman and child in no. 276; 275 C, in ink, 40 × 29 cm, signed on the back, once the property of Roede and now in the hands of a private collector, both in Oslo (XV no. D 14).

276 ⊕ 24 / 16 ▤ Gósol 1906

Nude Woman from Behind with Child
Whereabouts unknown.
Previous owner: Bollag, Zurich.
Bibliography: Z 54 no. 719, DB 66 XV no. D 3.
At least three sketches in charcoal are known which are definitely related to this water-colour: 276 A, 22 × 10 cm, signed, in the ownership of Josefowitz, Geneva (DB 66 XV no. D 1); 276 B, 31·1 × 23·9 cm, signed, in the Cone Collection of the Museum of Art in Baltimore (DB 66 XV no. D 2); 276 C, 24 × 15 cm, signed, once in the ownership of the Bollag Gallery, Zurich, and now owned by Kirchheimer, Küsnacht (DB 66 XV no. D 6), the last of which shows the child alone. See also the preceding number.

277 ⊕ — ▤ Gósol 1906

Mother and Naked Child
Whereabouts unknown.
Previous owner: Bonnet, Paris.
Bibliography: Z 32 no. 315, DB 66 XV no. D 8.
This picture is noted only in the work of Zervos, the dimensions are unknown, and it is not certain whether it was signed. Zervos dates it Paris 1905, but it would seem more convincing to assign it to the time of Gósol.

278 ⊕ 54 / 38,5 ▤ Gósol 1906

Houses in Gósol
Copenhagen, Statens Museum for Kunst.
Previous owner: Tetzen, Lund (Sweden).
Bibliography: Z 32 no. 316, DB 66 XV no. 50.
The signature of the artist is on the back of the picture.

281

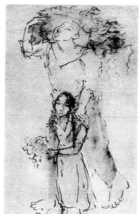
287

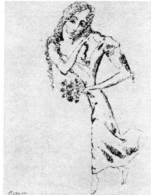
289 A

279 ⊕ 70 / 99 ▤ Gósol 1906

View of Gósol
New York, Private collection.
Previous owner: Spingold, New York.
Exhibition: 57 NY.
Bibliography: Z 54 no. 732, DB 66 XV no. 48.

280 ⊕ 62 / 47 ▤ Gósol 1906

Cattle Drover with Small Basket

282

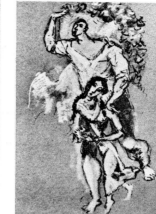
288

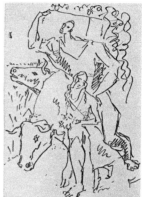
289 B

Columbus (Ohio), Gallery of Fine Arts.
Previous owner: Dudensing, New York.
Bibliography: Z 32 no. 338, B 46, DB 66 XV no. 56.
See Plate LXII, for which the photographic originals were kindly provided by the Gallery of Fine Arts, Columbus.

281 ⊕ 24 / 31,5 ▤ Gósol 1906

Cockerels
San Francisco (Cal.), Museum of Art.
Previous owner: Levy, San Francisco.
Exhibition: 39 NY.
Bibliography: B 39, Z 54 no. 725, DB 66 XV no. 49.

282 ⊕ 24 / 31 ▤ Gósol 1906

Fowls
Baltimore (Md.), Museum of Art, Cone Collection.
Previous owner: Cone, Baltimore.
Bibliography: DB 66 XV no. 51.
Indiàn ink and watercolour on paper.

283 ⊕ 100 / 70 ▤ Gósol 1906

The Bread Carrier
Philadelphia (Pa.), Museum of Art.
Previous owners: Vollard, Paris; Caussignac, Paris; Guillaume, Paris; Harriman, New York; Ingersoll, Chestnut Hill (Pa.).
Exhibitions: 36 NY, 39 NY, 58 F, 66 P.
Bibliography: S 48-55, Z 54 no. 735, EM 55, DB 66 XV no 46, P 66.

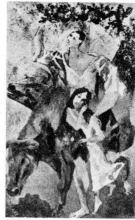
289

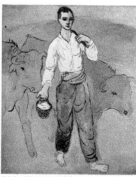
289 C

Dated by Picasso at a later time and erroneously as 1905. See Plate LXIII.

284 ⊕ — ▤ Gósol 1906

Vase and Flowers
Winnipeg (Canada), McAuley Collection.
Bibliography: DB 66 XV no. 15.
Dimensions not given.

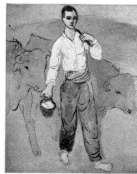
280 [Plate LXII]

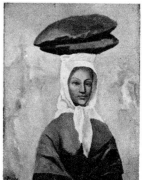
283 [Plate LXIII]

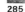
284

285

286

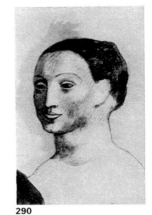

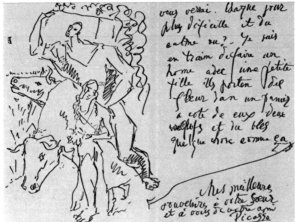

Letter from Picasso and Fernande Olivier to Leo Stein, containing drawing no. 289 C.

285 ⊘ 70,5 / 54 ▤ Gósol 1906 ⦂

Pottery and Vase with Flowers
New York, J. K. Thannhauser Collection.

Previous owner: Thannhauser, Paris.
Bibliography: Z 54 no. 889, DB 66 XV no. 16.

286 ⊘ 40 / 30 ▤ Gósol 1906 ⦂

Vase with Flowers
Zurich, Bollag Collection.
Bibliography: Z 54 no. 723, DB 66 XV no. D 42.
Indian ink and watercolour on paper.

287 ⊘ 63 / 46,5 ▤ Gósol 1906 ⦂

The Peasants
Toronto, Zacks Collection.
Previous owners: Vollard, Paris; Harriman, New York; Knoedler, New York; Perls, New York.
Exhibitions: 57 NY, 58 F, 64 T.
Bibliography: Z 32 no. 311, B 46, B 57, DB 66 XV no. 60.
Indian ink and watercolour on paper. The first of three compositions with the same theme: see the next two numbers.

288 ⊘ 69 / 47 ▤ Gósol 1906 ⦂

The Peasants
Paris, Walter-Guillaume Collection.
Previous owners: Guillaume, Paris; Walter, Paris.
Bibliography: Z 32 no. 312, DB 66 XV no. 61.
The second of three compositions on the same theme.

289 ⊘ 218,5 / 129,5 ▤ Paris 1906 ⦂

The Peasants
Merion (Pa.), Barnes Foundation.
Previous owner: Vollard, Paris.
Bibliography: Z 32 no. 384, DB 66 XV no. 62.
This is the definitive painting of the series of *The Peasants* (see the two previous numbers) which was inspired by the style of El Greco. In DB 66 are published two preparatory sketches in ink: 289 A, 63 × 48 cm, signed, once in the ownership of Mrs S. B. Resor, New York, who in 1950 donated it to the Museum of Modern Art in that city (XV no. 58); 289 B, 18 × 12 cm, signed on the back, once in the Bollag Gallery, Zurich and the current property of Kirchheimer, Künacht (XV no. 57). A third sketch, 289 C, also in ink, contained in a letter (DB 66 XV no. 59 page 339) written by Picasso and Fernande Olivier to Leo Stein on 17 August 1906 from Paris: ("I am in the middle of painting a man with a young woman carrying flowers in a basket, with two bulls and a cornfield on one side"). The letter is preserved at Yale University and is documentary evidence that the series probably begun at Gósol was completed in Paris. On the following page all four sheets of this letter are reproduced. This picture terminates the Rose Period.

290 ⊘ 62 / 47 ▤ Gósol 1906 ⦂

Head of a Woman with Sleek Hair
Whereabouts unknown.

290

291

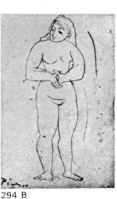
298

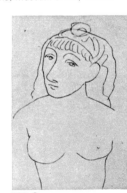
299

Previous owner: Vollard, Paris.
Bibliography: Z 32 no. 332, DB 66 XV no. 20.
A study for the *Nude Woman with Clasped Hands* described under no. 294.

291 ⊘ 61,5 / 43,5 ▤ 1906 ⦂

Head of a Woman with her Hair Down her Back
USA, Private collection.

Previous owners: Vollard, Paris; Museum of Art, Toledo

292

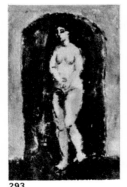
293

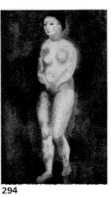
294

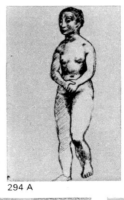
294 A

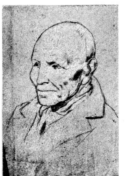
294 B

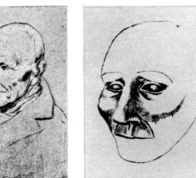
294 C

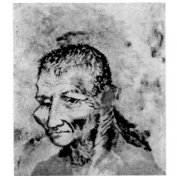
296

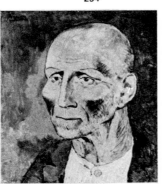
297

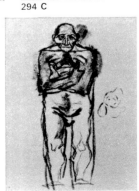
297 A

297 B

297 C

112

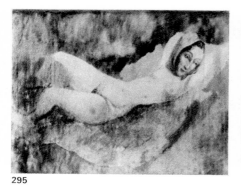

295

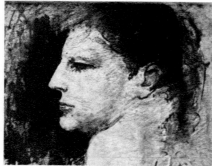

303

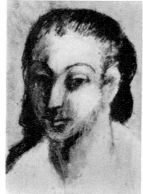

301

300

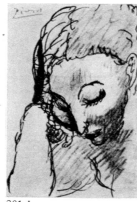

301 A

302

304

305

(Ohio); Knoedler, New York.
Exhibition: 36 NY.
Bibliography: Z 32 no. 333, M 42-48, DB 66 XV no. 22.
Probably painted at Gósol.

292 · 21 / 13 · Gósol 1906

Nude Woman with Triangular Background
Whereabouts unknown.
Bibliography: Z 54 no. 887.

293 · 26 / 18 · Gósol 1906

Nude Woman in an Archway
Merion (Pa.), Barnes Foundation.
Bibliography: Z 32 no. 326, S 48-55, DB 66 XV no. 26.
A sketch for the *Nude Woman with Clasped Hands* described under the following number.

294 · 153 / 94 · Gósol 1906

Nude Woman with Clasped Hands
New York, owned by the heirs of Gertrude Stein.
Previous owner: Gertrude Stein, Paris.
Exhibitions: 54 P, 59 M.
Bibliography: D 30, Z 32 no.

327, M 42-48, S 48-55, KP 55, D 64, DB 66 XV no. 27.
Apart from the gouache and the small oil painting given under nos. 290 and 293, there exists a pencil sketch, 294 A, also a study for this nude figure: 62 × 47·5 cm; signed, once the property of Gertrude Stein, Paris; Perls, New York and Chrysler, New York, and now in the possession of Block, Chicago; published in Z 54 no. 779 and DB 66 XV no. 25. A further sketch of a nude woman with clasped hands, 294 B, also occurs in a pencil sketch, 17 × 11 cm, signed, owned by Rosengart, Lucerne, and published in DB 66 XV no. D 17; a variation on the head of the same model, 294 C, occurs in a pencil sketch, 21·5 × 13·5 cm, which is in the possession of the artist and is reproduced in Z 54 no. 852.

295 · 47,5 / 61,5 · Gósol 1906

Reclining Nude (Fernande)
Cleveland (Ohio), Museum of Art.
Previous owners: Guillaume, Paris; Straight, Washington DC.
Exhibition: 64 T.

Bibliography: Z 32 no. 317, DB 66 XV no. 47.

296 · 40,5 / 35 · Gósol 1906

Head of a Peasant
Philadelphia (Pa.), Meyer de Schauensee Collection.
Previous owner: Slater, Paris.
Bibliography: Z 32 no. 346, DB 66 XV no. 52.
Gouache and watercolour on rice paper.

297 · 45 / 40,5 · Gósol 1906

Head of a Peasant
New York, Schoenborn-Marx Collection.
Previous owner: Marx, Chicago.
Bibliography: Z 54 no. 769, B 55, DB 66 XV no. 53.
Three sketches relating to this picture are known: 297 A, pencil, 35 × 22·5 cm, given in 1906 by the artist to his landlord at Gósol and which is at present in an unknown collection (Z 54 no. 770; DB 66 XV no. 54); 297 B, ink, 31·5 × 24·5 cm, in the possession of the artist (Z 54 no 765); 297 C, pencil, 25·5 × 20 cm, also in the

possession of the artist.

298 · 16.5 / 10.5 · Gósol 1906

Head of a Woman
Paris, Georges Charensol Collection.
Previous owner: Cherbsky, Paris.
Bibliography: DB 66 XV no. D 21.
Indian ink and watercolour on paper. On the back is outlined the sketch (see no. 275A).

299 · 75 / 55 · Paris 1906

Woman Sewing
France, Private collection.
Previous owner: Bienert, Hamburg.
Bibliography: Z 32 no. 314, S 48-55, DB 66 XVI no. 3.

300 · 47 / 31 · 1906

Head of a Woman
Zurich, Private collection.
Previous owner: Bollag, Zurich.
Bibliography: Z 54 no. 787, DB 66 XVI no. D 4.
Gouache and watercolour on paper. Probably executed in Paris, on his return from Gósol.

301 · 62 / 47 · Paris 1906

Two Heads of Women
Houston (Tex.), on loan from the Hogg Collection to the Museum of Fine Arts.
Previous owner: Hogg, Houston.
Bibliography: Z 32 no. 335, DB 66 XVI no. 1.
A study for this gouache is given in a sketch, 301 A, in pencil and Indian ink, 17 × 11 cm, signed, the property of Rosengart, Lucerne, and published in Z 54 no. 753 and in DB 66 XVI no. D 1, on the back of which is outlined the sketch which has been referred to under no. 294.

302 · 51 / 39,5 · Paris 1906

Bowed Head of a Woman
Stuttgart, Staatsgalerie.
Previous owners: Mendelssohn, Berlin; Marlborough Gallery, London.
Exhibition: 55 M.
Bibliography: Z 32 no. 351, S 48-55, DB 66 XVI no. 4.
Signed on the back.

303 · 32 / 40 · Paris 1906

Profile of Fernande Olivier
Stockholm, Prins Eugens Gemäldegalerie.
Bibliography: DB 66 XVI no. 2.
Sold by the Svensk-Franska Konstgalleriet, in Stockholm in 1921.

304 · 21 / 13,5 · Paris 1906

Two Nude Figures
Düsseldorf, Liesenfeld Collection.
Previous owners: Bernheim de Villiers, Paris; Rosenberg, Paris; Berggruen, Paris.
Bibliography: DB 66 XVI no. 1.
Indian ink and watercolour on paper. Signed "Picasso fecit". On the back of the sheet is a sketch of a hand.

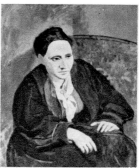

306 [Plate LXIV]

305 · 100 / 81 · 1906

Nude Woman with Water Jug
London, James Collection.
Previous owners: Reber, Lausanne; Richet, Paris.
Exhibition: 60 L.
Bibliography: Z 32 no. 330, M 42-48, DB 66 XV no. 23.
Probably executed in Paris, after his return from Gósol.

306 · 100 / 81 · Paris 1906

Portrait of Gertrude Stein
New York, Metropolitan Museum of Art.
Previous owner: Gertrude Stein, Paris, who bequeathed it to the Metropolitan Museum.

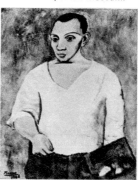

307

Exhibitions: 39 NY, 47 NY, 55 P, 57 NY, 58 F, 66 P.
Bibliography: Z 32 no. 352, S 38, B 39, C 40, M 42-48, B 46, L 52-54, B 55, EM 55, B 57, P 58, B 64, D 64, J 64, DB 66 XVI no. 10.

This picture was begun in the winter of 1905–6. In the spring Picasso painted out the head and in the autumn on his return from Gósol re-painted it in the form of a mask, without seeing the model again. Nevertheless, Gertrude Stein herself (1938) wrote: "I was and still am completely satisfied with this portrait. For me, it is me; and it is the only representation of me which always will be me." See *Outline biography*, 1905. See also Plate LXIV.

307 · 92 / 73 · Paris

Self-Portrait with Palette
Philadelphia (Pa.), Museum of Art, Gallatin Collection.
Previous owner: Gallatin, New York.
Exhibitions: 39 NY, 55 P, 55 M, 57 NY, 58 F, 60 L, 64 T, 66 P.
Bibliography: Z 32 no. 375, B 39, B 46, S 54, EM 55, B 57, D 64, DB 66 XVI no. 28.
Painted in autumn 1906.

Table of Concordance

This table shows the concordance between the catalogue given in this book, and those provided in two volumes (the first and the sixth) of the monumental work by Christian Zervos (Paris, 1932 and 1954) concerning the early years of Picasso's output, and also in the definitive work of Daix and Boudaille, Picasso 1900–1906 (Neuchâtel 1966).

CWA	Zervos	Daix & Boudaille	CWA	Zervos	Daix & Boudaille	CWA	Zervos	Daix & Boudaille
1	32 97	VI 19	59	32 178	IX D 18	115	32 219	XI 2
2	32 94	VI 21	60	— —	IX D 19	116	32 218	XI 3
3	32 79	VI 22	61	32 186	IX D 20	117	32 231	XI 4
4	32 92	VI 20	A	— —	IX D 21	118	54 617	XI D 9
5	32 83	VI 14	62	32 376	IX D 16	119	32 224	XI 5
6	32 101	VI 12	63	54 482	IX D 17	120	32 238	XI D 4
7	32 104	VI 18	64	54 481	IX D 15	121	54 615	XI D 5
8	32 102	VI 13	65	32 167	IX 9	122	54 704	XI D 6
9	32 103	VI 15	66	— —	IX D 6	123	— —	XI D 7
10	32 96	VI 23	A	54 451	— —	124	32 248	XI D 11
11	32 98	VI 24	67	54 462	IX 18	125	32 247	XI 6
12	32 100	VI 25	68	32 181	IX 19	126	54 631	XI D 20
13	— —	VI 27	69	54 548	IX 16	127	32 239	XI D 19
14	— —	X 9	70	32 166	IX 14	128	— —	XI 21
15	32 117	VI 31	71	32 165	IX 15	129	32 229	XI 20
16	32 115	VI 30	72	32 174	IX 21	130	32 214	XI 15
17	32 110	VI 29	73	— —	IX D 9	131	32 233	XI 7
18	32 109	VI 28	74	32 201	IX 20	132	32 240	XI 10
19	32 116	VI 32	75	32 205	IX 17	133	— —	— —
20	54 733	XV 42	76	32 194	IX D 8	134	32 215	XI 17
21	32 91	VI 35	77	— —	IX D 7	135	— —	XI 16
22	32 87	VI 34	78	32 199	IX 22	136	32 217	XI 18
23	32 86	VI 33	79	32 200	IX 24	137	54 632	XI D 21
24	32 160	VII 4	80	32 203	IX 23	138	54 652	XI 8
25	32 121	VII 5	A	32 204	— —	139	— —	XI 9
26	32 119	VII 2	81	54 563	IX D 13	140	32 234	XI 11
27	32 120	VII 3	82	— —	IX D 1	141	32 235	XI 12
28	32 133	VII 6	83	— —	IX 4	142	32 212	XI 22
29	32 105	VII 7	84	32 198	— —	143	— —	XI 14
30	32 130	VII 15	85	32 197	IX 5	144	32 241	XI 13
31	— —	VII 8	86	32 208	IX 6	145	32 221	XI D 12
32	32 118	VII 10	87	32 162	IX 11	146	— —	XI 19
33	32 155	VII 9	88	32 161	IX 12	147	32 213	XI D 16
34	32 131	VII 11	89	32 179	IX 13	148	54 616	XI D 14
A	32 192	— —	A	54 534	IX D 4	149	— —	XI D 15
B	— —	VII D 1	B	— —	IX D 5	150	32 211	XI D 10
C	54 418	— —	90	32 188	— —	151	— —	XI D 18
D	54 420	— —	91	32 175	IX 30	152	— —	XI D 28
35	— —	VII 18	A	32 170	IX 29	153	— —	XI D 29
36	32 381	VII 21	92	32 202	IX 34	154	32 291	XII 1
37	54 478	VII 20	93	32 172	IX 31	A	54 681	XII 2
A	32 151	VII D 9	A	54 533	— —	155	— —	XII 4
38	— —	VII 19	B	— —	IX D 23	A	32 220	XI D 26
39	32 163	VII 22	94	32 168	IX 32	156	32 257	XII 3
A	54 436	VII D 4	95	32 187	IX 33	157	32 307	XII 5
B	54 435	VII D 6	96	32 230	IX 27	158	54 718	XII 15
40	— —	VII 16	97	54 600	IX 28	159	54 702	XII 12
41	54 449	VII 17	98	54 578	IX D 11	160	32 244	XII 11
42	— —	VII 12	99	32 183	IX 26	161	32 298	XII 6
43	— —	VII 14	A	32 191	IX 25	162	32 289	XII 13
44	32 132	VII 13	100	32 169	IX 7	163	— —	XII D 1
45	— —	VII 1	101	54 483	— —	164	— —	XIII D 7
46	32 142	VIII 1	102	54 438	IX D 22	165	32 299	XII 7
47	32 182	VIII 2	103	32 184	X 5	A	— —	XII D 3
48	32 180	VIII 3	104	54 544	X 4	166	— —	XII D 8
49	— —	VIII 5	105	54 684	X 3	167	32 296	XII 8
50	32 123	VIII 4	106	32 209	X 1	168	— —	XII 10
51	54 413	X 7	107	32 210	X 2	169	32 292	XII 14
52	54 479	X 8	108	32 232	X 6	170	32 297	XII 9
53	54 476	IX 10	109	54 653	X 11	171	32 306	XII 16
54	54 467	X 10	110	32 164	X 12	172	32 300	XII 17
55	32 206	IX 8	111	— —	XI D 2	173	— —	XII 20
56	32 122	IX 1	112	32 237	XI D 3	A	— —	XII D 21
57	— —	IX 3	113	32 185	XI D 1	174	32 290	XII 19
58	32 207	IX 2	114	32 227	XI 1	175	32 293	XII 26

CWA	Zervos	Daix & Boudaille
A	32 322	— —
176	— —	XII D 4
177	— —	XII D 5
178	32 301	XII 25
179	32 245	XII 21
A	32 246	— —
180	— —	XII 18
181	— —	XII D 6
182	32 281	XII D 2
183	32 225	XII D 9
184	54 734	XII D 18
A	— —	XII 30
B	— —	XII D 20
C	54 691	— —
D	54 690	— —
185	54 703	XII D 7
A	32 279	— —
186	32 284	XII 28
187	32 283	XII 29
188	54 697	XII D 19
A	54 689	— —
189	32 286	XII 31
190	32 287	XII 33
191	32 288	XII 34
192	32 285	XII 35
A	— —	XII 32
B	32 280	— —
193	54 798	XII 22
194	— —	XII D 15
A	— —	XII D 14
195	— —	XII D 11
196	32 243	XII 24
197	32 275	XII 23
198	32 302	XII 27
199	32 261	XIII 2
200	32 260	XIII 1
201	32 255	XIII 4
202	32 309	XIII 3
203	32 259	XIII 5
204	— —	XIII D 3
205	— —	XIII D 1
206	32 228	XIII 6
207	— —	XIII 7
208	— —	XIII D 5
209	— —	XIII D 9
210	32 251	XIII D 6
211	32 263	XIII 9
212	32 216	XIII D 11
213	32 276	XIII 19
214	32 273	XIII 18
215	32 272	XIII 17
216	32 262	XIII 12
217	32 274	XIII 13
A	— —	XIII D 10
218	— —	XIII D 8
219	32 256	XIII 8
220	32 308	XIII 14
221	54 688	XIII 10
222	32 295	XIII 11
223	— —	XIII D 12
224	32 294	XIII 20
225	32 252	XIII 16
226	54 686	XIII 15
227	32 271	XIII 21

CWA	Zervos	Daix & Boudaille
228	32 353	XIV 2
229	32 250	XIV 1
230	32 269	XIV 3
231	32 270	XIV 4
232	32 268	XIV 8
233	— —	XIV 5
234	— —	XIV 6
235	32 264	XIV 7
A	32 266	— —
236	54 683	XIV 10
237	— —	XIV 9
238	— —	XIV 15
239	32 265	XIV 16
A	— —	XIV 12
B	— —	XIV 13
C	54 682	XIV 11
D	— —	XIV 14
E	32 267	— —
F	54 864	XIV D 1
240	— —	XIV D 7
241	— —	XIV D 5
242	— —	XIV D 6
243	54 744	XIV 19
244	32 313	XIV 20
A	— —	XIV 17
B	54 741	XIV 18
C	32 282	— —
245	54 763	XV 55
A	54 762	— —
B	54 764	— —
C	— —	XV D 38
D	— —	XV D 37
246	— —	XV D 33
A	— —	XV D 36
B	54 633	— —
247	32 254	XV 41
248	54 749	XV 21
249	54 893	XV 44
250	32 253	XV 43
251	32 310	XV 28
252	32 258	XV 19
253	32 340	XV 18
254	54 662	XV 2
A	— —	XV 1
255	54 713	XV 4
A	— —	XV 3
256	32 303	XV 7
257	54 720	XV 8
258	32 304	XV 9
A	— —	XV 5
B	— —	XV 6
259	32 324	XV 11
260	— —	XV 24
261	32 305	XV 10
262	— —	XV 12
263	32 342	XV 14
264	32 343	XV 13
265	32 319	XV 45
A	54 754	— —
B	54 755	— —
C	54 756	— —
D	54 760	— —
E	— —	XV D 25
F	— —	XV D 26

CWA	Zervos	Daix & Boudaille
G	— —	XV D 27
266	32 331	XV 17
267	32 318	XV 37
268	— —	XV 31
269	54 736	XV 33
270	32 325	XV 34
A	— —	XV 29
B	— —	XV 30
C	— —	XV 32
271	— —	XV D 13
272	32 249	XV 35
A	— —	XV 36
273	32 320	XV 38
274	32 321	XV 40
A	54 657	XV 39
275	32 226	XV D 7
A	— —	XV D 4
B	— —	XV D 5
C	— —	XV D 14
276	54 719	XV D 3
A	— —	XV D 1
B	— —	XV D 2
C	— —	XV D 6
277	32 315	XV D 8
278	32 316	XV 50
279	54 732	XV 48
280	32 338	XV 56
281	54 725	XV 49
282	— —	XV 51
283	54 735	XV 46
284	— —	XV 15
285	54 889	XV 16
286	54 723	XV D 42
287	32 311	XV 60
288	32 312	XV 61
289	32 384	XV 62
A	— —	XV 58
B	— —	XV 57
C	— —	XV 59
290	32 332	XV 20
291	32 333	XV 22
292	54 887	— —
293	32 326	XV 26
294	32 327	XV 27
A	54 779	XV 25
B	— —	XV D 17
C	54 852	— —
295	32 317	XV 47
296	32 346	XV 52
297	54 769	XV 53
A	54 770	XV 54
B	54 765	— —
C	54 772	— —
298	— —	XV D 21
299	32 314	XVI 3
300	54 787	XVI D 4
301	32 335	XVI 1
A	54 753	XVI D 1
302	32 351	XVI 4
303	— —	XVI 2
304	— —	XVI 11
305	32 330	XV 23
306	32 352	XVI 10
307	32 375	XVI 28

Indexes

117

118

Prices

In nos. 4, 7, 17, 20, 24,
27, 36, 37, 45, 47, 48, 51, 79,
85, 116–7, 160, 174, 193,
198, 200, 219, 245, 296 and
303 are mentioned some of
the prices which Picasso's
works have fetched at
various times and in several
countries.